DREAM
THE END
OF THE WORLD

APOCALYPSE AS A RITE OF PASSAGE

SECOND EDITION

MICHAEL ORTIZ HILL

SPRING PUBLICATIONS, INC.
PUTNAM, CONNECTICUT

Copyright © 1994, 2004 by Michael Ortiz Hill

Published by Spring Publications, Inc.
28 Front Street, Suite 3
Putnam, CT 06260
www.springpublications.com

First published in 1994

Second edition 2004

Manufactured in Canada
Design by white.room productions, New York

ISBN 0-88214-556-8

Lines from "The Second Coming" are reprinted with permission of Macmillan
Publishing Company from *The Poems of W. B. Yeats: A New Edition,* edited
by Richard J. Finnegan. Copyright 1924 by Macmillan Publishing Company,
renewed 1952 by Bertha Georgie Yeats. "The Bomb Lost In Its Own Dark
Dreaming" was previously published in *The Sun: A Magazine of Ideas* 167
(October 1989). "Healing the Dream of Apocalypse: A Ritual" was previously
published in *Whole Earth Review* 66 (Spring 1990).

Library of Congress Cataloging-in-Publication Data

Hill, Michael Ortiz.
 Dreaming the end of the world : Apocalypse as a rite of passage /
Michael Ortiz Hill.—2nd ed.
 p. cm.
 Includes bibliographical references.
 ISBN 0-88214-556-8 (alk. paper)
 1. Dreams. 2. End of the world. I. Title.

BF1099.E53H55 2004
154.6'3—dc22
 004056486

∞ The paper used in this publication meets the minimum requirements of the
American National Standard for Information Sciences—Permanence of Paper
for Printed Library Materials, ANSI Z39.48-1992.

This book is dedicated to my daughter Nicole
and her faithfulness to the task of learning
what the heart feels and how it thinks
and to my wife Deena, mi querida siempre.

Nothing that is vast

enters into the life of mortals

without a curse.

<div align="right">

— SOPHOCLES

</div>

Contents

Acknowledgments

"ACKNOWLEDGMENTS" IS A rather long and awkward Anglo-Saxon word that means, simply, gratitude for those who have shaped the imagination, sensibility and thinking that went into this work. Although, formally, my work on this book began five years ago, my "research" into the apocalyptic rite of passage began twenty years ago. It is only right that I extend my gratitude to those who carried me in and through this passage—sometimes through bitterly hard times—over the past two decades.

First I thank Brother Bogel, a Detroit ghetto preacher who, on the radio, preaching the end of the world and the healing of the soul, drove me to my knees when I was fifteen-years-old. Shortly thereafter, I was taken under the wing by my second father, the Reverend Bill Brown of Ypsilanti, Michigan, who baptized me in fire till I spoke in tongues and helped me puzzle out apocalyptic scripture so that I myself could preach the necessity of waking up in these dire times. It is not without a certain sense of the ridiculous that I found myself in this book committed to modifying and elaborating in psychological language the old sermons of a high-strung teenage evangelist: "Repent, for the end of the world is nigh." It is the fierce passion and commitment of Brother Bogel and Bill's sweetness toward me that set me on this road, and to them I am forever indebted.

By a circuitous route, my brief career as an evangelist deposited me on the streets, where I spent three years as a homeless person. These years serve me now as the bass note that underlies the whole of what I have made of my life: the streets were inevitably the sacred ground on which I began to sink into the dregs of what I call, in this book, "apocalypse."

I expected to be something of a mendicant friar, a "fool for Christ," but, quite quickly, I found myself a fairly skilled thief with a voracious appetite for books. When you're homeless, your friends are, in a very literal way, your shelter in a cold world. And so I thank those people who sustained me during that time.

Especially, I want to acknowledge Monk. An ex-junkie and ex-Marine, he lived for years as a squatter in a canvas shelter in the forest near Big Sur. Monk ate Fives Dog Food (which, for him, had deep numerological significance) and whatever else he could lay his hands on. He would so enthrall me with stories that, eight hours later, I would suddenly discover he had pulled me out of the parameters of time into the place of enchantment. Though he is without a question one of the most intelligent people I have ever known and a true mentor, the last time I saw him was on the streets after I myself was no longer homeless. Just rendered toothless by a Medi-Cal dentist, he wasn't invited home to meet my wife because I thought he'd frighten her.

My street friends served as a buffer when I finally broke down into psychosis and insured that I remained homeless and crazy rather than institutionalized and crazy. It is for keeping me out of the institution that I will always be grateful to them, for, in those brief three weeks of sleeplessness, wonder and terror, my psyche enacted its "first draft" of the apocalyptic rite of passage.

In this context, I acknowledge my father, Milford Lee Hill. When, in the grips of madness, I called him from a phone booth he said, merely, "I went through the same thing when I was your age. It is a rite of passage. I know how unbearable and confusing it is but you can trust it." Those words, almost verbatim, made everything possible. His capacity to describe what I was going through was crucial: unbearable, mysterious and even, ultimately, trustworthy.

Last, among my street mentors, I have to include Professor Norman O. Brown. His essay "The Place of Apocalypse in the

Life of the Mind" was pivotal for me, as was the seminal *Love's Body*, shifting my apocalyptic concerns from the prophetic mode I had learned as an evangelist to the cultural and psychological perspective that was becoming so vividly real. Although I was much too shy to make Dr. Brown's actual acquaintance, when I was homeless I would often sit in when he taught the classics at the University of California at Santa Cruz.

Within a few months of my leaving the streets, my father died and my lover of five months conceived with a little girl. The following years of grieving, of fathering, of trying to create a "normal" persona from scratch while carrying the strange nostalgia for the street—these years were midwifed by my first wife, Marsha Isaacson, with remarkable kindness and patience.

Profoundest gratitude, also, to my men's group with whom I've been meeting every Monday night for the past fifteen years. David Steinberg, Kenton Parker, Tom Starkey, Allan Brill and Peter Varga—"the guys"—cleaned the dust of the street from my body, listened to my ramblings and helped me piece myself back together again and come to some measure of clarity about what I "saw" on the street. It took me fully ten years to enter into this small circle of men without fear, and the past five have been truly blessed.

My friend and patient Jesse Houts has been an exceptional teacher to me the past two years. Jesse will never walk in this life and for its duration will be fastened to his ventilator, but his untamed puer intelligence—the aliveness of his mind, his idealism and outrage—makes him a true child of apocalypse.

I want to thank Peter Levitt, Yona Adams, Jay Salter, Fran Peavey, Baba Ram Dass, Jack Kornfield and Ariel Dorfman, all of whom read this book in its earlier drafts and offered invaluable insights and encouragement. And I thank James Hillman for his support, but especially for his writings which have so deeply influenced my imagination and my heart.

I thank, also, Dr. John Seeley for the old wisdom and integrity he carries with such grace and my fellow analysand and friend Pami Blue Hawk. To Pami, I give thanks for simple raw

inspiration, for nobody I know has taken the apocalyptic rite of passage as deeply as she.

Gratitude to my informants who had the courage to share their dreams and sometimes their vulnerabilities. I hope this book reciprocates, in kind, their generosity and honors their trust. I especially want to acknowledge "P. H." Among this man's first memories was being awakened by his father before dawn and beholding the mushroom cloud in the distance—the nuclear testing in southern Nevada. As a young man, he was ultimately driven mad by the exigencies of living "under the Bomb" and, believing a nuclear exchange between the United States and the Soviet Union to be imminent, he killed both his parents to spare them the horror. He has spent the last twenty-five years in prison. Corresponding with him, I have come to appreciate his lucidity and insight, both the full measure of the madness of these times and the profundity of the way of healing that attempts to come to terms with them.

Gratitude also to my mother, Adelina Ortiz de Hill, from whom I inherit wild imagination and the gift of tears, without either of which I could not have done this work. It was she who drove me to the north edge of the White Sands Missile Range so I could find my way to Trinity under the cover of night and perform my ritual (described in the epilogue). Her attitude of "Do what you came to do, mijo. You have my blessing" will always remain for me incomprehensible in the magnanimity of its trust and respect.

Finally, inexpressible thanks to my wife, Deena Metzger. When one prays for a woman to wrestle with, it's best to forget the old proverb, "Be careful of what you pray for because your prayer just might be answered." It would be a cliché to say that without her this book never would have been written, but the truth of the matter is, without her this book never would have been written. Her encouragement, the relentless cross-fertilization between our minds as she has worked on her novel-in-progress (confronting that other primordial horror of this century, the Holocaust), the sweetness of her loving, her occasional

"towing me in" when I seem to linger too long in some far galaxy and her courage not to "tow me in" on other occasions that might appear just as dubious—and, of course, her merciless and impeccable editing—all this and more has been indispensable. In Deena, I have had the catastrophic good fortune of having met my match, and this book is very much the consequence of that good fortune.

To all my friends and mentors, I do *gasho* and say *"Gracias a la vida."*

<div align="right">

Michael Ortiz Hill
Blue Wolf Hill, Arizona

</div>

Honoring the Black God of Healing: Epidaurus, Greece; Ode Remo, Nigeria; Esquipulas, Guatemala and Hiroshima, Japan. May what was planted "be fruitful and multiply."

Foreword to the Second Edition

〜〜〜〜〜〜〜〜〜〜〜〜〜〜〜

One

September 11, 2001: Africa

FOR AN ARCHEOLOGIST Great Zimbabwe is the most extensive ruin in Africa south of the pyramids. The center of the Shona Empire: shards of porcelain in the Queen's chamber from China, connected as it was to the Muslim trading routes that opened on the far coast. Walking between workers buttressing a wall a distance from the fallen tower, Augustine Kandemwa reminded me that during the War of Independence, the apartheid forces placed land mines all around the ruin so the *ngangas*, the shaman or medicine people, couldn't come here to draw strength from their ancestors. (In 1996 I was initiated by Augustine, a *nganga* of the Shona tribe, into the *ngoma* of the water spirits, the Central African tradition of medicine and peacemaking that so shaped what was to become African-American culture.)

On this particular day, September 11th, we were initiating a group of Westerners. "Great Zimbabwe is where the Mambokadzi and the Mambo live, the Queen and the King. This kingdom we are in is a kingdom of spirits," Augustine explained. The essence of African traditions, as I see it, is the offering one makes to the spirits. It could be offering one's body to the drumbeat in a possession ceremony or leaving a flower on a stone in a creek—every offering is in reality the full offering of oneself. That is how we reach across worlds, extend ourselves towards the spirits so that they can meet us. In the tradition it is also the quintessential act of peacemaking: the reach across worlds.

Robin Wilds accompanied me up the holy mountain, past the cave where the King was buried. "The Queen has two faces," I told her. "One looks towards the welfare of the village. The other looks toward the forest and the wild things." Passing between boulders, I said, "Now it is time for you to dance an offering to the Mother of the Animals.

"Turn your back," she said, and I understood this offering was for the Mother's eyes only. But facing outward to the forest, I saw her offering received—seven or eight baboons, stately and enthralled, gathering at a nearby cliffside, watching her. The offering, given freely, was fully accepted, and separate worlds came together. Peacemaking.

Two hours previous, in the country I would soon return to, a swift act of mass murder altered the territory of the world. Our little community huddled before *CNN* in a tourist hotel adjacent to the ruins of the Empire, watching the redundant images, the redundant comparisons to Pearl Harbor: Lacking a language for the incomprehensible, but nonetheless calling on the metaphors of war, those old invocations that make it all seem so necessary, inevitable and righteous. We knew we had been well prepared to meet this moment and that now, as we were about to return to a country far different than the one we left, our true initiation was beginning. "The time of offering has arrived: offering the life itself to those who reach across worlds, the spirits of peacemaking."

Everyone in America remembers the moment when they learned what happened. Each of us are passionately involved in the story because it was a moment in which our world was punctured and we were delivered into a shapeless place by fear, grief, outrage, astonishment. As a *nganga*, I have to say that this is the blade of initiation, dividing who we were from who we are called to be. Tell the story, chew on it though it is indigestible, carry with compassion its wild range of feeling and meaning and then step forth and make your offering. Your whole life has prepared you to meet this moment. The world is endangered.

In some Central African cultures, the initiates learn hundreds of proverbs. This is not to have a proverb to apply to every situation; rather, one is taken into the field of reflections the ancestors themselves carry when they sit in council with one another.

My meditation now returns again and again to the proverb "One's relationship with God is best measured by one's relationship with one's enemy."

The enemy, the aggrieved one who would happily kill us given the chance, whose wound we refuse to know, who we will always approach fully armed: this one is the measure of my relation with God.

Returning to the New America, trying to discern the path across worlds to the enemy, two threads presented themselves: one unbearably dark, the other sweet and filled with light.

The end of a long night shift at the hospital, where I work as a nurse: breakfast and the *L. A. Times.* On the second day of bombing an unstable nuclearized part of the world, the business section has an upbeat little article with three glossy photos of missile systems. Investors are "bidding up," we are told. And I think in what way am I / are we invested in apocalypse? Eager to invest or deeply invested but lying about it? What does the life we live in America cost the world? In what exactly do we invest our lives? Do we truly wonder why fanatics like Al Qaeda see us as both dangerous and spiritually deranged, why much of the world sees us as a rogue superpower? It is a dreadful thing when the enemy sees us more clearly than we see ourselves, but for that at least, we can be thankful. Since World War II, American policy in the Arab world has been brutal. In African medicine the offering that reaches across worlds is the simple acknowledgement of our actions and a recognition of their consequences. Until then, one is left in the predictably bloody hallucination of us versus them.

The next day, quite raw from this glimpse of seeing America through the enemy's eyes, I was meditating in the hospital chapel when a very small man, a midget perhaps three and a half feet tall, walked up to the bookshelf. With much effort he took down the Koran and sat in the chair in front of me. While he was lost in reading, a Latina sat beside him who was soon equally lost in prayer. "I can't ask her to move," he whispered to me. "She's praying for all of us."

She smiled and moved out of his way. When he began drawing a chair so he could reach the drawer with the prayer rug in it, I stood up and got the rug for him. He laid it out, exquisitely raised his cupped hands to both sides of his head and silently sang

the first sura of the Koran: "Praise be to God, the Cherisher and Sustainer of the Worlds; Most Gracious, Most Merciful." The prostrations done, the offering fully made.

When he finished, I helped him put away the rug. "Lately," I said, "I find myself praying only for peace between Muslims and non-Muslims. I come here every day to meditate before I'm with my patients, and every day I watch Muslim people lay out the rug and pray. May I ask you to teach me how to pray in the Muslim way?"

In an English that was both broken and lyrical, he said, "We want our forehead to be right in the dirt." Then he smiled mischievously and said, "We do this because we want to be very small before God, very, very small."

And having returned to America, I learn the Arabic prayer and prepare the offering, not as a Muslim, but because peace requires that we get very, very small and reach across worlds to each other in "the name of God, Most Gracious, Most Merciful . . . "

Two

9/11 and the Apocalyptic Rite of Initiation

Dreaming the End of the World was begun before the end of the cold war and finished a few months after the fall of the Berlin Wall. The world has changed, has it not? Apocalypse was not on everybody's lips, but now it is. Many people with excitement or dread see this as the time when history and prophecy coincide: the final days. But the book is not about history really. Or rather, it is about history as the ritual theater of a rite of initiation, fierce and true as any culture might enact. Contemporary history is the place where myth crawls under the skin. The apocalyptic rite of initiation is about the awakening of compassion in a dark time.

In this initiation, we meet the Messiah and the Beast; that which would save the world and that which would devour it. This old story/paradigm is at the foundation of Indo-European cul-

ture: Babylon was founded when Marduk slew the chaos dragon, Tiamat. A late version, the *Revelation of St. John,* where Christ was pitted against Antichrist, was grafted into Christian scripture reluctantly in the fourth century. It seems that the heretic Montanus, rather like some contemporary Christians and Muslims, took it literally, whereas the Early Fathers knew it to be allegory. Montanus was quite sure Christ would soon establish his kingdom in his native Smyrna.

But there is literalism and then there is literalism. On July 17, 1945, north of Alamogordo, New Mexico, the Messiah and the Beast resolve into a singular, terrifying, ecstatic image: the mushroom cloud. What had been the legacy of apocalyptic myth became a technological possibility—the nightmare of the daily news.

This, again, is not only history; it is myth. And because it is myth it is an invitation to initiation. Remember the Bomb was and continues to be our culture hero, our Messiah. It was going to defeat Hitler, after all, and who could argue against that? Many intelligent people, like Oppenheimer, believed it could make war itself obsolete. Simultaneously it was and is the Beast, proliferating, hungry.

Not surprisingly, the nuclearization of the myth of apocalypse found its way into the dream life of contemporary people. What is surprising is that the patterns of these dreams bear a ritual intelligence consistent with rites of initiation that are hundreds of thousands of years old. As the soul approaches the incomprehensible it is cut away from the community and "common" sense. Stripped bare it suffers the raw truth of the moment, its conundrums and heartbreak, and witnesses the death and rebirth of the self/planet. The images are contemporary but my initiations as a tribal healer in Africa confirmed that the ritual grammar is ancient: separation, vision, return. If history is a nightmare, the apocalyptic initiation is about waking up from its self-destructive imperative.

The end of the Cold War presented the possibility that an epic hallucination might come to an end. What could possibly equal Stalin or Mao, the gulags and re-education camps, the Khmer Rouge and Sendero Luminoso? What Beast might step forth to contend with the Messiah?

In 1987 an Arab translation of *The Late Great Planet Earth* by Hal Lindsey was published in Cairo. Lindsey's book, first issued in the early seventies, has sold twenty million copies and has had a pervasive influence on the End-Times world view of fundamentalist Christians in America and elsewhere.

Before its publication in Egypt, the Muslim apocalyptic tradition had been dormant for centuries. Not so now. Lindsey's book and the fertile atmosphere of the first Gulf War reawakened the apocalyptic imagination in the Arab world, informing, for example, Al Qaeda. David Cook, the principal scholar of Muslim apocalyptic literature writes, "The contemporary Muslim sees the present world turned upside down by Christian Millennialism. In defense, Muslims make heavy use of the Bible, or one might say the Bible as seen through the eyes of Hal Lindsey . . . The only difference is that the 'good guys' are Muslims, not Christians."

This postmodern cross pollination of cultures has assured that the world keep faith with the old story. The impulse towards destruction—the Beast—now hides in the bloody heart of a myth shared by enemies bent on destroying one another: redemp-tion through apocalypse. Messiah/Beast has transmuted into a Crusader/Jihadi complex. Two honorable and sometimes radiant traditions are led towards the abyss by their lunatic fringe, each driven to conquer the world for God, each bearing the sword of unassailable righteousness.

The Crusader/Jihadi makes real its cosmos by drawing to itself final things: the afterlife, the end of the world, the full sanctification of the children of God. This sacred solipsism is translated into a religious vernacular—the mutually assured destruction of the Cold War without detente.

Its self-convinced righteousness is of a piece with the unspoken, unspeakable sociopathy that will destroy whatever it deems necessary. The other does not exist, is not quite human, until he or she converts. Cluster bombs dropped into a suburb of Baghdad will deliver the unbelievers to damnation but if the pilot is by chance downed, not a small portion of his people are assured that he will rise to heaven. The Jihadi whispering "Allah Akbar" as the plane strikes the World Trade Center knows exactly where he's going on the other side of death and exactly where he delivers

his not-quite-human victims. One commandment forever in stone whatever the bloodshed: Thou shall not for a moment recognize any resemblance between thyself and thine enemy.

It's almost dawn, the sky lightening to dark blue after a long night. The stellar jays are mad with chatter and the snow is at last beginning to melt. I invite the reader to the wilderness, to the beginning of the apocalyptic rite of passage. My description of the way is perhaps more relevant now than when I first wrote it down. That being said, I offer this book with a single caveat: Beware the seduction of the image, mine and others, for the myth of apocalypse seeks to enthrall us into an epic fiction with very real consequences. Beware the fascination with what is larger than life, this vulgar Passion Play that would crucify the world.

Introduction

THIS BOOK IS about dreams of the end of the world—both the cultural or collective "dream" that we are embedded in that led to the invention of the first atomic device in the 1940s and our continuing and relentless war against nature, and about personal dreams that I've culled from individuals in the course of my research.

How do we "hold" apocalypse in our deepest psyche? What is this dream of destruction that we seem compelled to live out? What yearnings in us do the Bomb and ecological destruction answer? Who in us would destroy the world, and who would save, protect and cherish it? "Who" is the Bomb? What are these dreams asking of us? And how might the psyche image the continuity of apocalyptic drama now that the Cold War has ended?

In his novel *Joy of Man's Desiring*, Jean Giono writes,

> One has the feeling that, at heart, men do not know exactly what they are doing. They build with stones and they do not perceive that each of their gestures in placing the stone in the mortar is accompanied by a shadow gesture that places a shadow stone into shadow mortar. And it is this shadow building that counts. (Giono, 1980:20)

The first section of this book, "The Dream at the End of the World," is about the building of the "shadow bomb" and its ambiguous nature as an object of *holy* terror. Whereas much has been written about the technological crafting of the Bomb, these first three chapters speak to its *unconscious* crafting as a mythic image within our collective imagination—and, as

such, the nucleus of an apocalyptic dream into which we were all recruited during the duration of the Cold War.

This book is not about the Bomb per se, but in order to understand and negotiate the terrain of the country called apocalypse, we must take into our psyches the full, complex, radiant and terrible *koan* of the Bomb that has dominated this terrain for almost half a century. The Bomb has served as a tightly impacted metaphor for doomsday and the crazy and apparently uncontrollable passions that impel us in that direction. It has astonished us with the bitter knowledge that we do have now the technological capacity to annihilate ourselves and a good portion of the biosphere as well. This astonishment has made of the Bomb a monolith that has, to a degree, obscured the field of interrelated causes that are moving toward the rapid unraveling of both nature and human culture. As the Bomb recedes as the archetypal dominant of an apocalyptic era, we find that apocalypse itself continues unabated and that, if we look closely and deeply enough, the psychological dynamics of this new era are explicitly prefigured in the "dreaming up" of the Bomb. For that reason, this book begins by looking at the "shadow work" of making the Bomb; and the "shadow bomb" will remain a touchstone throughout the text because it constellates the most focused realm of imagery from which we can interpret an otherwise inscrutable situation.

This "focusing" of apocalyptic imagery in the Bomb metaphor is vividly exemplified by many of the dreams I examine that use it as a primary symbol of specifically ecological horror. Even in dreams of ecological holocaust (see, for example, chapter eight on the "invisible poison"), the Bomb often symbolically serves as a catalyst for that holocaust. To perhaps oversimplify, Bomb dreams show us two kinds of apocalypse: incineration (for example, the devastated city, the ashen landscape) and the poisoning of the world, of nature, of human and natural habitats.

In a demythologized world, the Bomb may be the only mythic presence to which postmodern humanity gives credence.

In this first section, I hope to establish that the passions and fears that ultimately bore fruit in the invention of nuclear weaponry have a mythic continuity as old as civilization itself—stretching from the foundational myths of the Neolithic iron age through the Christian apocalyptic imagination and Jewish Messianism and into the scientific and technological sublimation of the eschatological hope of slaying the primordial enemy and establishing the New Age. In other words, what I call the "dream at the end of the world" attempts a technological realization of a story that originated with the founding of the first cities in ancient Mesopotamia—a story that is, in fact, the mythic substratum of an urban reality exalted above and against the wilderness. Waking up from this dream, then, requires entering a new story or myth or dream, a radical rapprochement between the human realm and the wilderness—including, very much, the wilderness within the human psyche.

Section two, "Entering the Wilderness," works thematically with dreams that individuals have sent me about the end of the world. If rapprochement with the wilderness is the task at hand, then these dreams speak intimately of finding our way through the wilderness of apocalypse in which we are placed and through which we must pass. In these chapters, apocalypse is withdrawn from the sphere of technological literalism and folded back into the psyche where it properly belongs, to be submitted to and suffered as a rigorous and radiant rite of passage.

A few notes on my approach to dreams are due here. Rather than treating the dreams psychologically in the traditional sense—that is to say, as statements relating to the unconscious processes or history of the individual dreamer—my approach may well be called "geographical." Just as the Australian aborigines speak of a "dreamtime" parallel to ordinary, mundane reality, I take the geography of apocalypse to be a real and vivid territory running alongside or beneath the day-to-dayness of our lives. We live, in effect, in two worlds—in the foreground, our daily preoccupations and activities; and

behind that, a fantastic landscape of terror or ecstasy: invisible poison, mutant fish, random violence or poignant tenderness; underground shelters, blistered skin, lost children; ashes, ruination or grave mystery.

These dreams offer windows to this extraordinary world that is eclipsed behind our everyday lives. Although the over one hundred dreams that I gathered span every decade since World War II (beginning with Dr. Michihiko Hachiya's prescient dream in the ashes of Hiroshima), and though my informants vary from age seven to seventy, a remarkable and consistent interbraiding of themes helped me discern a definable and complex landscape. I came to regard these dreams as a core sample like that which a geologist might take to find out what exactly stood beneath his or her feet—and likewise, the dreamworld of apocalypse I took to be the substratum upon which we have come to live our lives.

"Entering the Wilderness" not only takes apocalyptic dreams as a geography, but specifically as a geography of initiation and transformation. Cross-culturally, the way of initiation is expressed as the way of death and rebirth—often mythologized as the descent into the underworld and eventual reemergence. While I will sometimes reflect on these dreams as disturbing mirrors of our waking reality or as grim contradictions to technocratic positivism, I predominantly read them as a way of descent, of facing the most difficult realities of being human, of dying, of depth and of rebirth.

The necessity of descending away from life and through the realm of death in a rite of initiation goes so much against the current of "common sense" in a death-denying culture that my insistence regarding this could be seen as morbid. James Hillman addresses this misunderstanding in his *The Dream and the Underworld*.

> When I use the word *death* and bring it into connection with dreams, I run the risk of being misunderstood grossly, since death to us tends to mean exclusively gross death—physical, literal death. Our emphasis upon physical death corresponds

with our emphasis upon the physical body, not the subtle one; on physical life, not psychic life; on the literal and not the metaphorical. That love and death could be metaphorical is difficult to understand—after all, something must be real says the ego, the great literalist, positivist, realist. We can easily lose touch with the subtle kinds of death. For us, pollution and decomposition and cancer have become physical only. We concentrate our propitiations against one kind of death only, the kind defined by the ego's sense of reality. (Hillman, 1979:64)

It is away from this literalized life and its fantasies of death that apocalyptic dreams inexorably draw us for the sake of being initiated into the realities of the soul.

The book ends with a brief reflection on the apocalyptic initiation as the era of the Bomb gives way to ecological concerns, an epilogue recounting a ritual of "healing the dream" that I performed at the Trinity site, and an extensive glossary of dream images offering a more textured map of the apocalyptic landscape.

When I write that the Bomb has ceased to be the archetypal dominant hovering over this landscape, I by no means intend to imply that nuclear issues have become suddenly obsolete now that the Cold War has ended. Star Wars technology proceeding apace, the specter of nuclear terrorism and the diffusion of nuclear technology in the breakup of the Soviet Union, the bipartisan incapacity of American leaders even to begin to imagine a serious change in the military budget after the demise of "the Soviet threat," Japan's grievous development of a fast breeder reactor—not to mention plutonium with its half-life of twenty-five thousand years: nuclear concerns continue to be very real and grave. I do sense, however, a shift in how we are *imagining* apocalypse—no longer the onset of nuclear winter in the wake of a full-fledged nuclear exchange between superpowers. This shift is one of the issues I address in this book.

The poet Leonard Cohen sings, "Into this furnace I ask

you now to venture, you who I cannot betray." At the end of the twentieth century, the dream at the end of the world is our Underworld, our place of initiation. It is into this dream that I bid the reader enter for the sake of this dear planet and all sentient beings.

SECTION I

The Dream at the End of the World

Now is the time for your loving, dear

And the time for your company

Now that the light of reason fails

And fires burn on the sea

Now in this age of confusion

I have need for your company.

—RICHARD FARINA

ONE

The Radiance of a Thousand Suns

IN 1799, AN engineer in Napoleon's army discovered in the Egyptian desert a large, flat, black stone of ancient origin upon which was inscribed the same message in Egyptian hieroglyphics and in Greek. The Rosetta Stone made it possible for the first time for scholars to decipher the lost language of hieroglyphics because it placed alongside them the known language of ancient Greek. The next three chapters intend to establish how the language of apocalypse inscribed in the complex and contradictory image that the Bomb presents in our psyche can serve as a Rosetta stone for understanding the language and imagery of ecological catastrophe.

Almost fifty years later, as we emerge from under the shadow of the nuclear threat, it is difficult to recall how a weapon of unimaginable destruction carried a fantasy of Messianic hope as the clouds of war gathered over Europe and Asia in the early forties. Nevertheless, the Manhattan Project drew together some of the best minds of a generation to create the first atomic bomb, peculiarly focusing one of the most durable, recurrent passions in Judeo-Christian culture: the longing for the Messiah and the Golden Age. As the passion to "save the world" necessarily wells up in us as we approach the end of the millennium, it serves us well to understand how a similar passion, wedded to technological positivism, bore fruit in the first nuclear device.

In the invention of the Bomb, two millenarianist currents intersected with one another—one political and the other scientific. To elucidate the political—or, more accurately, nationalistic—current, we may extend a metaphor provided by General Leslie Groves, who oversaw the Manhattan Project. The Bomb's invention was comparable, in his eyes, to Columbus's discovery

of America. Like the Spanish before them, the Anglo-Saxon colonists of the New World regarded this vast continent as the site of the Kingdom of Heaven on earth: America the New Canaan, the New Order of the Ages, a light unto the nations. For Groves and President Harry S. Truman, the Bomb was a gift from God, confirming a symbolic mandate that would make the United States the leader among nations. As Truman wrote in his diary, "It seems to be the most terrible thing ever discovered, but it can be made the most useful" (quoted in Rhodes, 1986:691). For many military and political leaders since the forties, our "arsenal of democracy" not only promised to protect the sacred space of the American dream but also was a way of ensuring that that dream shape the world at large. After World War II, the new world order was to have a specifically American cast.

Running parallel, and ultimately merging, with nationalistic millenarianism was an equally naive faith that science would eventually create the circumstances of the Golden Age. If, as J. Robert Oppenheimer, the father of the atomic bomb, said, the Manhattan Project was the culmination of three centuries of physics, it was also, by a more subterranean route, the fulfillment of three centuries of millenarianist longing.

In the Christian world, the desire for the Messianic age, though nominally marginalized by the secularization of Western society, found itself translated freely into a scientific idiom. The Age of Reason emerged from the breakdown of the Catholic hegemony on truth, thereby laying the ground for the utopian hopes of the French and American revolutions as well as a new age of scientific enquiry.

For example, the Catholic heresy of "immanentizing the eschaton"—that is to say, accelerating the end of the world— was braided with the humanistic pursuit of knowledge at the very outset of the scientific enlightenment in England. The Freemasons and Rosicrucians, for example, desired "to create a band of illuminati who could lead the world to a better, more peaceful and tolerant way of life." Martin Bernal writes of this strange marriage of theology and secular studies:

Many millenarians believed that knowledge had to be reassembled before the coming of the millennium. Therefore the scholar could be the midwife of eschatology. It is from these schools of thought that the English "scientific revolution" of the late 17th Century seems to have evolved. (Bernal, 1987:174)

Also in the seventeenth century, when a third of European Jewry embraced a rather erratic young man, Sabbatai Zvi, as the Messiah, his conversion to Islam necessarily threw Judaism into profound crisis. The scholar Gershom Scholem traces a direct continuity between the ruins of Sabbateanism and the beginning of the Haskala or Jewish Enlightenment. But the Haskala was unable to extirpate the intense longing for an end to the nightmare of history, and one finds this longing transmuted into socialist idealism, Zionist passion—and into scientific positivism.

The end of the last century and the beginning of this one saw a resurgence of marginal religious sects anticipating the literal coming of the Messiah. Jehovah Witnesses, Adventists, Hasidic Jews all believed the time was imminent. By then, however, what had far more credibility was the promise that scientific discovery would herald a new age of abundance and peace.

The hopes that nuclear radiation would form the basis for this new age almost coincided with its initial discovery. Only a few years after Frederick Soddy detected, with Ernest Rutherford, the radioactive breakdown of thorium into radium in 1901, he was already envisioning the New Jerusalem:

A race that would transmute matter would have little need to earn its bread by the sweat of its brow. Such a race could transform a desert continent, thaw the frozen poles, and make the world one smiling Garden of Eden. (Quoted in Weart, 1988:6)

The possibility of fantastic new weaponry didn't diminish these hopes, but amplified them by incorporating them full-

fledged into the apocalyptic drama of the death and rebirth of the world. One of Soddy's more influential and earnest admirers was H. G. Wells. It was to Soddy that Wells dedicated his 1913 novel *The World Set Free*, in which he coined the term "Atomic Bomb" and first fictionalized a nuclear holocaust. *The World Set Free* was one of Wells's speculative "histories of the future"—ending at approximately our present decade when humanity, sobered by its capacity for destructiveness in the wake of a horrible nuclear war, ripened into wisdom and created a world republic and a technological paradise on earth. Wells wrote,

> Never before in the history of warfare had there been a continuing explosive; indeed, up to the middle of the twentieth century, the only explosives known were combustibles whose explosiveness was due entirely to their instantaneousness; and these atomic bombs which science burst upon the world that night were strange even to those who used them. (Wells, 1926:89)

The core of the Bomb, "lumps of pure carolinum," shed layer after layer of radioactive efflorescence indefinitely, poisoning everything around. Impossible to put out, Wells's atomic bomb was "uncontrollable until its forces were nearly exhausted." Even when dropped in the ocean, the effluvia sat "like frayed out water lilies of flame" (ibid.:89, 91, 112).

In Wells's novel, the first three bombs were used on Berlin sometime in the 1950s or perhaps early '60s—dropped manually after the bombardier bit off a celluloid stud with his teeth to oxidize the atomic core. The Central European power reciprocated until the "last war" left civilization as we know it in ashes.

Looking back in retrospect from the 1990s from his Himalayan laboratory, the narrator realizes that the

> old tendencies of human nature, suspicion, jealousy, particularism and belligerency, were incompatible with the

monstrous destructive power of the new appliances the inhuman logic of science had produced. (Ibid.:168)

Under the guidance of a small technocratic elite—"the directing intelligence of the world" as Wells put it—the world came of age. Nationalism was abolished. Nuclear energy provided for illimitable prosperity, with flying cars and arctic and desert wastelands transformed. Women were liberated from their subjugation to men, free sex abounded and the majority of humans became artists. "The bulk of activity in the world lies no longer with necessities, but with elaboration, decoration and refinement," wrote Wells (ibid.:200-01).

Deeply influenced by the writings of H. G. Wells, whose acquaintance he made in London in 1929, the physicist Leo Szilard carried with both irony and sincerity what he regarded as the true meaning of his life. He wanted to save the world. Wells's tract "The Open Conspiracy" (which, like *The World Set Free*, advised the collaboration of scientists, financiers and technocrats to create a world republic) especially appealed to Szilard's utopian proclivities. It was Szilard's deep concern that the Germans were taking very seriously the possibility of inventing a nuclear device that led him to draft, with Albert Einstein, the 1939 letter to President Franklin Roosevelt that would result in the American Effort to develop the first atomic bomb. Wells's fantasy, then, found a rather perverse realization in the not-so-open conspiracy to save the world called the Manhattan Project.

Both Wells and Szilard were infected by millennial aspirations that were rampant between the wars. The success of the Russian Revolution captured the imagination of the best and the brightest who were still reeling from the carnage of the "war to end all wars." Many believed that World War I was the final gasp of imperialism which, as Lenin wrote, was the last stage of capitalism preceding its collapse. A classless society was prophesied to emerge from the vicious conflict between the exploited class and those who owned the means of production. Dialectical or scientific materialism offered the blueprint by

which the fruits of labor would return to those who labored. Intelligent people asserted that this revolutionary shift from an economy dangling from the irrational fluctuations of the marketplace to a scientific planning of the economy for the general welfare was already being enacted in the Soviet Union. Soviet films of Stalin in the thirties show him wreathed in a numinous light so there could be little doubt that he was no mere human.

In a Germany shambled by war and political and economic chaos, Hitler similarly subsumed the confused yearnings of the German people into his fantasy of the thousand-year Reich. He was seen as the great Promethean who ignited the imagination and will of a humiliated people to lead them forward toward a glorious destiny. Although Churchill and Roosevelt never took on the mantle of the Messiah in the same fashion as Hitler or Stalin, as the tide of chaos rose in the early forties they nonetheless carried a measure of projection as the martial embodiments of good against the absolute evils of the Axis powers.

Within this extreme context, nationalistic (and military) millenarianism joined hands with its scientific counterpart. J. Robert Oppenheimer's collaboration with General Leslie Groves made the Manhattan Project the watershed when weapons research became the right and proper focus of the best scientific minds of a generation. Half a century later, 95 percent of all the scientists who have ever lived are alive. Half of these are involved in perfecting the human capacity to annihilate one another.

Oppenheimer was drawn to left-wing causes in the late thirties, partly out of his outrage on behalf of his relatives in Germany who were suffering from Nazi anti-Semitism. Later when his ideology became more compatible with the American war effort, he would still rely on the leftist idiom, speaking of a "people's army" or a "people's war" to overthrow fascism. Many at the core of the Manhattan Project knew the horrors of Nazism more directly. As students in Göttingen, Berlin and Hamburg, Eugene Wigner, Leo Szilard, Edward Teller and John

Van Neumann witnessed the rise of Nazism, the vilification of Einstein's "Jewish physics" and the growing violence against Jewish people. Hans Bethe, who was said to have been the only human who knew why the stars shine, used award money for his unpublished paper on the subject to get his mother out of Germany. Otto Frisch extracted his father from a concentration camp.

However, the hope that the Bomb might free the world from Hitler's madness was inevitably extended even further to the fantasy that the Bomb might make war itself obsolete. The ideas of Niels Bohr, the *pater familias* of the Manhattan Project, had an incalculable influence on this utopian longing. Oppenheimer was to compare the importance of Bohr's vision of the "complementarity" of the Bomb to when he learned about Rutherford's discovery of the atom's nucleus. By complementarity, Bohr meant that, although the Bomb might be the greatest disaster to have befallen humankind, it may well be a great blessing, "a turning point in history." Inadvertently echoing H. G. Wells's vision thirty years after he fictionalized the Bomb in *The World Set Free*, Bohr believed that weapons of such magnitude would impress upon nations the grave necessity of resolving crises peacefully. "We are in a completely new situation that cannot be resolved by war," said Bohr (Rhodes, 1986: opposite 481). World War II then, rather than "the Great War," could be the war to end all wars—and the Bomb would be the deciding factor. Bohr's vision was a source of inspiration amidst the ambivalence of some of the scientists. Of his visit to Los Alamos in 1944, Oppenheimer was to write, "He made the enterprise seem hopeful, when many were not free of misgiving" (ibid.:524). The Bomb was not merely "the Second Coming in wrath" (Weart, 1988:102), as Winston Churchill described it, but also offered the possibility of a new era of human progress.

The particulars of that new era would be filled in after the war when nuclear energy could be put to civilian use. Just as the Bomb was to bring on a new era of peace, the idea would be current among scientists and journalists in the fifties that

limitless nuclear energy would fructify that peace, carrying humanity at long last into the land of milk and honey. Soddy's dream of the magnificent potentials of atomic energy that so excited H. G. Wells—and through Wells, Leo Szilard—after the war found its greatest enthusiast in the irrepressible *New York Times* journalist William Laurence (who, when he was covering the Manhattan Project, confided to his editor that he was onto a "sort of second coming of Christ yarn" [ibid.:100]). Laurence assured the public that nuclear energy could "make the dream of the earth as a Promised Land come true in time for many of us already born to see and enjoy it" (ibid.:158–59). The Hydrogen Bomb was a world-covering umbrella, "shielding us everywhere until the time comes, as come it must, when mankind will be able to beat atomic swords into plowshares, harnessing the vast power of the hydrogen in the world's oceans to bring in an era of prosperity such as the world has never dared dream about."

"We will change the earth's surface to suit us," Edward Teller would write in 1957 (Weart, 1988:211). But in the meantime, as the war raged on in the Pacific, the hopes for a kinder world were focused on the first dark stage of preparing for the first atomic explosion at the Trinity site, which many would describe in terms befitting the advent of a god.

It is impossible to ignore or to diminish the religious element that turns up again and again in the accounts of the Trinity blast.

The site is in a vast gypsum desert under the blue shadow of the Sierra Oscura in southern New Mexico. It was named by Oppenheimer, invoking by way of John Donne the mystery of the martyred and resurrected God:

> As West and East
> In all flatt maps—and I am one—are one
> So death doth touch the Resurrection.
>
> (Rhodes, 1986:571)

"That still doesn't make a Trinity," Oppenheimer confessed in a 1962 letter to Leslie Groves—and then speculated that perhaps he was influenced by a better known poem, one of Donne's Holy Sonnets, beginning,

> Batter my heart, three **person'd** God; for you
> As yet but knocke, breathe, shine and seek to mend;
> That I may rise, and stand, o'erthrow mee, and bend
> Your force to breake, blowe, burn and make me new.
>
> (Ibid.:572)

After Trinity, Thomas Farrel wrote:

> The effects could well be described as unprecedented, magnificent, beautiful, stupendous and terrifying. . . . The lighting beggared description. The whole country was lighted by a searing light with the intensity many times that of the midday sun. It was golden, purple, violet, gray, and blue. It lighted every peak, crevasse and ridge of the nearby range with a clarity and beauty that cannot be described but must be seen to be imagined. It was that beauty that great poets dream about but describe most poorly and inadequately. (Lifton, 1982:88–89)

The epiphany of beauty was experienced as well by physicist Robert Wilson, who headed the project's research division. In the documentary *The Day After Trinity*, he says, "Perhaps it was some kind of beauty, but awesome is what I would call it. . . . It made a large desert rimmed by mountains appear to be a small place. . . . once that had happened, I was a different person from then on." An assistant to Julian Mack concurred from his vantage point ten thousand meters from Ground Zero: "My God, it's beautiful" (Szasz, 1984:89).

Other observers were more explicitly religious in speaking of the event. One noted "a hushed murmuring bordering on reverence" amongst those present. William Laurence wrote that it was like being "privileged to witness the Birth of the

World—to be present at the moment of Creation when the Lord said: 'Let there be light' " (ibid.). He compared the experience to witnessing the second coming of Christ and believed that many others there had been profoundly moved. Ernest Lawrence wrote that Trinity "bordered on a religious experience" for him (Weart, 1988:101).

"It was an overwhelming, awe-inspiring sight," wrote the Viennese physicist Victor Weisskopf.

> When the brightness subsided, we saw a blue halo surrounding the yellow and orange sphere, an aureole of bluish light around the ball. This effect of the radioactive radiation was a totally unexpected phenomenon, although it would have been easy to predict. The appearance of this uncanny blue light made a deep impression on me. It reminded me, in spite of an inner resistance to such an analogy, of a painting by the medieval master Matthias Grünewald. Part of the altar piece at Colmar, the painting depicts Jesus in the middle of a bright yellow ascending sphere surrounded by a blue halo. The explosion of an atomic bomb and the resurrection of Christ—what a paradoxical and disturbing association. (Weisskopf, 1991:152)

It is striking that, following Oppenheimer's lead of naming the site of the first nuclear test "Trinity," Weisskopf and William Laurence—both Jews—saw in the Bomb the glory of Christ. In the Jewish tradition, the character of the Messiah has distinctly human dimensions, a "Son of Man" rather than the "Son of God" of Christian eschatology, while the Christ metaphor speaks to an experience that dwarfs the human realm. Ferenc Szasz notes, "Others whispered, more in reverence than otherwise: 'Jesus Christ' " (Szasz, 1984:89).

Known to be something of a mystic, I. I. Rabi described Trinity by the overwhelming light that engulfed him:

> Suddenly, there was an enormous flash of light, the brightest light I have ever seen or that I think anyone has ever seen.

It blasted; it pounced; it bored its way right through you.
It was a vision which was seen with more than the eye. It
was seen to last forever. You would wish it would stop;
altogether it lasted about two seconds. . . . (Rhodes,
1986:672)

Oppenheimer said, "We waited until the blast had passed,
walked out of the shelter and then it was extremely solemn.
We knew the world would not be the same. A few people
laughed, a few people cried. Most were silent." He recalled the
terrible and ecstatic eleventh chapter of the Bhagavad-Gita,
where the warrior Arjuna requests that Vishnu display the
nakedness of his transcendental form. Arjuna is cowed in holy
terror as the god visits upon him "the radiance of a thousand
suns." "Now I am become Death, the destroyer of worlds," Op-
penheimer quoted the Gita. "I suppose we all felt that, one
way or another," he continued (ibid.:676).

Three weeks later, the pilot of Enola Gay, Paul Tibbets,
requested God's blessing upon the Bomb that would initiate
the citizens of Hiroshima into the darkest consequences of this
ecstatic presence. "Be with those who brave the heights of Thy
heaven," intoned the chaplain, "and carry the battle to our
enemies" (ibid.:704).

Another striking theme that repeats again and again in
the "dreaming up" of the Bomb is that of birth and paternity.
On the mythic level, it is clear that the Bomb was not invented
as much as "born." Some people recognized the godlike
epiphany of light and fire—so long anticipated—as the birth-
ing of something or "someone" new. We can discern a spe-
cifically paternal pride and even hints of tenderness toward the
Bomb.

William Laurence called the rumblings of the Trinity ex-
plosion the "first cry of a newborn world." The telegram regard-
ing the test to Secretary of War Stimson at Potsdam was more
explicit:

Doctor has just returned most enthusiastic and confident that
the little boy is as husky as his big brother. The light in his
eyes discernible from here to Highhold and I could hear his
screams from here to my farm. (Ibid.:688)

Indeed, the procreative metaphor is embedded in the no-
tion of nuclear fission itself. When Otto Frisch discovered the
elongation and lysis into two parts of uranium nuclei, he asked
the American microbiologist, and his friend, William Arnold
what the equivalent process in living cells was called. "Fission,"
replied Arnold (ibid.:263). The primary process at the core
of nuclear weapons was named directly after the primary proc-
ess of the mystery of conception.

In his memoirs, Curtis LeMay, who coordinated the World
War II air combat over Japan and consequently the bombing
of Hiroshima and Nagasaki, wrote of "the nuclear baby cling-
ing as a fierce child against its mother belly" (Weart, 1988:147).
And, of course, Paul Tibbets enwombed the bomb named Lit-
tle Boy into the plane that, immediately prior to his mission
over Hiroshima, he named after his mother. Recognizing them
as the first among many brothers, the Japanese referred to Little
Boy and Fat Man as the "Original Child" bombs.

In a rather perverse extended fantasy in which Edward
Teller makes a confused attempt to wrest paternity of the Hy-
drogen Bomb from his competitor, Stanislaw Ulam, he writes,

It is true that I am the father in the biological sense that I
performed a necessary function and let nature take its course.
After that, a child had to be born. It might be robust or it
might be stillborn, but *something* had to be born. The proc-
ess of conception was by no means a pleasure; it was filled
with difficulty and anxiety for both parties. (Rhodes,
1986:773)

After this long and difficult labor, the first Hydrogen Bomb,
named Mike, was tested in the South Pacific (only seven years

after its older brothers). Teller sent a telegram to Los Alamos saying simply, "It's a boy" (ibid.:777).

Although Hans Bethe once quipped, "I used to say that [Stanislaw] Ulam was the father of the hydrogen bomb and Edward [Teller] was the mother, because he carried the baby for quite awhile" (ibid.:773), one notices a vivid absence of the feminine amidst all this imagery of birthing. The classicist Karl Kerényi claims that the essential nature of a god is displayed in the manner of its birth: Christ born in straw among animals or Aesclepius snatched from his mother's womb as she lay burning in a funeral pyre in Hades. I sense in the physicists' imagination an *imitatio dei*—like the Father God, these men would birth without the aid of women: Athena the war goddess sprung fully armed from the forehead of Zeus.

This "miraculous birth" and the millennial hope that gathered around it translated the submerged Judeo-Christian myths of the apocalyptic triumph of good over evil into a particularly twentieth-century idiom—an idiom humanistic and utopian, to be sure, but equally militaristic and nationalistic. At the end of the last millennium, Europe was alive with the anticipated return of a Messiah. Masses of people looked to the sky, trying to discern Christ on his white horse, his terrible swift sword drawn to slay at last the primordial beast, the Antichrist, and to establish on earth his holy dominion. Now, in the last century of the second millennium of the Christian era, we have attained the technological facility to literalize this vein of dreaming which, in spite of the culture's secularization, has in no way died. If I were to specify the dream narrative that we are unconsciously living out in which the Bomb has congealed as "a pearl of great price" in the midst of our longing and despair, it would go something like this:

> *Storm clouds gathered and the world was covered in darkness. A Beast ran rampant. Blood flowed freely, and all*

*that was loved by human beings felt intimately threatened.
What could save us from the Beast? Far from the rivers of
blood, a small group of men gathered secretly in a desolate
place to birth together the Messiah. Pregnant imaginations,
futility, fever of excitement, desperate ambivalence and tireless
idealism—how did they carry such a child? In the desert at
dawn, finally, came the birth of the new light, as if that day
the sun rose twice. Nature itself was set afire in its radiance
and the men, moved beyond words, were silent with reverence
toward that which they birthed. Surely now the war would
end and with it war itself. Surely now the New Age would
begin.*

Human beings constellate their spirituality in numerous
ways. The exquisite tenderness toward the finite—almost a
caress with an open hand—with which a Zen master pours
tea is quite different, say, from the convulsive ecstasy of a
Yoruba priestess as the drum beat opens her to being mounted
by the Orisha. For centuries before this one, the Mescalero
Apache would spend days fasting in caves in the Sierra Oscura
overlooking the place that would be called Trinity. A bear might
appear or coyote the fire thief—or, rarely, a wolf—and lead
the seeker to the home of its medicine. "This is the home of
the flowers and the herbs used to cure men all over the world,"
the animal might say. And, learning his medicine, the Apache
would return to his tribe to practice healing because that is
mainly what power is for, according to the Mescalero.

The Messianic dream of the Bomb as it was enacted at
Trinity partakes of a very particular way of spirituality that
far precedes the invention of the Bomb itself. The plurality of
nature is stripped away, and the fire that burns in the heart
of things is witnessed naked, unmediated—the *mysterium
tremendum*. In Greek, this is called *apokalypsis*—literally "reve-
lation" or "a tearing away of the veil, of that which conceals"
(*kalyptein*). Nature—matter itself—is rendered as a burnt of-

fering toward that which utterly transcends the differentiation of form.

The Bomb as the advent of Messianic hope is one all-too-real dream in which we have been embedded since the forties. But Hiroshima did not mark the beginning of a peaceful era, nor has the civilian use of nuclear energy created a New Jerusalem of unimagined prosperity. Lining the underside of the Messianic dream is another, darker realm of fantasy. If the Messianic dream is an epiphany of light drawing our imagination into the stars, this other dream is an eruption from that realm under the earth so long cemented over by Western Civilization. This dream is the awakening of the Beast.

What Rough Beast

IN THE BEGINNING of time, according to the Mescalero Apache, a Giant tried to devour all who lived on the face of the earth. God spoke to the first woman, Changing Woman, and said, "Go to the top of a mountain and there I will come to you." And so she did. And as she slept atop the mountain it rained, and a little bit of rain water slid inside her vagina. With that she conceived Child of Water who slew the terrible monster, so that people and animals could again thrive.

Under the influence of the Spanish, Child of Water became associated with Christ in the Mescalero imagination, and indeed one senses a mythic resonance with the avenging Christ pitted against the Beast or Antichrist in the biblical apocalypse. And, of course, one suspects a reenactment of this myth on the Mescalero traditional lands, when at Trinity the Christ was born in a ball of fire with his sword drawn against those who would devour the world. Through our technological literalism, the Mescalero Child of Water became our Child of Fire.

The nuclear dream, however, carries us into a complex and confusing ambiguity in a typical dreamlike fashion, for the Bomb quickly showed us that it bore two faces: the one who would save us and the one who would devour us. Of awaiting the explosion of the first atomic bomb with the wives of other physicists in the Jemez Mountains 150 miles from Trinity, Jane Wilson would write, "Perhaps something was amiss down there in the desert where one's husband stood with the other men to midwife the birth of the monster. God only knew what this strange thing could do to its creators" (Wilson and Serber, 1988:2). Each new weapon system seduces us with the promise that at last we will be secure from the primordial enemy, and then each system, turning to us its other face, has

delivered us into worse circumstances. This other face of the Bomb, after its biblical prototype, belongs to the Beast.

Despite its traditional use in apocalyptic scripture, I use the term "Beast" cautiously. Especially in these times when the war against nature rages out of control, one should not slander the realm of animals by attributing to "bestiality" the savagery of the human species. So I ask of the reader a small measure of trust: in the next chapter, I hope to clarify the paradoxical relationship of the Bomb to the realm of the Beast—the understanding of which will prove crucial in finding the common thread woven into both the psychology of nuclear holocaust and of ecological devastation. For it seems that now, while the wilderness has been diminished, all the wildness of nature itself has been impacted into nuclear devices.

What we fear in the Beast is an energy—sometimes personified, sometimes not—that is uncontrollable, unstoppable, wildly proliferating, coldblooded and heartless: the desire to destroy run rampant. Very often the Beast's violence is located specifically in its hunger. Like a raging fire, it would devour all in its path. Also—and this will prove important in trying to decipher the meaning of the dream of apocalypse—the Beast is very often associated with the realm under the ground. Its lair seems to be in the bowels of the earth or in the dark enclosures of secrecy and cunning.

The faces of the nuclear Beast are numerous but similar enough to define a particular "being" or presence. In the fifties and sixties, the Beast was depicted emerging from its place under the ground or under the sea—or from that prehistoric time under history—in a spectrum of enraged ruthless animals whose only instinct was destruction: radioactive dinosaurs, giant leeches, spiders, crabs, grasshoppers, praying mantises and scorpions. In the classic 1954 movie *Them!*, enormous black ants emerged from under the desert earth near Trinity to terrorize the scattered citizenry.

When the Beast bears a human face, he is often a power-mad ruler or a mad scientist. This was a common theme in the popular movies of the 1930s. "Gene Autry descended into

an underground atomic-powered city to battle a prince armed with radium ray devices," writes Spencer Weart in *Nuclear Fear* (1988:59). "Crash Corrigan overcame an undersea ruler who planned to enslave the world using 'the atom—the most destructive force known to science.' "

In its human incarnation, the Beast not uncommonly takes on a new quality. Unlike the mindless omnivorous hunger of, say, Godzilla, the human Beast—no less malevolent—will often have a subtle and devious intelligence animated by the passion to destroy. The Beast as alter ego of the mad scientist has a venerable continuity with Mary Shelley's Frankenstein, which she based on the Jewish folklore of the golem, the rabbis' good but soulless servant run amuck. With the dawning of the atomic age, the Beast sometimes became the scientist himself. In J. B. Priestley's *The Doomsday Men*, written in 1938, a mad scientist in great despair over the suffering of human existence sinks his intelligence into creating an atomic reaction that would kill all life on earth.

Another variant of the human Beast is the fundamentalist Christian fantasy of the Antichrist. Cold, sociopathic, charming and charismatic, the Antichrist embodies both the complexity of human intelligence and the primitive will to destroy.

In some of the dreams collected for this book, the Beast appears as a man or woman who would destroy the world. He or she is crazed, radically out of control and unreachable by negotiation. In other dreams, a nuclear exchange has begun and is unstoppable until devastation is complete. In the ruins, the Beast still runs amuck: as a motorcycle gang or a Tyrannosaurus Rex. In one other dream, a mysterious plague erupts from under the earth after the Bomb has dropped.

Bruce Chatwin offers a striking image of the Beast in *Songlines*, his semifictional account of his experiences among the Australian Aborigines. "Before the British H-Bomb test at Maralinga, the Army posted 'Keep Out!' signs, in English, for Aboriginals to read," writes Chatwin. "Not everyone saw the signs or could read English" (Chatwin, 1987:77).

Chatwin's protagonist, Arkady, is an Australian of Rus-

sian descent who was hired to consult with the Aborigines so
that the proposed cutting of the Alice-to-Darwin railway does
not violate any of their sacred sites. As he drove near Mara-
linga at the northern frontier of Aranda territory, he noticed
that the five Aborigines with him became overwhelmed with
fear:

> Again and again he asked, "What are the songs of this place?"
> or "What's the dreaming-story here?" They clamped their
> mouths and wouldn't say a word.
>
> "I couldn't think what was up," he said. "So I told them
> about the [railroad] cutting, and that really set them off. They
> all began blubbering, "Blackfella die! Whitefella die! All peo-
> ple die! End of Australia. End of world! Finish!"
>
> "Well, obviously," said Arkady, "*that* had to be something
> big. So I asked the Elder, who's shaking from head to foot,
> 'What *have* you got down there?' And he cups his hand
> around my ear and whispers, 'MAGGOT POWER!' "
>
> The song that lay along the line of hills told of a Dream-
> time Ancestor who failed to perform the correct ritual for
> controlling a bush-fly breeding cycle. Swarms of maggots
> overran the Burt Plain, stripping it bare of vegetation—as
> it is today. The Ancestor rounded up the maggots and
> crammed them back beneath the spur of rock where, ever
> since, they'd been breeding and breeding underground. The
> old men said that, if they cut into the hillside, there'd be a
> giant explosion. A cloud of flies would burst upward and
> cover the whole earth and kill every man and animal with
> poison.
>
> "The Bomb!" I suggested.
>
> "The Bomb," said Arkady, grimly. "Some of my friends
> knew a lot about the Bomb. *After it went off.*" (Ibid.:77–78)

Just as the thirties and forties were in the grip of Mes-
sianic longing, so also were they possessed by the fantasy and
reality of the coming of the Beast. As early as 1921, William
Butler Yeats foresaw this advent in his prophetic poem *The*

Second Coming. "Things fall apart," lamented the poet, "the center cannot hold."

> Mere anarchy is loosed upon the world,
> The blood-dimmed tide is loosed, and everywhere
> The ceremony of innocence is drowned.

"Surely some revelation is at hand," wrote Yeats. "Surely the Second Coming is at hand." But the Second Coming that the poet foresaw is not the return of the Prince of Peace. Rather

> A shape with lion body and the head of a man
> A gaze blank and pitiless as the sun,
> Is moving its slow thighs, while all about it
> Reel shadows of the indignant desert birds.
> The darkness drops again; but now I know
> That twenty centuries of stony sleep
> Were vexed to nightmare by a rocking cradle,
> And what rough beast, its hour come round at last,
> Slouches towards Bethlehem to be born?
>
> (Yeats, 1959:184)

If one thinks of World War II as a mass psychotic episode that captured both Axis and Allied powers, then the personas of Messiah and Beast represent the two poles between which the madness circulated. "I have found that in schizophrenia there is most often a special range of the hero image that happens quite regularly to be messianic: of saving the world, changing society, or reforming the nations," writes psychologist John Weir Perry in *The Far Side of Madness.*

> What makes a psychotic idea sound "crazy" is that each element in the unconscious is taken perfectly concretely and in externalized form; that is, the psychotic ego identifies with each archetypal image or process as soon as it is activated in the unconscious. (Perry, 1974:66)

This extreme literalism, which Perry calls "one of the prime characteristics of schizophrenia," found its full expression during World War II when the forces of light battled relentlessly against the forces of darkness.

The coldheartedness of the German SS, the suicidal devotion of the Japanese kamikaze pilot, the rape of Nanking, the London Blitz, the Bataan Death March, etc., have been deeply incorporated into American folklore about the perniciousness of the enemy. The same folklore has God firmly on our side despite the utter disregard for civilian life that characterized, for example, the Allied area bombing of Germany and the American saturation bombing of Japan. It is telling that, in spite of the Blitz, the leveling of Warsaw, Guernica, etc., the Nuremberg tribunal avoided the issue of the Luftwaffe's war crimes, knowing quite well that the Allies lacked the ethical leverage to prosecute atrocities that were functionally indistinguishable from their own.

The dynamics between Messiah and Beast played themselves out most vividly in the war against Japan. Much has been made of the fanaticism of the Japanese government and its refusal to surrender unconditionally that presumably made the bombings of Hiroshima and Nagasaki necessary. Without denying the harsh realities of Japanese militarism, or the crazed tenacity of its war establishment, it seems that we pay very little attention to the context of Japanese intransigence that the Allied war effort itself created. Why, after all, we seemed genuinely to wonder, would the Japanese be reluctant to unconditionally surrender to the benevolent arms of a nation such as ours?

As in the Nazi propaganda against the Jews, our propaganda portrayed the Japanese as vermin to be eliminated, so that in one wartime poll, 10 percent of the American population professed that doing away with the Japanese people altogether should be an ultimate aim of the war. The naval blockade established early in the hostilities was so effective that not even a fishing boat could puncture it; as a consequence,

women, children and old people faced lingering starvation as food supplies were funneled to the men in uniform.

After Iwo Jima, General Curtis LeMay found himself frustrated with the restrictions of precision bombing of military and industrial targets. A spokesman for the Fifth Air Force claimed that, since Japanese civilians would undoubtedly resist an American invasion, "the entire population of Japan is a proper military target." And so, on 9 March 1945, LeMay launched the rain of fire over working class Tokyo—a target area that the U.S. Strategic Bombing Survey estimated to be 87.4% residential—that left over one hundred thousand dead and a million and a half homeless. In a matter of six hours, more people were killed than in any comparably short period of time in all of human history. "Congratulations" went the telegram LeMay received later from Hap Arnold, the commanding general of the U.S. Army Air Forces; "this mission shows your crews have got the guts for anything" (Rhodes, 1986:599).

After the devastation of Tokyo, LeMay wrote, "The 20th Air Force is systematically bombing out the following cities with the purpose in mind of not leaving one stone lying on another: Tokyo, Yokohama, Nagoya, Osaka, Kyoto, Kobe, Yawata and Nagasaki" (ibid.:627). LeMay warned the Manhattan Project that they'd better hurry with their gadget because soon there would be no significant city in Japan to drop it on. He expected the strategic bombing of Japan to be completed by the end of 1945 after which "availability of future targets will be a problem" (ibid.:639).

And on 31 May of that year, a small group of men gathered to discuss exactly what to do with the first nuclear devices that were nearing completion. Secretary of War Stimson, greatly ambivalent about the Bomb, cherished few illusions. He was more than a little aware of the presence of the Beast in the American war effort. Oppenheimer recalls Stimson speaking to

> . . . the appalling lack of conscience and compassion that the war had brought about . . . the complacency, the indif-

ference, and the silence with which we greeted the mass bombings in Europe and, above all, Japan. He was not exultant about the bombings of Hamburg, of Dresden, of Tokyo. . . . (Ibid.:647)

There is a tendency in dreams and psychotic fantasy that Jung noted and to which he gave the Greek name *enantiodromia*—that is to say, that qualities or personas, carried to their extremes, tend to become their opposite. The Messiah, crazy in his desire to eliminate the enemy, easily becomes the Beast. This tendency is graphically displayed in the issue of *Life* magazine that came out immediately before the bombings of Hiroshima and Nagasaki. Under the caption "A Jap Burns," *Life* shows six sequential photographs of a Japanese soldier slowly being burnt alive by a flamethrower in the jungles of Borneo.

> With liquid fire eating at his skin, Jap skitters through underbrush. Blind and still burning, he makes agonized reach for support, falls. He tries to crawl, falls again. Flames have already consumed clothing. After one last effort, the Jap slumps in his own grisly funeral pyre.

After invoking the heroism of the 7th Australian Division, *Life* tells us that

> . . . the flamethrower is easily the most cruel, the most terrifying weapon ever developed. If it does not suffocate the enemy, its quickly licking tongues of flame sear his body to a black crisp. But so long as the Jap refuses to come out of his holes and keeps killing, this is the only way. (*Life*, 13 August 1945:34-35)

In its lurid, pornographic detail with its scarcely disguised delight shifting effortlessly into the rhetoric of moral high ground—the "hard necessity" of having to use such a weapon to kill such a merciless killer—this paragraph demonstrates in

miniature the strange psychic alchemy in the tangled narrative
of the nuclear nightmare that undergirded the Cold War and
the (un)realpolitik of stockpiling arms. Fifty million people were
fed to the Messiah and the Beast who so easily became each
other during World War II.

　　　Inevitably, the Beast was very present in the Manhattan
Project alongside (and even within) the unquestioned ideals
of many of the scientists.

　　　After the defeat of Germany, the Manhattan Project's
rhythm grew increasingly uncontrolled, exuberant, sleepless.
The frenzy of the last few months of the war against Japan
reveals the telltale signs of the presence of the Beast. Although
the project to develop the atom bomb began with the goal of
defeating Hitler and although many of the scientists joined for
that particular reason, it was actually after his downfall that
work on "the gadget" reached its most feverish pitch. It was
then that Oppenheimer was so possessed by the symptoms of
sleeplessness, frustration and short-temperedness that some
feared for his sanity. His brother Frank recalled that the mo-
mentum of the project during those months had a life of its
own.

> It's amazing how the technology, tools, trap one. They're so
> powerful. I was impressed because most of the sort of fer-
> vor for developing the bomb came as a kind of anti-fascist
> fervor against Germany, but when V-E day came along,
> nobody slowed up one bit. (*The Day after Trinity*, Pyramid
> Films, 1981)

Robert Wilson said of that time:

> I would like to think now that at the time of the German
> defeat, I would have stopped and taken stock, and thought
> it all over very carefully, and that I would have walked away
> from Los Alamos at that time. In terms of everything I be-

lieved in before and during and after the war, I cannot understand why I did not take that act. On the other hand, I do not know of a single instance of anyone who made that suggestion or who did leave at the time. . . . Our life was directed to do one thing. It was as though we had been programmed to do that and as automatons were doing it. (Ibid.)

It may seem absurd to discern a demonic presence at work in weapons research, but at least one nuclear physicist did exactly that. Theodore B. Taylor pioneered the miniaturization of nuclear weaponry—designing, for example, a fifty-pound device tested first in 1962 under the code name "Little Feller." In 1966 he quit, claiming that he was participating in the work of the devil. "The excuse that nuclear weaponeers like myself had was that we were making war impossible," he said in an interview. He continued,

I have a sense of some supernatural forces that are distinctly evil. I can't identify them, but sometimes things happen, people do things—I've done them—that I would call the work of an evil spirit holding control, at least for awhile. I think that happens in many forms of addictions, particularly psychological addictions. For the last year or so, I have been calling myself an addict with respect to nuclear weaponry. Becoming involved with it, being close to it, working on it, creates an altered state of mind. I'm convinced that the real driving force in the nuclear arms race is the weaponeers, the people who come up with the concepts. It all starts with that devilishly creative act of imagining something which is infinitely destructive. . . . (Quoted in Del Tredici, 1987:82)

Whether one uses the religious concept of supernatural forces or speaks of an autonomous complex loose in the collective psyche (what I have called the Beast), there is no question that the simple proximity to so much destructive power was seductive. Physicist Freeman Dyson articulated this attraction:

> I have felt it myself—the glitter of nuclear weapons. It is irresistible, if you come to them as a scientist, to feel it is there in your hands to release this energy that fuels the stars, to let it do your bidding to perform these miracles to lift a million tons of rock into the sky. It is something that gives people an illusion of illimitable power. (*The Day after Trinity*)

This dazzle of possibility and power was so great that the most responsible scientists went ahead toward Trinity even though there was genuine concern that the test might get out of hand. One of the real concerns prior to the Trinity blast was whether or not the Bomb would initiate a chain reaction in atmospheric hydrogen that could not be contained—thereby enveloping the whole planet in fire. Scientists in Chicago and Los Alamos spent endless hours trying to determine the mathematical probability of this result. Edward Teller confessed he found this sort of puzzle "truly delightful" (Weart, 1988:143). Enrico Fermi jokingly took bets over whether the first atomic test would ignite the atmosphere—and, if it did, whether it would destroy merely New Mexico or the entire world. Finally, the participants went ahead when they had calculated that the chances that Trinity would literally spell the end of the world were less than three million in one.

This drama of perching on the technological brink of the uncontrollable is a motif repeated again and again in the dreaming of the nuclear beast. Finding the fulcrum point at which a certain mass of uranium-235 went critical was essential to knowing how much of this element Little Boy would require. This dangerous investigation the physicists at Los Alamos called the Dragon experiment after Richard Feynman quipped that it would be like tickling the tail of a sleeping dragon. Feynman's joke offers new meaning to the chaos of Godzilla or Rhodan swooping down and breathing fire on the post-war citizens of Japan.

At the immense Hanford nuclear complex in Washington state, William Laurence was overawed by the technological array of the nuclear reactor that would produce Little Boy's other fissionable component, plutonium-239. In his mind the controls kept "this manmade Titan from breaking his bonds. Left without control for even a split second, the giant would run wild" (Weart:100).

Keeping the Titan from breaking his bonds, tickling the tail of the dragon in its sleep—walking the tightrope between control and the uncontrollable in order to submit the furious power of nature to human ends—these are the fantasies upon which much of the scientific positivism feeding the dream of nuclear utopia depends. These fantasies of control, however, have yielded their opposite: the fear and the actuality of the uncontrollable. Just as we have insisted with Messianic fervor that the New Age required the unconditional surrender of the enemy, so also, apparently, does it require the unconditional surrender of that vast field of unpredictability and otherness called nature. Add to this a measure of intoxication with the power that we have coaxed out of natural processes, and the Beast rises up on its own in the midst of religious idealism.

Probably the most disturbing example of *enantiodromia* in the Manhattan Project is the stark synchronicity between the annihilation of the Hungarian Jews and the lifting of the lid of Pandora's box that the possibility of developing the Hydrogen Bomb promised.

Edward Teller—like Leo Szilard—was a Hungarian who fled anti-Semitism in his native country to study in Germany, only to witness there the rise of Nazism. It was in May of 1944 that the number of death commandos manning the gas chambers at Auschwitz-Birkenau was quadrupled to accommodate the arrival of up to twelve thousand Hungarian Jews a day. In less than two months, over three-quarters of the eight hundred thousand Jews of Hungary were exterminated.

When the first shipment of Jews was arriving at Auschwitz, Edward Teller finally got the go-ahead from Oppenheimer to sink his passion and creativity into the development of the "Super," a fusion bomb that would make the bombs dropped on Japan seem like firecrackers. For Teller, this was a godsend. He had been obsessed with the thought of a thermonuclear device since the fall of 1941 when Enrico Fermi had, "out of the blue," tossed out the possibility in the course of a casual conversation. By October of 1944, Teller was enthusiastically speculating that the explosive blast of a thermonuclear device would produce an "equivalent to 100,000,000 tons of TNT, which in turn should produce Class B damage over an area of 3,000 square miles" (Rhodes, 1986:563).

Teller, in his excitement, was prone to exaggerate. Since the equivalent of about 3,000,000 tons of TNT was used in all of World War II, Teller's "Super" as he originally imagined it would have the explosive charge of over thirty World War IIs. Ultimately, however, Teller's Super did, in fact, equal a thousand Hiroshimas. Oppenheimer called it, bitterly, "The Plague of Thebes."

Edward Teller's ample contributions to the technology of apocalypse (including selling Ronald Reagan on the concept of Star Wars) always came under the pretext of idealism, and sometimes utopianism. Before the Cold War, he wrote of his vision of world government. After the Communists took over Hungary in 1949 and cut him off from his kin, his focus became the defense of the "Free World." May 1944 presented the heartbreaking picture of Teller pouring his vast imaginative skill into hugely escalating the human capacity of mutual annihilation at exactly the moment his tribe was being systematically destroyed by the Nazis. It would be a great distraction to presume that this strange symbiosis between Messiah and Beast belongs to the madness of Edward Teller as much as to the madness of the times we live in. Yet whatever his ideals, it is easy enough to catch the scent of the Beast in his obsessions and curiosities and his evident intoxication with amplifying the means of destruction.

This and the previous chapter give a skeletal shape to the dream-at-the-end-of-the-world in which we are entrenched: a dream prefigured and embodied in the Bomb and now, continuing as our unconscious positivism and rapacity, leveled against nature. The Messiah and the Beast, though of ancient origin, have awakened with a fury in response to the deepest psychic urgencies of a violent and confusing century—and we have wedded their images to the Bomb.

"We were told to lie down on the sand," writes Teller of the Trinity test, "turn our faces away from the blast, and bury our heads in our arms. No one complied. We were determined to look the beast in the eye" (Rhodes, 1986:668).

Fifty years later, as the millennium draws to a close, the Beast has proliferated at an astonishing rate. How do we look in the eyes of what we have created, and how do we find these eyes of the Beast now that we are no longer blinded by the overarching light of the mushroom cloud? How can we awaken from such a dream?

The Dream at the End of the World

꧁꧂꧁꧂꧁꧂꧁꧂꧁꧂꧁꧂꧁꧂꧁꧂꧁꧂꧁꧂꧁꧂

THE BOMB DISPLAYS with magnificence and horror the images of Messiah and Beast, and thereby places us collectively in a dream at the end of the world—a dream that is apparently destined to continue unabated even as the Bomb ceases to be the central archetypal presence in its midst. These primal antagonists cry out to be understood, for it is clear that we can no longer act them out blindly or ignore them. Their ancient conflict is being literalized in ecological depredation as surely as it was in the geopolitical insanities of the Cold War. As the psychologist C. G. Jung warned, what is not made conscious will be lived out unconsciously and experienced as fate.

In order to understand the dream at the end of the world, it is important, first, to ask where it locates us—that is to say, what is its full psychological, and ultimately its mythical, context. Answering this question makes clear, in this chapter, how this dream serves as the germ of both nuclear and ecological holocaust, how both share a single complex metaphor in the mythic struggle between Messiah and Beast.

Psychologically, this dream places us within that unbearable rite of passage called madness. The Bomb itself was created out of, was incorporated into, and contributed to the psychotic drama called the Second World War, in which the fantasies of Beast and Messiah were literalized and enacted in the bloodiest possible fashion. John Weir Perry in his study of schizophrenia locates the apocalyptic struggle between good and evil at the core of psychotic processes. He writes:

> There arises a world conflict of cosmic import between the
> forces of good and evil, or light and darkness, or order and

chaos (surprisingly often expressed nowadays as democracy
and communism); Armageddon or the triumph of the An-
tichrist; destruction or end of the world, or Last Judgement;
intrigues, plots, spying, poisoning—for all to gain world
supremacy. (Perry, 1974:29)

Whether one presumes that war is psychosis writ large or that
psychosis violently inscribes our mythic and geopolitical fan-
tasies into individual psyches, it's clear that the crazy visions
of those who are broken offer a dark reflection of the dream
world we inhabit.

The language of war, like the language of madness, speaks
in absolutes. Psychotic fantasy shows that the mythic grid un-
derlying these languages is apocalyptic, relying quite often on
the core of Christian apocalyptic scripture, the Revelation of
St. John. In St. John's vision on the island of Patmos, the figures
of Messiah and Beast were central. The destruction and re-
creation of the world culminate with the avenging Christ, sword
drawn, descending from the heavens on his white horse. He
casts the Beast, also called Antichrist, alive into the lake of
fire over which he establishes his kingdom of righteousness.

It is generally understood that the apocalypse of St. John
draws from the Babylonian chaos myths. Associated with the
sea and the Milky Way, Tiamat was the primordial dragon who
bore the womb of chaos from which the gods were born. She
rebelled against Babylon's municipal god Marduk, who killed
her. Heaven and earth were created out of her dissevered body,
and upon the new earth Marduk built his palace.

The Marduk/Tiamat saga is one variant of scores of Indo-
European myths of the culture hero defeating the primordial
agent of chaos. Indeed, I think it is safe to say that this basic
story laid the substratum of meaning upon which the Neolithic
city state was founded. With the crystallization of urban reality
around agricultural settlements, an abyss opened up between
the place of human habitation and the realm of the wild—an
abyss that did not exist amongst hunters and gatherers. A new

generation of gods took ascendancy to protect the human community from what might emerge from that abyss. The dream at the end of the world hearkens back to a mythical landscape where the realm of wilderness, wildness, maternal darkness, underworld and death was defeated so that the logos of the new urban order could reign supreme.

In the Psalms of David, Yahweh brought the boundaries of the earth, the regularity of the seasons and sunlight out of the slain body of the dragon Leviathan. Apollo, with his arrows, killed the Pythoness who held fast to the sanctuary at Delphi. In India, Vritra was the primordial snake who contained within himself the sun, the waters of chaos and all that would lend sustenance to the earth. He lived at the frontiers of darkness, in the far mountains, and was slain by the sky god Indra with a bolt of lightning. Afterwards, writes Joseph Fontenrose in *Python: A Study of Delphic Myth and Its Origins,* "Vritra was cast into the outer darkness, the enduring chaos that surrounds or underlies the cosmos, and there he remains. For death and banishment to the underworld are the same thing" (Fontenrose, 1959:195–96).

Throughout these myths, qualities of both the monster and culture hero profoundly resonate with the personae of Beast and Messiah in our contemporary dream of apocalypse. Of the monster, Fontenrose notes that he was a son of a chaos demoness or earth goddess. He lived in a cave or under the earth or in the dark waters. Gigantic, he sent death by fire or glance. His nonhuman form was a boar or snake; a dragon or panther; a bull, harpy, giant scorpion, crocodile, wolf or any of the bestiary that various cultures associated with the animals of the Underworld. He was a death spirit, plundered and murdered and carried off the young, and was often associated with the god who rules the lower realms. Gluttonous, a man-eater, unstoppable in his appetites, he wanted to rule the world.

The culture hero, on the other hand, was a weather god from the realm of the sky and was associated with stormwinds,

clouds and the beneficence of the fertilizing rain, as well as with lightning and war. As a warrior he was often on a winged horse or flying chariot, and he wielded the thunderbolt or its analogs—the "terrible swift sword," the trident, the spear or the uncannily accurate arrow. He belonged to a newer generation of hero gods, whereas "chaos" belonged to the ancient order.

Just as these myths speak of the carving out of a humanized world within nature, so also do they define a very particular psychological relationship between our humanized sense of self and the wilderness within us. These myths, as statements of the phenomenology within the psyche, contrast the sharpness of the hero's weapons—his arrow, thunderbolt or sword— with the inchoate wildness of appetite that defines the monster's power and danger. Indeed, Indra's weapon against Vritra is the *vajra* or thunderbolt which, in Tantric Buddhism, is the name of the diamond-sharp blade of the contemplative mind which pierces into the heart of chaos and cuts through all delusion. In the twentieth-century secularization of this myth, Freud posits the submission of the animal hungers of the id to the civilizing agents of ego and superego.

Nonetheless, however skillfully one might wield the blade, it's clear that this very old story leaves us in an extremely top-heavy and unbalanced situation. Once the *temenos* or sacred space of the city/logos—the sanctuary of human activity—is divided away from and above the realm of the wild, then that ecology is inevitably demonized as chaos and maintaining the ascendancy of the sky gods over the chthonic deities becomes the essential mythic background to the world as we know it. In *The Return of the Goddess*, Edward C. Whitmont writes:

> The heroic self-disciplined will that shall rule henceforth is embodied in the hero figures. . . . The onset of the heroic age coincides with the beginning of iron technology. It is dominated by the mind, the ego, the spirit. Abstraction leads to an eventual loss of the gods, and of the soul. Yet it

facilitates conquering the world through technology. (Whitmont, 1988:65–66)

The "world as we know it" constellates mythically, culturally and in the intimate places of our psyches, and it is precisely this world that is ending in the dream at the end of the world. Although the invention of the Bomb is the ultimate achievement of logos, it delivers us into the presence of the primary personae of Beast and Messiah to a degree perhaps unprecedented since the dawn of the Neolithic era. And it cannot offer us the happy ending of the older drama for the simple reason that, in this dream, Beast and Messiah cohabit the same image. The trajectory that began in the Iron Age of sharpening and refining our weapons against the agents of chaos ends here: the ultimate weapon has delivered us unprotected into the chaos it promised to do away with once and for all. The old story which was the grid that organized what we called "the world" has unraveled, and we stand stripped bare before or within the *massa confusa* of Messiah and Beast. And as the Bomb recedes as the archetypal dominant of an apocalyptic era, this *massa confusa* deepens because we can no longer rely on the artificial clarity of the Us versus Them absolutism that the light (or shadow) of the Bomb provided us.

This is not to say we can't or won't act atavistically out of the old paradigm. It is absurdly easy to indulge the fantasy that we wield our bombs on behalf of righteousness, while our enemies' weapons are the very teeth of chaos that would devour the civilized world. We did, after all, conspicuously name our bombs after the newer generation of gods and heroes in Greek mythology (or their weapons) who overthrew or replaced the old chthonic order: Trident, Nike, Poseidon, Nike Hercules, Nike Ajax, Triton or the old IRBM's Thor and Jupiter.

One example of playing out the old story with passionate unconsciousness is the recent war against Iraq. In his ravenous hunger, the swarthy Beast in the hinterlands of the civilized world devours Kuwait. He thereby threatens to drag into the

pit of darkness the realm of order and civility—the "Free World" —for it is well-known that the appetite of the Beast has no limit. The sky god intervenes—the one who wields the thunderbolt—and with the sharpness and precision of his weapons (read "smart bombs") defeats the agent of chaos. And over the ashes of defeat, a new world order is established. (It should go without saying that, by relying on the rhetoric of Holy War against the Great Satan, Hussein showed that he was as blindly committed to the old story as the United States, if rather less successfully.)

But, however repeatedly we live out this story under the guise of realpolitik, our dreams—and the dream at the end of the world—don't partake of these simple dualisms. The nuclear dream left us in unbearable nakedness before the vastly over-determined image of the mushroom cloud which contains both the realm of the sky god—his terrible swift sword, transcendence and ecstasy—and the chthonic Underworld of death, putrefaction, initiation and rebirth. Like the World Tree in ancient cosmology, the mushroom cloud has roots that extend into the darkest recesses of the Underworld and branches that reach to the stars. As such, it has carried our fantasies of wildness and ecstasy; transcendent meaning and the ashes of meaninglessness; disease, death, mystery, terror and awe. Indeed, all that has been cemented over by establishing human habitation against the wilderness and all the longing for the stars that has been stunted within the confines of Descartes' clockwork universe—everything both above and below that the technocratic world has so rigorously excluded—poured into the mushroom cloud with a singular fury. This mushroom cloud, as a psychic image, vividly confirms Freud's contention that what is repressed will inevitably return—and return with a vengeance. It should be no surprise that the sheer immensity of this image with all its contradictory potential would stupefy us from fully appreciating the numerous other fronts upon which the Beast and Messiah do battle.

The suddenness of this "return of the repressed" has stag-

gered our psyches. Inevitably in the apocalyptic dreams studied here, the shock of this abruptness echoes over and again. "All of a sudden I looked up from my plate and saw this huge mushroom cloud." "The streets suddenly begin to slide swiftly in different directions." "Suddenly there is a blinding flash of light." "Suddenly from out of the cracks come children, like seeds from the earth." "All of a sudden, the film of my life ran out and everything turned white." Suddenness is the modality of time in the apocalyptic psyche—or, perhaps more accurately, from some place utterly outside the rhythms of mundane time, something punctures our encapsulation in those ordinary rhythms. What was not, suddenly is; and the world that was suddenly cannot be anymore. Christian theology calls this breaking through from eternity into time *Kairos*, understanding thereby the appearance of the Messiah, who "cometh like a thief in the night," at the end of time.

The dream at the end of the world, however, vastly extends the theological discourse on *Kairos*: for if within the shadows of our technological positivism Messiah and Beast appear together, it is in coming to terms with the reality of the Beast that our salvation depends. For it has been the work of ages first to demonize the Beast, sharpen our weapons against the wild, decimate nature and finally exile wildness itself into the image of the mushroom cloud. If our collective psychosis has been characterized by an exclusive and unconscious identification with the sky god in his fight against the vilified Beast, it is abundantly clear that healing the dream of apocalypse depends on descending into the Beast's lair with tenderness of heart, surrendering our inflated conceptions of ourselves and learning how to live peaceably with the wildness of nature—and even of human nature.

What the Jewish theologian Arthur Cohen said of the Nazi death camps we can now recognize as true of the Bomb:

> It is the human tremendum, the enormity of an infinitized man, who no longer seems to fear death or, perhaps more

to the point, fears it so completely, denies death so might-
ily, that the only patent of his refutation and denial is to build
up a mountain of corpses to the divinity of the dead, to
placate death by the magic of endless murder. The death
camps cannot be transcended. There is no way of obliterating
their historicity by overleaping them. Quite the contrary. If
there is no transcendence beyond the abyss, the abyss must
be inspected further. The descent deeper into the abyss must
take place; in a word, the abyss must be sub-scended, pene-
trated to its perceivable depths. (Cohen, 1988:22)

Even if nuclear weaponry were all dismantled in a day's time
like the crematorium of Auschwitz was dismantled by survivors
when the Russians liberated the camp, the abyss that the Bomb
has opened up would still need to be sub-scended if we are
to find our way out of the dream at the end of the world.
Mythologically speaking, sub-scending the madness of the
twentieth century means descending into the Underworld to
be initiated there. To the ancient Greeks and Romans, the
Underworld—Hades—was the domain of the death god (also
called Hades), located in the heart of the earth just as plu-
tonium forms the impacted core of death in the Bomb. The
god's Roman name, Pluto, means "treasure." Although the an-
cients also feared death, they recognized the descent into Hades
as an entrance into the realm of riches.

In the Christian era, Hades became Hell, the pit of eter-
nal damnation and the prison for the Beast we have demon-
ized in our fear of nature. Hell was a place to which no sane
person would venture. For the ancient Greeks, however, the
descent into Hades was not prohibited but rather encouraged
and ritualized in the Eleusinian mysteries upon which the
replenishment of society and the fertility of the earth depended.
At Eleusis, one was reconciled with death and came to recog-
nize the mysteries that underlie the human and natural world.
In Hades, in a process of healing, one looks at, suffers, and
ultimately embraces all that one imagines one isn't. It is my

contention that behind the Hell of the twentieth century lies Hades and that the realities of the very difficult times we live in have potentially deposited us in a rigorous and profound rite of initiation.

Because the mushroom cloud has been the most compelling image within the apocalyptic psyche, this initiation rite relies on our turning to face it and its implications. In the realm of the psyche, as in Blake's vision of the Last Judgment, this image contains the inexorable flux between the infernal domain and the heavenly sphere, the *prima materia* of dark light and radiant darkness that is the stuff of which apocalyptic dreams are made. In the next few chapters we will walk into this imaginal landscape, the nakedness and death it invites us toward, the ineffable mysteries at the heart of apocalypse and the new world that might emerge on the dream's other side. We will examine the similarities and disjunctions between apocalypse imagined through a nuclear metaphor and apocalypse imagined through an ecological one, where these metaphors overlap and where they stand distinct from one another, and what might be the particular responsibilities of facing ecological apocalypse.

SECTION II

Entering the Wilderness
The Apocalyptic Rite of Initiation

Thrice blessed are those who have seen these mysteries and descended into Hades. They know the end of life and the beginning.

— PINDAR

.

Introduction

IN THE PREVIOUS chapter, we referred to the descent into the Underworld as a rite of initiation practiced by the ancient Greeks as the Eleusinian mysteries. The myth underlying these mysteries begins with the daughter of the earth goddess Demeter—the nameless, therefore uninitiated one called *Kore* (Greek for "girl")—picking flowers with the daughters of Ocean in the field of her own innocence. Suddenly the ground opens up, and Hades rapes her downward into the pit of the Underworld. Demeter wanders bereft over the face of the earth and renders barren all of the fields. Eventually, through the intervention of the god Hermes, who moves so freely between the heights of Olympus and the depths of the Underworld, Demeter secures her daughter's release. Before Hades lets her go, however, he has her drink of a cup of pomegranate wine. By this ruse, she is cyclically bound to him as wife, taking on the name Persephone, Queen of the Underworld. Thereafter, during the barrenness of winter, while her mother grieves, Persephone rules Hades with her dark husband—but with the coming of spring, she is joyfully reconciled with Demeter to share her company the remainder of the year.

This reemergence from the Underworld—this birth of light out of darkness—is symbolized by the fruit of Persephone's and Hades' marriage, the divine child Brimos. And in her gratitude and delight in taking her daughter back into her embrace, Demeter bequeaths to the world both the gift of grain and her incomparable mysteries, the rites of Eleusis which became the cornerstone of Greek society for fifteen hundred years.

In the Eleusinian mysteries, the initiate would ritually take on the story of the goddess, her suffering and her ecstasy. To

be stripped of innocence, dragged down to the place of death, married to the dark god, to give birth to light and reemerge into the arms of nature—through the intimacy of ritual the initiate would come, as Pindar wrote, to "know the end of life and the beginning": the mysterious continuities between death and life.

This section proposes a rite of initiation not unlike that practiced at Eleusis. While the mythic and imagistic background differs somewhat, the mysteries of apocalypse follow a similar archetypal pattern of abduction, descent into a dark and unfamiliar realm, the terrifying meeting with the persona of death, illumination and ecstasy, and reemergence.

While it would be too programmatic to graft apocalyptic dreams wholesale onto an Eleusinian metaphor, it is nonetheless evident that the unnamed, innocent one in us has been raped downward into the Underworld by the very fact of our technological capacity to annihilate ourselves—thereby inviting us to submit to a rite of passage as profound as that which transpired at Eleusis. The images of the dreams examined here explore and elucidate this way of descent and return.

Startling as it may seem, initiation into the apocalyptic mysteries seems to be a requisite for living a full and awake life during these exceedingly troubled times. This is not to say that the way of myth and dream is the only way of initiation—indeed, I suspect one enters into the apocalyptic mysteries whenever one seriously and with concentration looks hard into the realities of who one is and into the times in which one is living. These dreams do, however, give a very vivid and raw picture of the psyche's perception of its situation. "The way through the world is more difficult than the way beyond the world," writes Wallace Stevens. These dreams can help guide the reader through the psychic labyrinth of living in an apocalyptic era.

Anthropologists have analyzed initiatory rituals into three

parts, a form remarkably consistent throughout the world. Not surprisingly, the Eleusinian mysteries—as well as these thematic reflections on the apocalyptic mysteries—fall into this archetypal pattern.

Initiations usually begin with separation from the world and mundane reality and a tearing away of one's social persona, sometimes formalized as a rite of purification. This corresponds with the abduction of the *Kore* and the radical rending of her innocence in the Eleusinian myth.

The equivalent of the beginning of initiation is covered in chapters four through nine via the themes of children, seeking refuge, finding no refuge, chaos, invisible poison and the unnatural. Central to these chapters is the recognition of the undeniability of one's own suffering, the basic sense of being unprotected from the realities of who one is and from the harshness of the apocalyptic world.

One most often enters into the psyche—into one's depth—through the awareness of one's woundedness. These dreams offer uncompromising images of the vitality that lives in our afflictions—and of our wound being coextensive with the injuries we have inflicted on the earth. This section begins with dreams about children because, for most of us, recognizing the wounded child in ourselves is the most accessible way to separate from the social persona and move into our own depths.

Cross-culturally, the second stage of a rite of passage is the initiation proper—that is, beholding the fantastic world of the gods, the terrors and ecstasies that are eclipsed behind the literalized fantasies of the social role that we play out in our day-to-day life. In the Eleusinian myth, this corresponds with the mysterious union of opposites or divine marriage of Hades and Persephone and the radiant birth of light in the form of the divine child.

Chapters ten through twelve correspond with this revelation of the mysteries. Surprisingly, the personae of the one who

would destroy the world and of the one who would save it are consistent between dreamers, forming a dyad quite different, but perhaps no less intimate in its dance, from Hades and Persephone. The character of these archetypal beings in ourselves, their particular aliveness and the nature of their dance are examined in the chapters "Because Thou Lovest the Burning Ground" and "Saving the World," while "The Emergence of the Sacred" looks at the ecstatic birth of light out of such a dark drama.

Initiation is always consummated with the initiate's return to the world, to the embrace of the tribe, a reconciliation characterized by the motif of the gift. What one has seen or who one has become is a "gift" to the community. In the Eleusinian myth, Persephone returns to the arms of her mother and Demeter gives humanity the grain and the mysteries. In some iconographies, the divine child is portrayed as the cornucopia or horn of plenty—showing that Hades is the domain of wealth as certainly as of death.

These themes of reemergence and gift-giving are examined in chapters thirteen and fourteen. The dreams in chapter thirteen concern the compassion of the ones who have passed through the fire. And since some of my informants have dreamt the apocalypse as a drama of the death and rebirth of the world, chapter fourteen, "Joy of Man's Desiring," presents the gift of spring emerging after the wintry desolation.

This outlines a full circle of apocalyptic initiation that our era democratically offers to all of us. First, the breaking down of one's social persona and self-image. Second, engulfment by an uncanny realm where one recognizes that this life is far more mysterious and terrible than one had hitherto imagined, where one beholds the primordial dance between the life instinct and the destroyer in oneself. And then one sees the awe-full light and finally emerges bearing gifts. While the dreams display this cycle in extremely dramatic images, in one's daily life the initiation occurs in numerous ways. For some people, intensive meditation practice initiates them into this radical facing

of oneself. For others, psychotherapy. Some descend by way of accident and others by physical disease. An identity crisis—a breakdown of the habitual ways we consolidate our sense of self—is often imaged in the psyche as the end of the world, thereby opening another opportunity to face the "otherness" in ourselves. As Ezra Pound writes, "Out of chaos, renewal."

However it might be lived out, such initiation is essential to living responsibly and with heart in an apocalyptic era. We are far more likely to participate in the world's destruction by clinging to the fiction of our innocence than if we have a conscious and living relationship with the darker aspects of our own nature.

Therefore, what is required initially is an about-face: rather than enacting apocalypse in the world unconsciously, we deliberately enter the apocalypse of the psyche for the sake of the world. In this text, the shift from literal apocalypse to psychic apocalypse may occasion some confusion. Because the destruction of the world is happening very literally "out there," it's easy to presume our apocalyptic dreams are *only* its mirror images.

In the psyche, however, images often have different implications than in our waking life, and the apocalyptic initiation may well *require* destruction: one's "world falling apart" can be intrinsic to the way of transformation. In the world "out there," for instance, the mushroom cloud is invariably an obscene and pernicious thing. In the psyche, however, it can range from an image of horror to one of ecstatic understanding, and either way the path of initiation may require that one walk into its heart.

Since one necessarily walks toward the heart of apocalypse as a stranger into a strange land, the dreams in each chapter precede the commentary. Stepping into these images and dramas *is* "entering the wilderness"—the transformative rite of apocalypse as it appears in the psyche.

Many of the dreams of ecological holocaust examined in the next eleven chapters inevitably are about the Bomb. Because

it has served as such an overdetermined metaphor for the Messiah/Beast complex, unsurprisingly the Bomb itself often transparently symbolizes the violence we do to this planet's ecology. As far as I know, the psyche has yet to consistently imagine what a non-nuclear apocalypse would be—though several of the dreams I looked at image this, they are the exception, not the rule. Indeed, because a widening hole in the ozone layer, or rising statistics of skin cancer, or the silent but relentless decimation of plant and animal species proceed with a whimper and not a bang, it may be a number of years before the psyche can fully and sharply imagine—and therefore respond to—ecological catastrophe. This psychic conservatism makes it doubly important to disimpact the condensed imagery of nuclear apocalypse because we have only this imagery to rely on to decode the more subtle mechanisms by which the Messiah/Beast complex both reifies and diffuses itself in ecological devastation. The inchoate hunger for destruction and the terrified desire to be saved from destruction were the mutually defining impulses that wrapped themselves around the Bomb like a snake that feeds on its own tail; and, as the previous chapter showed, these impulses stand likewise at the heart of ecological disequilibrium.

One last note: "Dream ego" refers to the one in the dream who bears the face of the dreamer, the dream persona of our conscious waking personality. Just as we falsely imagine, in our day-to-day lives, that all things revolve around us, so also in dreams do we miss the richness of meaning by overidentifying with the dream ego at the expense of other personae. Ultimately, dreams show us that "who one is" is, in fact, plural, a vast community. In entering the dream, the ego enters this community as a member and participant no more important or "real" than the rest.

To underscore this point, "Entering the Wilderness" ends with retelling a handful of dreams from the Bomb's point of view—as if it, not the dream ego, were the central "actor" and subjective presence in the drama. "The Bomb Lost in Its Own

Dark Dreaming" is an idiosyncratic attempt to refine the portrait of the Messiah/Beast hybrid that this book defines as the essential archetypal presence behind the Bomb and our war on nature.

FOUR

Suffer the Little Children

❦❧❦❧❦❧❦❧❦❧❦❧❦❧❦❧❦❧❦❧❦❧❦❧

I AM WITH *my child, and we see a huge mushroom cloud rising in the sky. I know it means the end. I hold my child close and I try to run away. I know it is useless, so I pray for instant death.*

This is a real dream. It was so real that I couldn't even tell my husband why I was crying.

A terrible, apocalyptic time. Nature is being destroyed, everything is disintegrating, and we are all going to die. It could be the result of war or it could be something else. The most obvious aspect is the physical disintegration and chaos. In the house, everything is permeated with dirt and is disarranged. Our mood is that of people with a fatal disease who are waiting to die.

One of my children is a baby girl wearing filthy, tattered clothing. We are in the kitchen, and she is standing on a pile of debris. Her bottom is bare and smeared with diarrhea. I reach for her to take her into another room and clean her, but she pulls away from me and refuses to go. Because of the world disease that affects us all, she is "all seized up" inside and will probably never have another bowel movement anyway.

Nevertheless, her refusal sparks a determination in me to do what I can until the end comes. I pick up a couple of dirty pink towels and carry them into the laundry room, throwing them to the foot of the washing machine to wait for a future wash, even when I know I may never do a wash again. In the dining room, I collect wrinkled and yellowed newspapers into a stack.

Then my husband comes home from work. His clothes

are clean and pressed, and he has an air of aloofness from all the dirt, decay and impending death that we are living in. He even goes over to the table to nibble at grapes, as if nothing is wrong. His aloofness annoys me very much.

The nightmares took on increasing clarity. I wasn't even a teenager yet. In the dreams, I was a young Japanese girl running toward a river, my skin blistered and my hair stinking— what was left of it after the searing hot shock wave had passed. The mushroom cloud exploded over and over in my mind throughout my teenage years.

(From a nine-year-old girl)
When I woke up there was a layer of red dust covering everything. If you breathed, it would kill you. I was sort of the "mother" to my five-year-old sister and baby brother, and I dug a hole with her to live in. But we couldn't breathe under the ground near our house—so we walked twenty miles away where there wouldn't be so much radioactive dust. I carried my brother.

We could see the mushroom cloud while we were walking. We'd eat grass on the way. The mushroom cloud was very scary. We were just trying to survive. Sometimes the air was black and we couldn't see.

When we got far away from the city, we dug another hole in the ground so we could get air. It had to be a really deep hole, and it had to curve under so we would be safe.

I'm at the bank getting money at an electronic teller that I have to climb into. On an electric sign, I read that a nuclear bomb has dropped on the town over the hill. I am incredulous. My god, it has finally happened. I feel a desperate need to find my daughter and my wife as I know we will all die soon.

I run into my daughter and her best friend on the street. Walking toward home together, I divert them in the direction of the mushroom cloud. There is a distinct crater left by the

Bomb, and it is filled with water. We walk around the crater with a kind of awe—there is an odd sort of beauty attached to it. A mother is baptizing or drowning her baby in the water of the crater. I am aware of the intense radioactivity that must be in the area and can't resolve whether she is baptizing her infant or killing it. There is a deep sense of mystery to this, and when I awake it's extended to the choice I made to take my daughter and her friend to Ground Zero.

Later, with the children, we look through the window of the house at the mushroom cloud. I know we will be dead in a few days. I feel a deep sense of melancholy and acceptance.

Nuclear holocaust has occurred. Anguished, I was looking out the window of a white frame farmhouse onto devastation. There was nothing to see except a flat ashen landscape. Desperate to kill myself, I decided to slit my wrists in the bath, only to find the tub was filled with the body of an enormous dead black woman, too heavy for me to lift, who did not leave me space to lie down upon her. Agonized, I returned to the window. A car drove very, very slowly down what might once have been a road. It stopped and a dark man, Ethiopian perhaps, exited and came toward the house. As he approached, I felt relief. I intended to ask him to kill me or help me die. Then, in the dream, a voice ordered, "Make a child." I refused and yelled back, "I can't. I'm forty-six; there are no facilities left to test for birth defects; I've had cancer; I've had two children; the world is destroyed. I cannot, will not make a child!" The voice remained kind but adamant: "New life," it demanded; "New life!"

Without a question children are the largest discernible group of people that inhabit the dreamscape of apocalypse. Children appear in over a quarter of the dreams I've collected. They suffer or offer hope, are born, have to be protected or

are one's companions in death. Whether the dreamer is oneself seen as a child or is concerned with his or her offspring, the children are a significant preoccupation. "I see a whole bunch of school kids running down the streets. Their teachers are encouraging them along, trying to get them home as quickly as possible." "I went to my daughter's room. There was bloody drool on her pillow." "I look over the edge and see two Palestinian children beating each other mercilessly." "I put my little girl down in the quiet, rushing light for her afternoon nap." Even when no particular children appear, several motifs (hometown, mother and father and their house, abandonment, seeking refuge) and the ambience in numerous dreams of being dwarfed and rendered helpless by decisions made "on high," or as we stand in the midst of a disintegrating society or nature, suggest that being a child of apocalypse is an important subidentity of our waking lives.

Though there are exceptions, the children in these dreams fall into two different categories. The majority of these youngsters are unprotected or the persons we are trying desperately, often futilely, to shield. Sometimes these children provide us with the ultimate image of the victim—the innocent one burnt, mutated, diseased, parentless, huddled, hungry—profoundly emblematic of the cruelty of the situation. At other times it's our incapacity to safeguard this child that shows the dream ego that it, too, is helpless. "I hold my child close and try to run away. I know it is useless so I pray for instant death." Or, writes another dreamer, "I know the pain that we would face in having to watch our children suffer, and the pain that we would experience in not being able to protect our children, the children, all of the children."

The second brood of children that are the offspring of apocalypse is considerably less common. They speak of new life coming out of the ashes, of rebirth or of life's adamancy in the face of death. "There are large cracks and from out of these cracks come children, like seeds from the earth." These figures clearly represent the birth of the divine child from the

bottom of Hades that was the fruit of initiation in the Eleusinian mysteries.

Looking at the images of the first group, we see that the specter of apocalypse that the Bomb initiated us into has in effect obliterated any illusion of being protected in this life—which is to say, it has orphaned us all. That irreducible aspect of parenting—sheltering the child from the harshness of the world—has been functionally taken away so both the child and adult partake of the same primordial helplessness. The pathetic remnants of hearth and home in nuclear dreams—curling up in a basement and waiting to die, for example—show how close the dream ego has come to recognizing its proximity to the wounded child. These dreams deliver us to the textures of the suffering we so easily disavow as we play out our fantasies of adulthood in our waking life. Becoming an adult in an era that has made parental protection unconvincing to the child's psyche is no simple matter. Nor is maintaining the fiction of one's adulthood easy when the reality of watching the world fall apart constantly reminds one that beneath one's social persona exists a frightened child. Because "adulthood" is erected in denial of the child within, it has no living, organic vibrancy. Instead, it is a survival strategy that hardens into a social persona. As the introduction to this section indicated, precisely this kind of social persona stands as a barrier to the mysteries. The reality of the wounded child leads us away from adult fantasies of control, self-sufficiency and fearlessness.

The dream of my nine-year-old informant shows something of the process of taking on the project of adulthood (and its psychic cost) in a field of horror. The fiction of adulthood that compensates for our sense of helplessness in a ruined world can easily emerge from the stark apocalyptic recognition that our parents are dead and no adult is to be found. "I had to take care of my little sister and my baby brother 'cause our Mom and Dad were dead. I was sort of their mother." The theme of one's parents being dead after the Bomb drops is almost ubiquitous among the dreams I've collected from children. This little girl dreamt the existential dilemma with poignancy and

clarity: either she creates out of nothing the persona of being the adult, or she faces the poisoned landscape with the same helplessness as her younger siblings. In the abruptness of time that characterizes the ambience of apocalypse, there is no slow ripening toward maturity. Rather, a brittle mantle of adulthood is assumed under the threat of death, and the frightened child within oneself, whether denied or acknowledged, is never far away.

The images of this next dream show a variation on this theme—here expressed in the different relationships between each of two personae of "the adult" and the persona of the helpless child:

> *One of my children is a baby girl wearing filthy tattered clothing. Her bottom is bare and smeared with diarrhea. I reach for her to take her into another room and clean her, but she pulls away from me and refuses to go. Because of the world disease that affects us all, she is "all seized up" inside and will probably never have another bowel movement anyway. Nevertheless her refusal sparks a determination in me to do what I can until the end comes.*

The self splits into two ways an adult persona can deal with the child of apocalypse. The maternal ego "does what she can" in spite of the fact that her mood is that of a person with a fatal disease who is waiting to die. Her husband, on the other hand, "has an air of aloofness from all the dirt, decay and impending death that we are living in," and he obliviously nibbles on grapes at the kitchen table. His lack of concern irritates the dream ego greatly.

The woman dreamer rightly saw that the dream's core concerns how she confronts or ignores the reality of her own suffering. She had this dream in the context of her own deep reflections on these issues. She wrote me:

> After starting to reread the Book of Job last night, and also having just read the Buddha's sermon on the Truths about

suffering, I had gone to bed with the thought that from now
on I would accept whatever my dreams gave to me as valid
descriptions of my state. If I saw myself as suffering, I would
not try to explain my suffering away the way Job's friends
tried to do with him.

Perhaps our most effective way of eluding the reality of
our own suffering is by identifying with these adult personae,
whether they be aloof or involved in the rigor of doing what
one can in an unbearable situation. We don't feel the core of
suffering because we refuse to inhabit the experience of the
bereft child. Probably the most accessible ways of descent into
the Underworld are through this child's wounds. Just as the
Bible enjoins that "a little child shall lead them," it is clear that,
given a chance, the children of the apocalypse will guide us
into the place of ash, where we must go if we are to emerge
from this nightmare. The leading edge of our vulnerability in
a very difficult time, the child understands the realities of this
era more profoundly than any other psychic persona. The
task—which is one way of making the descent itself—is to suf-
fer the range of what the child sees and feels, and thereby recon-
nect with these elemental aspects of our aliveness.

We need to ask hard questions to arrive at the door of
the house of Hades. Who is the child in me who is "all seized
up" inside from the world disease, who wanders through the
debris in tattered clothes with her bottom bare and smeared
with feces? Who is the child in me clutched tight against her
mother's panicked body as the mushroom cloud arises in the
background? How is it that I, merely five-years-old with my
parents dead, walk through the blackened air, tired and hungry,
eating the dusty grass that my big sister gives me? How has
my little body been disfigured by fire or mutated by the poison
that invisibly permeates the food and the water—even the waters
of my mother's womb? Who will hold me when I cry, now that
all the big people are dead? The questions are numerous and
essential.

The last two dreams I want to examine speak of the small cluster of children very different from the desolated children of apocalypse who invite us down into the Underworld. In some apocalyptic dreams, children embody rebirth, mystery and futurity. Just as the Eleusinian mysteries began with the violation of a child—the innocent *Kore*—so were they consummated with the birth of the divine child. These last two dreams present radiant images of this divine child, the very gift of initiation itself.

The extraordinary image of the child born from fire, death or ash recurs in mythology and shows the intimacy that exists between death and fertility, the adamancy of life with its roots nourished in the putrefying dark. In the Eleusinian mysteries, sometimes the divine child was associated with the god Dionysus, the life principle itself. If the children of apocalypse insist that we follow them into the Underworld, it is sometimes to witness this: the miraculous birth of their immortal sibling.

> *I run into my daughter and her best friend on the street. Walking toward home together, I divert them in the direction of the mushroom cloud. There is a distinct crater. left by the Bomb, and it is filled with water. We walk around the crater with a kind of awe—there is an odd sort of beauty attached to it. A mother is baptizing or drowning her baby in the water of the crater. I am aware of the intense radioactivity that must be in the area and can't resolve whether she is baptizing her infant or killing it. There is a deep sense of mystery to this, and when I awake it's extended to the choice I made to take my daughter and her friend to Ground Zero.*

This incomprehensible image of the mother "baptizing or killing" her infant in the Bomb's crater might be best elucidated by a startling parallel in the Eleusinian myth.

After the rape and abduction of her daughter, Demeter, in her grief and rage, made barren the earth and wandered forsaken in the guise of a ragged, homeless old woman. Sitting

inconsolably by a wayside well, she was greeted by four maidens carrying water who were not unlike her lost child. These daughters of the king invited Demeter into their home to be the nursemaid for their new baby brother, Demophoön. By day, Demeter took care of the child, and each night she tenderly placed him in the hearth, turning him quietly in the flames so he would become one of the immortals. One night the boy's mother, the Queen Metaneira, stumbled upon this nightly ritual and in a panic snatched him from the fire. "How foolish you are," said Demeter, revealing her divine nature in all its splendor. "For you have just deprived your son of the deathlessness of the gods."

In this dream, the dream ego diverts his daughter and her friend away from the place of refuge to Ground Zero, the epicenter of death itself. Lost in its mystery, he participates, at a distance, in the act of the Demeter figure who immerses her baby in the radioactive water. At the bottom of Hades, the question of whether this is a baptism or drowning is made irrelevant by the mystery of the act itself, for it is here that the end of life and its beginning coincide. Ground Zero, in this dream, becomes the hearth in which the Earth Mother attempts to bestow immortality on a mortal, and, far from interrupting her (as did Metaneira), the dream ego unconsciously brings himself and the little ones under his care to the threshold of offering themselves to the fire. As they are initiated into the knowledge of death and the intimation of immortality, the dream ends "with a deep sense of melancholy and acceptance."

This dream opens with the familiar panic over survival and ends with the sad tranquility common to many of the dreams I've been sent. We see here how dreams can invert the priorities of our waking lives—the dream ego makes an about-face away from our daily concerns and toward the place of initiation. Extraordinary images—like Demophoön being turned quietly in his bed of coals or of the mother immersing her baby in the waters of death and the dream ego bringing the children to the crater's edge—awaken us at once to the frailty of the

flesh in the place of death and to the immortal core that the psyche perceives in the midst of our mortality.

In passing, we should note that this dream may provide some hints of the imagery the apocalyptic psyche gathers within itself as it faces ecological crises. Freud pointed out that we cannot long tolerate our fears without localizing or personifying them. The psyche craves an image to what we fear. One way or another, we need a "Ground Zero," a Chernobyl or Love Canal to locate where we are in a world that is subtly and silently falling to pieces all around us. Likewise we need our places of initiation—the rain forest, for example, has become a mythical topography in the last few years, a place of pilgrimage where one sees the beauty and fragility of nature and the impact of human hunger that eats at its heart. After Trinity, the mushroom cloud became the inescapable "localizing" image that nailed our psyches securely within the nightmare of history. Now, it seems that other, multiple images are destined to stand alongside the insistency with which the cloud has demanded we face ourselves. But this dream also shows how easily the Bomb metaphor can overlap with concerns about ecological destruction, especially the poisoning of the earth. The effortlessness with which nuclear and ecological devastation share a single cluster of images (the Bomb, Ground Zero, the poisoned waters, the fate of children) is very common in apocalyptic dreams.

In the last dream presented above, nothing is left of the world except a flat ashen landscape. Hope also is leveled, even the hope of committing suicide—for the bathtub in which the dream ego would slit her wrists is "filled with the body of an enormous dead black woman, too heavy for me to lift, who did not leave me space to lie down upon her." If the presence of the black woman frustrates her desire to die, perhaps the black man who arrives would be kind enough to kill her. But this is not to be the case. Instead, kindness arrives in the form of the insistent demand "new life!" and the dark man who drives slowly across the ashen landscape, it is implied, is to

be the father of the new child. Instead of death, however merciful, he brings the seeds of rebirth.

"Abandon hope, all ye who enter here," read Dante at the gate of Hell. There is no descent without shedding hope, shedding even that last tattered thread of hope that, if only one could kill oneself, then one wouldn't have to face living in a desolated world. And without this descent into hopelessness, there is no rebirth symbolized by the divine child.

In *A Rap on Race*, her dialogue with James Baldwin, Margaret Mead points out that both white and black personae inhabit the land of the dead. White ghosts haunt the gullies of the Ozarks; La Llorona, the wailing woman in her ragged white gown, wanders the dry river beds of New Mexico and the back alleys of East Los Angeles seeking children to steal; and in the New Guinea highlands, the white Australians were initially mistaken for Underworld spirits, their skin being the color of bleached bones. In Egypt, however, the citizens of the netherworld were black, and among white people, blacks quite often carry the problematic image of those who inhabit the geography of death. The poetry of the blackness of Hades displays its complexity in these two black personae: the first who fills up the space in which one would kill oneself and the second who, in tenderness, will sire with one the divine child. We are initiated by seeing these two faces of Hades, his immovable coldness which allows no escape and the sweet mystery of his embrace from which new life will emerge.

Though not reducible to them, some of the themes in the early part of this chapter will be retold through different metaphors in the next five: No Refuge, Taking Refuge, Things Fall Apart, Invisible Poison and The Unnatural. These chapters articulate the difficult and necessary first step of the apocalyptic rite of initiation—the stripping away of the personae that stand between us and both our own suffering and the mysteries of our time.

FIVE

No Refuge

&xxxxxxxxxxxxxxxxxxxxxxxxxxxxxxxxxxx

I HAVE BEEN *buried alive, can hardly breathe and am digging through the dirt attempting to get to open air. Then, suddenly, I hear vast explosions above ground and realize the nuclear bomb has been dropped. I can stay underground and be suffocated to death or dig my way to earth and be burned alive by the radiation. I awake in total panic.*

I was looking across the Rio Grande Valley toward Los Alamos where nuclear weapons are designed and saw a large mushroom cloud engulfing that city. My instinctual reaction was to pack up my backpack and head for the mountains, in spite of the fact that I knew it was a futile act. But I felt driven to follow my instincts.

In the dream, the place where we lived had been nuked and I, with my family, was trying to escape. We were walking and carrying some things, but not much; and there were hundreds of other people walking, too. We were walking along a motorway—filling the whole road—all trying to escape the same way. The banks of the motorway were too high to see over, and there was no traffic, no cars. The shock came and the real horror hit home as we went to where a bridge went over the road and met hundreds of people walking in the opposite direction. There was no place to go, no refuge. It affects us all.

The night had been close with many mosquitoes. Consequently I slept poorly and had a frightful dream.
It seems I was in Tokyo after the great earthquake and

around me were decomposing bodies heaped in piles, all of whom were looking right at me. I saw an eye sitting in the palm of a girl's hand. Suddenly it turned and leaped into the sky and then came flying back toward me, so that looking up I could see a great bare eyeball, bigger than life hovering over my head, staring point-blank at me. I was powerless to move. I awakened short of breath and my heart pounding. (Rhodes, 1986:747)

If the dreamscape of apocalypse is a background, parallel world that informs our waking lives, then having no shelter is the primary existential condition of the late twentieth century. This plays itself out in a thousand ways that the psyche could easily translate into the imagery of the end of the world: being a refugee from war, poverty or political repression; vast migrations of people; the destruction of indigenous cultures; homelessness, unemployment, urban violence puncturing the sanctuary of neighborhood or home; incest, spouse or child battering, dysfunctional families, disintegrating families and divorce, etc. The psyche is sheltered and contained by culture, land, kinship network, home—a background of social reality from which it gains coherent meaning. There is no way to exaggerate the stark, raw nakedness of the apocalyptic psyche when it has lost this encompassing "home."

In the previous chapter, the dream life imaged this rawness as the unprotected "child of apocalypse" leading into the descent necessary to initiation. Whereas the way of transcendence —of ascent—usually requires moving above and away from suffering, the apocalyptic initiation requires the opposite—to move with imagination and courage more deeply into the suffering which reveals the soul. Images of "no refuge"—of which bereft children are certainly a variant—are like little doorways inviting us to descend further.

The issues of seeking refuge and/or of finding none form

the ragged boundary of the country of apocalypse. The lives of most citizens in this dreamscape are driven by these concerns. They are refugees from another place or time, where life was safe and shelter could be taken for granted. Indeed, this land has more of the atmosphere of a vast and sprawling refugee camp than an actual country. For here are no polity, no leaders, no sense of institutional protection, no viable bomb shelters and no hint that "our" bombs will protect us against "their" bombs. The refugee community is atomized, individuals or small clusters of family or friends trying to keep death at bay or waiting helplessly for it to take them. Running furiously to sink one's blistered body in the solace of the river or slogging along with hundreds of others going no one knows where —it makes little difference. The realization is the same: the time of death has descended, and there is no refuge from that fact. Here, as in the previous chapter, it is this radical lack of protection from the elemental realities of suffering which is so essential to the rite of transformation.

I think of this psychological rawness as analogous to the "salt" which alchemists claimed transforms dross into gold. Alchemical salt has a dual nature—the bitter salt of suffering (which was considered the same as the ash left over when everything was burnt away) transmutes into its pristine nature, the salt of wisdom. Because its flavor pervades everything, the salt was considered the *animus mundi* or soul of the world. "The whole secret lies in the prepared common salt," reads one treatise. *The soul of the apocalyptic world, its pervasive flavor, is carried by this multifaceted complex of refuge/no refuge.* This "soul" implicitly informs almost all of the dreams I've gathered. The children are orphaned, the ground cracks open beneath one's feet, an invisible poison permeates everything, etc. Even dreams of selfless activity are largely dreams of offering refuge or of refusing sanctuary for oneself for the sake of the broader good, while dreams of apocalyptic ecstasy concern turning one's back on shelter and walking into the fire.

Because the soul of the apocalyptic world yearns for the

place of death, the near total fragmentation of community in these dreams could image the process of disintegration that is the way of descent. Family falls apart and with it the familiar, and one goes down into the dark place alone with one's vulnerabilities and the unavoidability of facing one's deepest fears.

According to the Tibetan Book of the Dead, after death one is cast into a room in which all four doors are guarded by Herukas, the terrifying and wrathful aspects of Buddha nature. With eyebrows quivering like lightning, protruding teeth, and black serpents and dissevered human heads wreathing the body, the blood-drinking Herukas represent the utterly uncompromising quality of one's own natural wisdom. One cannot escape them because ultimately there is no refuge from oneself. "I can stay underground and be suffocated to death or dig my way to earth and be burned alive." Recognizing there is no escape from oneself is considered in Buddhism to be the prerequisite to realizing compassion and understanding. The dream at the end of the world has deposited us all in this little room to face the Herukas: "The shock came and the real horror hit home as we went to where a bridge went over the road and met hundreds of people walking in the opposite direction. There was no place to go, no refuge. It affects us all."

In the apocalyptic psyche, the Bomb has stared us down, demanding we look deep into our own troubled hearts. In these dreams, one cannot escape from the fact that one has survived to witness the desolation of the planet: this reality also stares one down. "I saw an eye sitting in the palm of a girl's hand. Suddenly it turned and leaped into the sky and then came flying back toward me, so that looking up I could see a great bare eyeball, bigger than life hovering over my head, staring point-blank at me. I was powerless to move" (Rhodes, 1986:747).

Dr. Michihiko Hachiya had this dream on 24 August 1945, almost three weeks after he suffered the end of the world when Little Boy fell on the unsuspecting citizens of Hiroshima. With extraordinary prescience, it isolates a recurrent theme hidden in many of the dreams I've gathered about nuclear apocalypse,

a theme presented in its singular image of the cold, malicious eye bearing down from up in the sky to immobilize the dreamer.

In these dreams, death rains down from above, from an alien source very much beyond the human sphere. Sometimes that source is explicitly foreign—extraterrestrial—death rays extending from a malevolent, inscrutable intelligence technologically far superior to us. (In fact, technology itself frequently appears in these dreams as something outside and above human reality and animated with dangerous inhuman qualities.) Sometimes it's an evil man or woman who lives on top of a skyscraper—intelligent, devious, nearly omniscient. Or sometimes it is the "powers that be" who, in their idiocy, have made this happen. A plane flies over and drops the Bomb, but there is no indication of "whose" plane. More commonly, the Bomb merely falls out of the sky.

Conspicuously missing in these dreams are the geopolitical fantasies of "our" bombs versus "theirs" that have so dominated our waking lives. There is only "the Bomb," it is utterly "other," and like Dr. Hachiya we have been pinned under its relentless gaze.

The dialectic of power and powerlessness tends to be articulated in nuclear dreams by the images of above and below. Whether one is cringingly anticipating the avenging Christ coming out of the heavens or is the battered child bowed under the blow of his father, this "below-ness" we inhabit has made us children of an apocalyptic era. In our helplessness, wrote one of my informants, we are "forced to live closer to the wounded earth"—which is to say that it is in our hearts' brokenness that we understand that our wounds are coextensive with the deep wounds we have inflicted on the earth itself.

As we make the transition from the Bomb's being the axis mundi of the apocalyptic psyche to more ecological concerns, it seems likely that this above-and-below dialectic of power and powerlessness will change into imagery expressing laterality, a "horizontalizing" of helplessness. Dr. Hachiya's single eye staring at us from above might, in effect, become multiple eyes

surrounding us. In ancient Greek culture, if one wounded the earth, one would be surrounded and tormented by the Furies who avenged the violation of the Mother. Perhaps now the Furies are gathering around us again in the form of multifarious ecological catastrophes.

If I am correct about this, then this "horizontalizing" of the psyche might be the first step in remembering that the world has a soul. Meeting the accusing eyes of the Furies could be the first harsh, but necessary, lesson in learning to live peaceably with that soul. Nature then would not only be something we "look at" but also a presence that observes us and, by surrounding us, teaches us the true dimensions of an ecological niche within which our species can thrive.

James Hillman writes:

> I refer to the African experience described by Buxton: "For the Mandari night and darkness have strong emotional overtones. . . . darkness is not disturbing simply because something may be lurking in the dark, but because the darkness itself is felt to be lurking—it 'looks' at us." And the Navaho chant: "I am ashamed before earth;/I am ashamed before heavens;/I am ashamed before dawn. . . . these things are always looking at me./I am never out of their sight." (Hillman, 1986:52)

Indigenous societies have often relied, in this fashion, on nature to be a "superego" teaching the necessity of living within limitations, the grace in doing so and the painful consequences of transgressing. The apocalyptic rite of passage could potentially lead us to rely on nature in this manner also.

SIX

Taking Refuge

❧❧❧❧❧❧❧❧❧❧❧❧❧❧❧❧❧❧❧❧❧❧

LIVING UNDER THE *threat of immediate nuclear war. As the danger heightens, the populace throws caution to the winds and lives on its final earthly moments. Like a porcupine arching its back in self-defense, countries bristle, missiles aimed. There is horror; there is protest; there's indifference. I watch a softball game. The distance from pitcher's mound to home plate is several hundred feet, but nothing matters. I'm pissed at a woman who believes that after four hours following attack we survivors will be safe. I shout, "But the air, the water, the earth will be ruined! Come out of your shell."*

In cars, on foot, in busses, people flock to a large shopping mall. There's a serious threat of nuclear war. Whole families are off on a spree. Their actions are aggressive, tense; the money flows. Their big worry is the missiles. One guy, a reporter maybe, approaches me and asks: "In one word, how would you describe what's happening here?" I answer, "Dread." We're standing near an exit to a parking lot. A parachute is angling downward toward the mall. I add, "I don't like the looks of that."

I saw a vast gray mountain of appliances at a great distance. As I got closer, I could see that there were stereos, refrigerators, televisions and PC's wedged into the mass. Getting closer still, I could see movement: wisps of smoke rising, men and women in raggy clothes scrambled up and down, hauling boxes and trading from other spots. The mountain was honeycombed with caves in which these people lived. Furthermore, it was evident that these creatures had amassed certain types

*of products around their own particular cave. One had a con-
centration of radios, another of stoves, some new, some in
stages of disrepair. It was obvious from watching that they were
continually trading these things with each other, a kind of
pointless, endless bartering which only served to keep the junk
in eternal circulation. It was a smoking dump, almost worse
than apocalypse.*

*In a tropical paradise, the beautiful women are everywhere.
Suddenly we learn that the earth is under fire, atomic bombs
exploding. We escape the fires and learn that the exchange was
"limited." People rejoice as if only they mattered. Everyone
wants to stay in this tropical paradise. They can live forever.
Ultimate depression.*

*I know that a nuclear war is about to start, but when I
tell others, no one believes me. Only Carolyn (a very over-
weight, probably retarded, helpless, emotionally demanding
eighteen-year-old girl assigned to my room on a kibbutz when
I was twenty-one), hysterical with fear, believes also in the im-
pending catastrophe. I choose to hide away in a fallout shelter,
which is like a large laundry room underground; layers and
layers of clothes will be my protection against the radiation.
Carolyn cowers in the underground room with me, while
everyone else wanders around outside. I am aware that if a
nuclear bomb drops and everyone above ground is killed, I
will be trapped alone for the rest of my life with Carolyn—my
shadow figure, whose presence I can't tolerate.*

*Suddenly there is a blinding flash of light. The Bomb
drops. Covering my eyes with sheets, I attempt to block out
the blinding glare and save my eyes.*

*Then I am alone in the underground room, in a room I
have created next to the original room. I have chosen to be
alone, seeking protection in my own underground shelter, rather
than be alone for the rest of my life with Carolyn.*

Because seeking refuge in an apocalyptic era is the flip-side of recognizing that, ultimately, no refuge exists, this chapter is in many ways continuous with the previous one. These dreams also mirror that contemporary existential condition of having no shelter—but from a different angle.

In the "developed" world, much of what has become the fabric of post-traditional, consumerist society can be read for its subtext as a desperate scrambling to protect the naked psyche. From this perspective, there is a common root to taking refuge in drugs or alcohol, say, with taking refuge in the fundamentalist mind-set where religious, political or ideological absolutes cocoon one from the uncertainty of living in this era. Chapter four showed how the frightened child within us precariously burrows in a precociously constructed adult persona. For many people, workaholism provides shelter, while for others it might be the passions of consumption and accumulation or the mindless migration from distraction to distraction as entertainment is elevated to the reason for being.

Moving toward the apocalyptic mysteries is moving out of this sprawling opium dream to face the realities of these times and what they demand of us. As James Baldwin wrote, "Being alive is learning to make love with what you most fear"—an alternative to the disintegrating collective strategies of taking refuge where none exists.

"We're not sure who the enemy is," dreamt one of my informants. "There is no one, nothing to confront except the fear and horror of removal from the land, of losing homes and children. We are running through the barren hills, taking shelter in the ruins, feeling missiles launched from within, exploding there. . . ."

For those few souls in the fragmented community of apocalypse who have not completely surrendered hope, the issue of finding refuge is a complex matter. To each, his or her own refuge seems to be the basic rule of the game. By and large, however, these shelters fall into a few predictable categories—delusional, provisional, complacent or a form of imprisonment into the indefinable future.

For those who have given up hope, refuge is a much simpler matter, and always provisional. The overweening concern is to find a decent place to pray for death or to await it quietly or with dread.

"The mountain was honeycombed with caves in which these people lived. Furthermore, it was evident that these creatures had amassed certain types of products around their own particular cave. One had a concentration of radios, another of stoves, some new, some in stages of disrepair." This honeycombed mountain images the architecture of the urban world in the country of apocalypse. "In cars, on foot, in busses, people flock to a large shopping mall. There's a serious threat of nuclear war. Whole families are off on a spree." In these first two dreams, the dream personae that the ego watches with horror seem to find relief from their fear by encrusting themselves in the blind hunger to consume or in the dull, rote habit of accumulation.

The honeycombed mountain presents its meaningless cohesiveness, its own strange *communitas*. "They were continually trading these things with each other, a kind of pointless, endless bartering which only served to keep the junk in eternal circulation." Consumer goods are the only remaining sacrament of this community, the only evident connection the residents have with one another. One can always leave one's cloister to barter for something to embellish or fortify it. In the urban sprawl of the country of apocalypse, this sacrament of exchange serves as an important principle or logos keeping at bay the danger that lurks outside.

In most apocalyptic dreams, even this perverse coherence of life doesn't exist. If the true conviviality of friends and kin is the means through which we contain each other's process of ripening, then the extreme individualism displayed in scrambling for refuge shows how thoroughly shattered that vessel is now. From the point of view of Kabbalah, the weaving to-

gether of the world—and thus also of community—from its fragmented, fallen state is the primary work of one's waking life. So highly is this regarded that it is considered the essential labor of preparing the ground for the coming of the Messiah.

But if weaving together the world is the rightful priority of our *waking* lives, the primary way of the apocalyptic initiation strikes off in the opposite direction toward an unraveling of our world and our sense of place within it for the sake of radical renewal. Dream images of the disintegration of community serve well the task of meeting death. This pulling away from life, from the environment that one exists in, from the "exterior world" into the interior, is imaged in countless ways in apocalyptic dreaming. When we look at these dreams, we can trace a long path from being lost in the "exterior world" to finding "refuge" in the interior world where we are initiated.

On the *most* exterior level, the impulse toward shelter can be seen in dream images of hiding out in one's own cravings or in what one has accumulated. In other dreams, one seeks islands or the place of "elsewhere," the far country where the apocalypse hasn't reached. "The mountains form a bowl, and I think that one might be safe there." "Radiation levels were reportedly lower in the Mediterranean." This dream place of "elsewhere," where the grass is greener, tends to be a no-man's land of complacency, remote from both Thanatos and Eros: "Everyone wants to stay in this tropical paradise. They can live forever. Ultimate depression," as one dreamer put it. Enwombed away from the landscapes of poison, the dream ego feels isolated also from anything real.

The place of "elsewhere" is always in the "outside world"— be it the shopping mall or an island off Australia. The dream images of refuge that acknowledge the pull of Thanatos, however, tend toward "the interior" where the fantasy of living forever cannot be indulged. "I stay in the shadow to protect myself." "We had to make a shelter for ourselves out of wood from the ruined houses." "When we got far away from the city,

we dug another hole in the ground so we could get air." These dreams exist on the other end of the continuum from dreams of "elsewhereness." Here, the apocalypse is immediately present, nailing our psyches to the spot, leaving no room for avoidance.

If one arranges the places of refuge in a spectrum from "elsewhere" to the dark interior, certainly the darkest is the hole in the ground, the cellar or the bomb shelter. Usually in these sanctums one hasn't come to elude death so much as to postpone it and eventually rendezvous with it—and if not with it, then with the unbearable realities of who one is.

Cloister, prison cell, tomb or harsh womb of gestation— these pits of refuge can be seen as analogous to the vision pit in some hunter/gatherer societies. Among the Lakota Sioux, for example, after a suitable rite of purification, an adolescent boy or a medicine man enters into the vision pit where, for four days, he sits without food or water. After the extremity of facing himself and the gods, he brings back to the tribe his vision, both the source of his personal power and a gift to his people. In the psychic territory of the apocalypse, the bomb shelter may be equivalent to a vision pit in which we are empowered facing what we most fear.

Of this dark place in which we claim our interior life, James Hillman writes that it is "hidden, as contained within (interior) or as contained below (inferior), where the Latin *cella* ('subterranean storeroom') is cognate with the Old Irish *ceile* ('cellar') and *cel* ('death'), again cognate with our *hell*" (Hillman, 1979:29). Hel, Queen of the Underworld, the Norse equivalent to Persephone, had her name appropriated to denote the place of damnation in Christian mythology. In Old Teutonic, Hel means literally "the coverer up or hider." Like Hades, the womb of Hel was a place of descent, death, purgation and rebirth. Covering up or hiding ourselves in the bomb shelter or the dark cellar, or the drawing in to the interiority of our shadows—in alchemy the *prima materia* of one's own confusions is sealed into the hermetic vessel until the process of transmutation is

complete. If we think of the bomb shelter as an apt symbol of our interior space in the country of apocalypse, then this last dream is remarkably blunt about our required submission to the challenge of initiation.

"Carolyn cowers in the underground room with me, while everyone else wanders around outside. I am aware that if a nuclear bomb drops and everyone above ground is killed, I will be trapped alone for the rest of my life with Carolyn—my shadow figure, whose presence I can't tolerate." The ego and its shadow are such distinct and incompatible personalities here, and yet they are forced to live trapped underground together "for the rest of my life." The dream ego comes across as foresighted, competent, efficient, protective of her own boundaries, while her bête noir is helpless, probably retarded and hysterical with fear. The way of initiation now requires a deep look into the "otherness" within us and learning to live peaceably with it. After the Bomb drops, the dreamer makes an elemental choice of self-preservation—rather than be dragged down by the neediness of her alter ego, she hollows out a parallel room in this underground prison.

This decision is the fulcrum upon which the rite of initiation depends in our day-to-day lives: Do we take refuge *from* our shadow, or do we take refuge *with* our shadow? One of the reasons the Bomb has provided such a profound opportunity for realizing wisdom is that it awakens and enlivens these shadowy aspects of our nature and challenges us to face them. This otherness within ourselves, these invisible companions of our waking lives, displays facets of our wholeness that are sometimes disturbing. In the land of apocalypse, shadows loom large, sometimes considerably larger than who we imagine ourselves to be. Though it is possible to run from one transient refuge to another, it is also exhausting and makes for a meaningless existence. Sooner or later, one has to face oneself, and the mushroom cloud just beyond the horizon has given one an incentive to do so.

The bomb shelter emblematizes in these dreams the in-

escapability of death. Within its four small walls, the mystery of finitude itself is realized—and, along with it, the preciousness of life. One question that faces us now is how the psyche will localize the place of initiation in response to ecological crises. Where, now, in our dreams and in our waking life will we face ourselves as fiercely as the bomb shelter insisted we do? To what small circle will the Furies confine us until we come to terms with our hunger and our fear?

Circling back to the dream that begins this chapter, one sees the perfect fusion of nuclear and ecological holocaust in the imagination and the dilemmas both pose regarding taking refuge, refusing to take shelter, complacency and waking up: "Living under the threat of immediate nuclear war. . . . I shout, 'But the air, the water, the earth will be ruined! Come out of your shell.' " In this chapter, we see how the craving of the soul to be initiated to face the exigencies of living in an apocalyptic era can be anesthetized by a death-denying culture. If my speculations in the previous chapter about the "horizontalizing" of the psyche are correct, then maybe I can speculate further that nature or the natural world or the wilderness or the desert might come to replace the bomb shelter as the imaginal ground of apocalyptic initiation. This would require relinquishing our image of nature as a romantic idyll—an "escape" —and instead meeting her suffering, harshness, tenderness and beauty through the raw and uncompromised encounter with one's own difficult self.

SEVEN

Things Fall Apart

❦❦❦❦❦❦❦❦❦❦❦❦❦❦

WE'RE IN A *place like Central Park. The family's there, baby, too. The boy has taken on the features of a newborn chicken. No one seems to care though. Something else is going on. The ground's erupting, swelling with volcanic rumbles. There is a large, dark, bristling boil in the ground. Folks aren't overly concerned, however. It's a new volcano maybe, something for the six o'clock news. We gather what we have and move, but another similar eruption is occurring at the other end of the park. Confusion, fear and wishes to remain stationary now grip the people. There is a fascination with this motion of the earth, but with a baby, we're concerned. Family members scramble, lose themselves in the mob. I grab the "chick," find a woman who is willing to express her concerns; other places in the world were now reporting the eruptions, too. Eruptions here were growing louder—they were not from underground bombs but from the earth itself. Were they the result of "chance" or from something we had done in our relentless persecution of the earth's diversity? We ran for the car, drove homeward, but eruptions were becoming commonplace. Lights were fading; traffic jams occurred; the air was fouled with new debris and smoke; the drive became impossible; the baby cried. . . .*

D. and I are standing on an open concrete porch with other people. The sea is green and beautiful. I am about to remark on how calm the sea is when suddenly it gets rough. Waves roll in, frightening us, but we recover. When I look again, I see a monstrous wave threatening to engulf us. I hope D. doesn't try to save me. We can both swim. It would be silly to hold on to each other because then we would drown.

Miraculously the wave doesn't kill us, but the world has been thrown into a panic. Other things are happening. The streets suddenly begin to slide swiftly in different directions. At the crack where they meet, they simply disappear or swallow themselves up, so that everything remains level. On the broad, cleared street (which reminds me of Oxford Street in London), a caravan speeds by. It includes a limousine of worried look-ing government officials. I know where they are going and I ridicule them. They think that by passing a few laws, they can stop this destruction, but it is too late. I start to call after them, "You should tell everybody they have to pray! The people of the world have to repent!" But I stop myself because, especially using the word "repent," I will sound ridiculous.

I'm visiting the friend of a gay man I know in a hospital in Florence, Italy. He is a Catholic priest dying of AIDS. My friend tells me before I meet the priest that his nose and mouth are rotten, so that I won't react with shock when I see him. I assure him that these things don't disturb me as I am a nurse—but inwardly I am uncertain.

I tell the priest a dream about ecological disaster; and, as I do, I look out the window at Florence and see the cathedral in the center crumbling and the town itself falling to pieces into little islands and clumps of trees that scatter with the wind over the water.

I climb up a rock escarpment and find refuge there. My cousins have also found higher ground nearby.

As I fall asleep, I have visions of great confusion. Streaks of light, straight, curved or zigzagging appear, and then there are fireballs which form as they coalesce. The fireball is gen-erally reddish with a blue nucleus and seems to turn while burn-ing with varying degrees of intensity. There is no explosion, although there is, at times, a large expansion followed by shrinkage and return to the initial size.

What follows is at once a different state of consciousness. The fireball is still turning with its blue gas-like center, but

I am conscious of what is beyond it. I do not have to visualize it. I simply have a sense of certainty that I am in Chaos.

Chaos is a turbulent flow causing incessant change, but also producing vortexes, networks of vortexes, which are forms with an impermanent type of order. I know this, I feel it. These forms also develop their own time—a time for each collective and individual form. There is a unity between myself as individual form with the collective form of humanity and the Chaos from which we emerged. Even the vortexes will disappear to reappear again, larger, smaller, similar or different.

In my dream, I also become aware that there is nothing boundless in this turbulent flow. It is a plenum. It is all there is, boundless only in the sense that it is the totality. There is nothing evolutionary and open-ended here.

Yet I do not see Chaos; I see only the fireball with the blue nucleus. Will it explode or not explode? It matters not. Even the fireball is part of Chaos and will disappear. Perhaps only to reappear, perhaps never to reappear.

The fireball is fixed yet moving, staring at me like an eye. I do not register any emotion. There is no merit or demerit to this thing. There is no merit or demerit for me or any other form. There is no merit or demerit for Chaos either. What I register is only form. I cannot register Chaos through my senses. I am aware and conscious of it. But I am not able to visualize it. I feel neither regret nor joy. Everything is as it has to be. Everything was as it had to be. I have nothing to regret. No forgiveness to be sought. Where a tree falls, there it shall lie.

I am not a fatalist. There is nothing preordained, predestined in all of this. How could there be predestination in Chaos? Chaos has no plan.

I now become aware that I am a slave of Chaos who is my creator. And this is the end of my dream.

If we have no refuge from the fierce gaze of the Bomb staring down at us from the sky, neither is there any refuge from

the erupting earth. As in the old Chaos myths, the sky god's aim is true, his weapons piercing and his sharp eye omnipresent. The beast that lives under the earth has an entirely different nature, and in these dreams its presence is experienced as eruptive and chaotic. Far from piercing in its intelligence, the beast undermines our lives in a generalized, sometimes volcanic, disintegrative way. The country of apocalypse is terrified of what is above and what is below. Its citizens can no longer exist peaceably on the surface of things or complacently survey the horizon, for the ground they stand on is untrustworthy and who knows what might come from the sky.

These dreams show how our world—the cohesion we've attributed to the world—falls to pieces in the presence of the unimaginable. The reality of the Bomb has been like a chemical catalyst that sets into motion the process of disintegration. Whether or not we dare acknowledge this decaying of our environment in our waking lives, our dream lives see it vividly.

The world cracks open and everything we've taken for granted, beginning with the ground under our feet, crumbles beneath us. "Big craters open up across the neighborhood," dreamt a seven-year-old girl. And a boy, three years older, dreamt, "The first floor of the building collapsed and all the people fell down the hole"—as if the earth itself intends to swallow us alive.

The earth cracks open to drag us down into its dark interior, as Hades abducted the *Kore*, or it cracks open like an egg so the unimaginable can emerge. "So much heat had been generated deep down into the earth from the atomic bomb explosions that earthquakes forced long dormant dinosaur eggs to the surface, where they hatched." "Somehow the Bomb and AIDS are related: the disease apparently erupts from under the earth." Cross-culturally the domain "under the earth" belongs to the god of death. It is not surprising that the psyche has often spontaneously made it both the home of the Bomb and the locus of ecological disintegration.

Over and over, these dreams express the intimate connec-

tion between facing the unimaginable (or of trying not to face it) and the world's falling to pieces. The unimaginable presents itself in particulars, and attempting to relate to those particulars provokes the world's loss of cohesion.

The dream ego visits a Catholic priest dying of AIDS. "My friend tells me before I meet the priest that his nose and mouth are rotten, so that I won't react with shock when I see him. I assure him that these things don't disturb me as I am a nurse—but inwardly I am uncertain." While telling the priest a dream about nuclear holocaust, the dream ego looks out the window to see in the far distance the cathedral crumbling and around it the city of Florence, until nothing is left but "little islands and clumps of trees that scatter with the wind over the water."

Here, the dreamer—a self-described "fallen Catholic"—moves from one image of crumbling inward to another. The priest's rotting face becomes analogous with the dream ego's fragile attempt to "put on a good face" in spite of her inward uncertainty—which in turn seems analogous to the city's collapsing around its sacred center when she mentions her dream of environmental catastrophe. The recognition of apocalypse begins with looking into the face of what is falling apart and finding it unbearable; in the event, the old world—which for this dreamer was constellated by her relationship to the Church —comes to an end. In this dream, environmental destruction and AIDS are metaphors that collaborate to dissolve a world that is ripe for death.

For the pilgrim wandering through the landscape of apocalypse, it is by no means a simple matter to preserve the ego's sense of what is normal or natural. Bertolt Brecht knew well from his experience of living in Nazi Germany that the project of preserving the fiction of normality in an apocalyptic time is itself the opium of the masses. Brecht writes:

> We particularly ask you,
> when a thing continually occurs—not on that account to

> find it natural
> let nothing be called natural
> In an age of bloody confusion
>
> (Quoted in Taussig, 1987:466)

The geopolitical "realism" behind the development of new weapons systems and the continuous accumulation of nuclear devices and the economic "realism" behind the desolation of this planet's ecology are two ways we "naturalize" what is, in fact, a relentless assault on the natural. What "continually occurs" in the country of apocalypse—in our "natural" habitat—is far from natural; and as long as we drift innocently on the surface of things, like the uninitiated *Kore* picking narcissus in the Nyassan Meadows, it is almost inevitable that sooner or later the bottom will fall out and our innocence will be raped.

More than anything, these dreams concern the falling apart of our defenses against connecting with what's really happening. "The family's there, baby, too. The boy has taken on the features of a newborn chicken. No one seems to care though. Something else is going on. The ground's erupting, swelling with volcanic rumbles. There is a large, dark, bristling boil in the ground. Folks aren't overly concerned, however. It's a new volcano maybe, something for the six o'clock news."

The monstrous particular, the dream ego's little boy who is a mutant, is made "familiar," just one of the family, and a volcano emerging in the middle of a family outing is, initially, also incorporated into the known—"something for the six o'clock news." But it is when the incomprehensible reaches critical mass and can no longer be normalized that all hell breaks loose. The moment that the dream ego recognizes what is happening is the moment that the familiar is engulfed by the reality of apocalypse.

Alchemy is regarded as an *opus contra naturam*, a rigorous movement against nature, like a salmon swimming upstream to spawn and die, or a descent into that dark realm of the imagination which fertilizes the roots of nature from underneath.

In Greek myth, the natural and unnatural worlds, the abode of the living and the realm of the dead, have an intimate symbiotic relationship. Not uncommon in these dreams, however, is recognition of our perverse literalization of this *opus contra naturam*—the mindless violation of nature that is pinpointed as the reason things are falling apart. The dream ego asks himself, "Were the eruptions the result of 'chance' or from something we had done in our relentless persecution of the earth's diversity?" In other dreams, there is no doubt about human complicity. "They think that by passing a few laws, they can stop this destruction, but it is too late. I start to call after them, 'You should tell everybody they have to pray! The people of the world have to repent!' " Because the sanctity of the earth has been violated, "things fall apart." She herself is the innocent *Kore* dragged, not into the Underworld, but into Hell, for it was not Hades that raped her but ourselves.

The last dream of Chaos considered here is in a category of its own. Here the mysterious festival of lights hidden in the heart of the drama of things-falling-apart is entered into fully. The dreamer, an old man and philosopher who lives just west of the Trinity site, writes of a transformation of his apocalyptic dreams that other informants have mentioned. "I remember in earlier years of having had nuclear dreams where everyone perished and I felt an incredible sadness. Now, however, my nuclear dreams are not frightful, but have a certain grand majestic quality. They are recurrent and, to a certain extent, satisfying." Having descended repeatedly into the personal Underworld in an apocalyptic era, this man has been blessed to witness the birth of light out of darkness which was the consummation of the Eleusinian rites.

Neither the demonized beast nor its primal antagonist exists in this vision, for chaos and logos are completely reconciled in the play of light. Redemption or refuge is not "elsewhere": there is nothing to run from nor anywhere to run to, for the dreamer exists within the totality of all that is. But this totality is not monolithic, unlike the world-encompassing Beast

and Messiah (and the Bomb itself), swollen by our fears and hopes into enormous beings in whose presence we are helpless. Instead, the inside of the fireball is a complex ecology of "incessant change" producing vortexes, networks of vortexes and individual forms which "develop their own time." Like the Buddhist jeweled net of Indra, everything in its transience is organically held within emptiness, pristine both in its changing individuality and in the flux of its relatedness with everything else that is. This fireball, in other words, is an image of a living, breathing universe.

In describing the fireball, this dreamer recapitulates the image of the "great bare eyeball, bigger than life, hovering over my head, staring point blank at me" that figured in Dr. Hachiya's post-Hiroshima dream. "The fireball is fixed yet moving, staring at me like an eye." It is obviously the same eye in both dreams—fixed, implacable, demanding that one return the gaze. But it's also utterly different. In Dr. Hachiya's case, the glare of the Heruka pinned him to his powerlessness in the ruins of his shattered city, whereas in this dream, the eye of the Heruka shares the same fierce and unshakable tranquility of the dream ego himself. I believe Meister Eckhart wrote something like, "The Eye in which one is beheld is the same eye through which one sees." Looking at the fireball without hope or fear, the dreamer sees that even it has a Buddha nature and that it is consubstantial with his own: "I now become aware that I am a slave of Chaos who is my creator."

This metaphor of "things falling apart" is the most salient theme bridging our fantasies of nuclear and ecological apocalypse in the dreams I've collected. I suspect that the themes of "invisible poison" and "the unnatural" (which are explored in the next two chapters) will eventually prove to be equally important as our dreams begin yielding a refined realm of imagery in response to our ravaging of the earth. At this juncture, we can predict an intimate interbraiding of themes as the nuclear idiom translates into an idiom of ecological apocalypse. In this chapter, for example, the realm of the unnatural and

the disintegration of our sense of "reality" imply one another just as the next chapter shows how living in a poisoned world necessarily evokes the previously treated theme of "no refuge."

This mutual implication of themes that span both nuclear and ecological concerns suggests that apocalypse is a single psychological gestalt—a complex—that is apt to transform its shape (but not its essential nature) in response to historical changes. These chapters show that the psyche has interpreted the presence of the Bomb as a specifically ecological catastrophe and that nuclear dreams provide us with a unique window through which we can see the direction the psyche is taking in its attempts to come to terms with the suffering of nature in the post-Cold War era.

Invisible Poison

∿∿∿∿∿∿∿∿∿∿∿∿∿∿∿∿∿∿∿∿∿∿∿∿

MY HOUSEMATES ARE *gathered together and I realize something is wrong. The Bomb has fallen in Canada. It's true. In about half a minute, the radio says, the effects will be here.*

I go into my large sunny room. It has little, if any, furniture, but is filled with clear light which enters from the windows halfway up the wall on three sides. Then I decide to wait with everyone else in the darkened hallway. We wait for some kind of sign, an earthquake, a tremor, but then we realize that we'll feel, see nothing as the radiation blows our way. I suggest that the small high window at the roof edge be closed as I look for a large jar to fill with water. "The search for food and water will be the worst," my housemate says. I try to imagine what will occur when we have to ration what we have together.

Perhaps it was an accident, the dropping of the Bomb, but the deadly invisible blast has arrived here nonetheless. They don't yet know about this on the East Coast.

We were in a farm house on an island—perhaps among the San Juan Islands near Seattle. A group of us were having dinner at a long rectangular table. I was sitting across a big picture window when all of a sudden I looked up from my plate and saw this huge mushroom cloud rising up like a tree. I thought, No, that can't be. It was in the distance. I showed it to the other people at the table. Most of the other people on the island had seen it, but we hadn't because we were inside.

We sat around awhile, and then I thought we'd better get some provisions together. Most of the people had left the island. We went into a deserted meat market and started helping our-

selves to an assortment that would last awhile. I wondered if the food was irradiated—but then thought, Well, what can I do?

Some friends (who had been in Europe when Chernobyl happened) had left immediately for Phoenix when the Bomb dropped. My image of Phoenix in this dream was a garden spot. When I awoke, I recognized the pun—Phoenix being the bird that rises from the ashes. There was a distinction between where I was as a place of death and Phoenix as a place of rebirth. My feeling was, well, this is it—a kind of grave but tranquil acceptance. I chose to stay on the island and face the inevitability of dying. My friends had escaped.

Austria. A family vacation. Arrived and rented a house, put the kid down for a nap and went to a bar. Spoke with English-speaking residents. I was quite concerned about Chernobyl radiation levels.

"We get differing, inconclusive reports."

"Well, we've got about as much as you get in your Catskills."

"Radiation: the great leveler."

No escape, but still I knew that levels were reportedly lower in the Mediterranean. Hey! The Alps are beautiful but Greece is on the phone. . . .

The country of apocalypse is a poisoned landscape. The odorless odor of death pervades everything. If the refuge/no refuge complex is the soul of the apocalyptic world, it is chemical toxins and the radioactive isotopes that form the salty precipitate of that soul. Invisible but not translucent, they cast the pall of the knowledge of death over the entire country. Its invisible nature, its insidiousness and its tendency to permeate into all the nooks and crannies of our existence make this poison the universal solvent that dissolves the boundary between our day-to-day lives and the land of the dead.

Although I introduce this chapter with specifically nuclear dreams, this pervasive sense of living in a poisoned world will long outlive the Cold War. The spurious, self-defeating security the Bomb offered us these past few decades will be paid for by the caretaking of massive quantities of nuclear waste for tens of thousands of years. The development of nuclear energy as "clean, safe fuel" continues apace even after Chernobyl. The Environmental Protection Agency estimates that, whereas in 1973 the annual toxic waste production in the United States rounded out to about 100 pounds per citizen, in 1989 the estimated output had increased to 50,000 pounds for every man, woman and child in the country—our environment is over five hundred times more poisonous than it was in the early seventies. This "invisible poison" that our psyches perceive, then, is the natural ambience of apocalyptic reality in both its nuclear and its post-nuclear dimensions.

In Greek mythology, the god Hades embodied this motif of the invisible presence of death. When he comes up to our daylight world wearing the helmet given to him by Hermes, none can see him though many feel his presence. James Hillman writes, "the invisible connection is Hades" and "the essential 'what' that holds things in their form is the secret of their death." Hades is the black background from which things emerge and to which they return; our intimations of his presence, says Hillman, "form a definite image of a void, an interiority or depth that is unknown but nameable, there and felt if not seen. Hades is not an absence but an invisible presence . . ." (Hillman, 1979:27, 28). In the land of apocalypse, this presence of death that accompanies us everywhere is imaged as the invisible poison from which no one, ultimately, can escape. Plutonium is the sacrament of Hades (Pluto) that draws us down into his domain, the undertow of depth that draws us away from the outside world toward those small, enclosed spaces where we are overwhelmed by our own mortality.

Strange synchronicities surrounded Pluto and plutonium in the thirties and forties. In 1930, near the eve of the plutonic

madness that overtook Germany, the twenty-three-year-old amateur astronomer Clyde Tombaugh discovered the planet Pluto. Not until August of 1942 did Glenn Seaborg and his chemists first transmute a microgram of uranium 238 into a microscopic pink flake of the ninety-fourth element. Just as uranium was named in 1789 after the recently discovered planet of Uranus (the Greek father of the starry night), so was this new element named after the recently discovered Pluto. A few months later in Basil, Switzerland, the chemist Albert Hoffman, working with synthetic compounds potentially useful for women in childbirth, accidentally ingested one—LSD 25—and thereby rediscovered the sacrament that, in the form of the hallucinogenic rye mold, ergot, had been used in the Eleusinian mysteries two thousand years earlier. If one looks at those facts as coherent clusters of synchronicity such as one finds in a dream, Pluto/Hades evidently is doing everything he can to get our attention. A few micrograms of LSD or a microscopic flake of plutonium—in either case we are led down toward the mysteries.

In apocalyptic dreams, this invisible poison that plutonium has so perfectly exemplified is the final defeat of the ego's positivisms, its fantasies of triumphing over death. Death has become the very air we breathe.

"It's weird; I can't see it or feel it, but I'm in a death field of radiation." "I worked not knowing when I myself will succumb—aware that I wouldn't even know when I was taken by other realms because the hallucinations are utterly real." This phenomenon of "not knowing" is the crucial quality of the invisible poison that makes it so effective as a universal solvent. It dissolves not only positivism and heroic posturing, but also the capacity to imagine what is going on. Imagination itself is rendered helpless, not because it is shattered (as it can be by witnessing the mushroom cloud) but because it is liquidated by uncertainty. "Rain drops are sprinkling through the screen window, and I crank it shut wondering if it's already acid rain." "We wait for some kind of a sign, an earthquake or tremor,

but then I realize we'll feel, see nothing as the radiation blows our way."

Is this food poisoned or edible? Is this truly a refuge or should we go elsewhere? Will we live or have we already joined the community of the dying? These questions are unanswerable, and the instinctive response to this existential uncertainty is to board up the windows and curl up "with everyone else in the darkened hallway."

Windows, in fact, have a prominent place in apocalyptic dreams. "I was sitting across a big picture window when all of a sudden I looked up from my plate and saw this huge mushroom cloud rising up like a tree." Quite often, the mushroom cloud or the field of devastation is "framed" by our domestic situation in this fashion. But if one were to wander the streets after the Bomb dropped, one would notice of many of the remaining houses that the windows are boarded up. It's as if the soul believes not only that the invisible poison has infected the air, but also that light itself has become lethal. Refuge, then, is most essentially refuge from the light.

As reflections of the issues of our waking lives, these dreams pose some very hard questions, for our daily lives transpire in that light which our apocalyptic souls know to be poisoned. Living in the light, yearning for the light, finding one's place under the sun—these are important and honorable concerns of waking consciousness. In what way, in our day-to-day lives, do we live with the quiet dread that we are being poisoned invisibly—at work, at home, in our families, among friends? How have we shut ourselves off from the outside world in a futile attempt to protect ourselves? Many dreams about the invisible poison display these pivotal issues in a stark choice: do I stay with the familiar and gravely accept my death by slow poisoning, or do I depart for the unfamiliar and live? "There was a distinction between where I was as a place of death and Phoenix as a place of rebirth. . . . I chose to stay on the island and face the inevitability of dying." "Hey! The Alps are beautiful but Greece is on the phone."

While it is essential that we choose life day to day—as difficult as it is now to live fully in the world's ruins—the way of initiation presented in these dreams carries us in the opposite direction. Indeed, in the final analysis, choosing to live life fully may now require the initiation of entering and returning from the wilderness of death.

One last theme on the dreams of invisible poison is that of hoarding food and water. In pure form these are in very short supply, and, of course, exactly how untainted they are is indeterminable. The principle of scarcity and rationing dominates the psyche. " 'The search for food and water will be the worst,' my housemate says. I try to imagine what will occur when we have to ration what we have together."

The specter of eventual hunger and thirst looms large—or the difficult choice to eat and drink what is defiled, to take death itself into one's body. "I wondered if the food was irradiated—but then thought, *Well, what can I do?*" To say that the invisible poison infiltrates everything implies also that, in the country of apocalypse, what one takes sustenance from or what one refuses to take in involves matters of life and death.

And yet in an impure world, these issues are rarely so clear-cut. What serves "death" can also serve depth—and thereby serve life—like Persephone accepting pomegranate wine from the Lord of Death and being impregnated with the ecstatic principle of life. There is tremendous vitality in being mortal—in knowing death, as Castaneda's Don Juan says, as the constant companion who is always just behind one's left shoulder. In a land pervaded by the invisible poison, what is truly toxic is not that which makes one intimate with death, but rather that which numbs one from a vital connection with life and death. The irony is that, by reminding us of the omnipresence of death, the poisoned landscape can keep us awake to the preciousness of being alive.

NINE

The Unnatural

AFTER THE BOMB *I am not killed, but radiation has caused mutations to form in the sea. I am astounded by the hordes of fish in the water, and suddenly I see dogs swimming underwater. They are able to breathe in the water. I realize they are starving, and I throw mosquito larvae (which are in the air) into the water to feed them. They eat ravenously. I have been trying to tell someone that something is wrong, but I am afraid that by saying the words, my mind will be broken into pieces like concrete.*

I am fishing off a wharf. Reeling in a "daredevil" lure, I hook a large one. It peels the line off my reel, but I fight it, pump and haul, eventually making progress despite a car hood protruding from the water, temporarily snagging the line. The fish turns out to be a large, gray creature with sad, staring eyes. Its body, like a big stuffed carnival toy, is humped in the fashion of a camel. I think, Kill it, knock it out of its pain, *but the hooked mouth is not the mouth of a fish or any creature I have known. Somehow, as a human being, I feel responsible for what is surely a wretched mutation. I release the "fish."*

Late afternoon on the couch in the family room of my old house. Several of us are there, apparently waiting. From the corner of my eye, I see the nuclear flash somewhere to the west. We all dive beneath covers or, in my case, the afghan, even knowing it's futile. We stay that way awhile. Rain drops are sprinkling through the screen window, and I crank it shut. I wonder if it is already acid rain. I cough a dry cough, and I know it's already too late for me. The house is a sort of

veterinarian facility, so I know there will be drugs when the time comes. I get up and look about. There is absolute stillness, not just to us but to everything within and without.

I am a plump old farm woman. My "man friend" suspects something is weird, and behind my back he tells others there are no seams to my fingers and somehow no nerves, and I am missing a finger. I go outside to the barn where I exchange my "found out" body for that of a middle-aged farmer, though first he was a young girl. I am surprised that I seem to have no remorse or human feeling about what I apparently must do to survive.

Our capacity to understand what is happening—to find any ground to support our perceptions—begins dissolving the moment we can't discern whether we are living or dying. Understanding and perception are the first casualties of a poisoned world. Only later do our bodies succumb. To put it another way, apocalypse inhabits a vague border region between the imaginable and the unimaginable. When the unnatural begins congealing after the fixity of nature itself has dissolved, we have entered into the province of the imagination.

This congealing of imagination within the unknowable possibilities of living in a poisoned world has been noted amongst Japanese survivors of the Bomb. Robert Jay Lifton, in his study of the *hibakusha* or survivors in Hiroshima and Nagasaki, isolated a particular "A-bomb neurosis," which he characterized as "a precarious inner balance between the need for symptoms and the anxious association of these symptoms with death and dying. . . . The *hibakusha* preoccupation with white blood counts becomes not only an effort to 'measure' that contamination, but also a means of physically localizing it and giving it form" (Lifton, 1967:119). When Little Boy delivered the *hibakusha* into the netherworld between living and dying, it positioned them simultaneously between the

imaginable and the unimaginable. And yet it is the way of the psyche not to tolerate the unimaged for long—for psyche lives within images.

The echo of Little Boy has moved us likewise into the netherworld of the unknowable—and consequently into the psyche's instinct to give image to the unimaginable. In our dreams of the unnatural, it's as if nature herself were the prone body of a survivor, and these strange beasts and grotesque mutations of our own flesh allow us to visualize an inscrutable disease we know to be immanent in the country of apocalypse.

In the apocalyptic literature of the Bible, strange creatures abound. The Beast/Antichrist of Revelation, for example, resembles "a leopard, but had feet like those of a bear and a mouth like that of a lion" (Rev. 13:2), and his companion, the "beast who rose out of the earth, . . . had two horns like a lamb, but he spoke like a dragon" (Rev. 13:11).

Biblically these monsters display an unnatural horror, hungry to devour the people of God. In the apocalyptic dreams I've gathered, however, the monstrosities that inhabit the end of the world are almost always smaller than humans, harmless and pathetic. Often dreams stress their infantile qualities and, alongside that, the instinct to protect them, take care of them, sometimes even parent them. "Suddenly I see dogs swimming underwater. They are able to breathe in the water. I realize they are starving, and I throw mosquito larvae (which are in the air) into the water to feed them." "It was strange to see such feared creatures [dinosaurs] as helpless infants." "Family's there; baby, too. The boy has taken the form of a newborn chicken." "Somehow as a human being, I feel responsible for what is surely a wretched mutation."

It's almost as if these creatures have been forsaken by nature—from the maternal embrace of the natural. Recognizing they are our offspring, as surely as hers, we take them into our care. The image of the unimaginable provokes in us a tenderness of heart, and one of the ways we begin healing the raped earth is to feed and nurture these images. These dreams

speak of the end of denial, both of what is going on and of our complicity in it.

This moment of admitting our responsibility to the unnatural and taking it into our embrace is the beginning of an alchemical *opus contra naturam* that may be one of the most profound responses to the literalized *opus in violation of nature* that both the Bomb and ecological rape signify. It may also be the first step toward being taken into the embrace of the dark, imaginal realm under the earth. Like the children of apocalypse, these strange beasts invite us to go down beneath the surface.

These hybrid creatures inhabit both the natural and the unnatural realms—both Demeter's barren earth and the dark depths of her daughter Persephone's domain. Though they have access to the surface of the earth, their habitat is conspicuously "below." "There were horrible, strange skeletal insect things wrestling next to me, and they nearly touched me." "So much heat had been generated deep down in the earth from the atomic bomb explosions that the growth of dinosaur eggs had been stimulated." Beneath the dark waters; beneath the earth; beneath history into the prehistorical; small, infantile and therefore "beneath" the adult; insect-like and crawling close to the ground beneath the night sky—these creatures consistently draw our attention to what is below us. Like gargoyles embellishing the entrance of a medieval church, they greet us at our entrance into the House of Hades.

The "beneathness" takes on a different inflection when humans mutate. One of my informants, in a ritual gesture of inviting what was "beneath" her into her spiritual practice, placed a piece of coyote scat on her Buddhist altar. That night she had a dream of nuclear holocaust in which she perished and, as a disembodied presence, looked down below at the burnt earth. She witnessed, as if through time lapse photography, humans mutate before her eyes in an effort to accommodate themselves to an unnatural environment. "I saw not only charred bodies," she said, "but the mutations and diseases

and the work needed to pull it all together because the people would not be human as we know it in future generations."

The last dream in this chapter locates us in the intimate dilemmas of one of these "mutants." After the Bomb, her "man friend" tells others behind her back that she is a freak—so she goes outside to the barn and exchanges her "found out" body "for that of a middle-aged farmer, though first he was a young girl. I am surprised that I seem to have no remorse or human feeling about what I apparently must do to survive."

This remorselessness seems consistent with other apocalyptic mutations: either cold-blooded creatures mutate, or mammals (like the water-breathing dog or the chicken boy) mutate in the direction of cold-bloodedness. One drops a notch in the evolutionary scale and acts in a way that is *beneath* the nobility of being human.

Mutancy, then, pushes us below to that place where the natural gives away to the imaginal and where we are forced to look into the mirror and see that we might act beneath ourselves in order to survive. These issues of survival and imagination—how we distort ourselves to persist in an unnatural world—place us in strange kinship with infant dinosaurs, chicken boys, skeletal insects, water-breathing dogs, airborne mosquito larvae and a fish that looks like an overstuffed carnival toy bearing the hump of a camel. To look with compassion at the distortions and mutations we've undergone in order to continue in a crazy world is a harsh and necessary task, especially if our social persona strives for consistency and elegance of form. And yet it is exactly this persona which we must shed to enter nakedly into the heart of the apocalyptic initiation.

With this chapter, we end our reflections on the first and probably the most difficult—indeed sometimes excruciating— part of the apocalyptic initiation: the separation from the tribe, the disintegration of the social persona, and the burning away of the veil that stands between the initiate and the stunning dance that takes place in his or her very heart between the one who would destroy the world and the one who would save it.

TEN

Because Thou Lovest the Burning Ground

THERE IS AN *underground city. It is inside me, and it is also the earth and a garden. Workers are planting bombs—like planting pellets in a garden to kill the gophers. Plants are being set up around the world manufacturing bombs. Like tumors growing inside my body, these plants are cropping up across the world.*

Large objects fall off the ledge of a city building. They are planting pots, black ceramic bombs being dropped in a computerized pattern. I try to find out what the pattern is so I can run between the bombs. I am afraid for my life.

I join a secret group in the city to stop the devastation. It is a woman who is trying to destroy the world. She is evil, dark, seductive and strong. She is in the world and in me. If she destroys the world, she destroys herself. I am fighting for my life in this dream. If I lose, I won't wake up.

The woman has found out that someone knows of her existence. She sends out planes throughout the city to destroy all the large corporations—all the large companies in the highrises where she thinks the opposition may be forming. She is in an airplane and can see into the windows of the highrises and destroys buildings with the ease and fervor of a child playing a computerized game. The building I am in is small and inconspicuous. I'm on a window ledge in a tree.

I realize I must get a pellet, put it in dark water under the canals of Venice—into my veins (for they have become the canals of Venice). I know if I put a pellet in a tiny opening under the water, I will neutralize her rage and the bombs will stop.

Somehow I was to deliver her food. I had to pretend to

beg for some food for my dog. She slipped me a pellet, think-
ing I would deliver it to her forces without knowing what it
was.

I knew that, once again, I had to find the pattern of her
troops so that I could slip past them unnoticed into the dark
water and bury the pellet.

The canals were my veins, the rivers of the world, my in-
terior landscape of world/garden/body. I dove into the water,
buried the pellet, neutralized her rage and woke up.

It's New Year's Eve. I'm on top of one of the twin towers
in New York City, and the world is going to blow up at
midnight.

I and a few others gather around a boardroom table and
try to negotiate with the man who wants to blow up the world.
He is dressed in a business suit, somewhat dapper, but has to-
tally crazy eyes and is beyond negotiation on any level.

His frail old mother sits next to him. She is apparently
deranged. She mumbles to herself and is very disheveled. To
prove to us he is crazy enough to blow up the world, he grabs
his mother by the ankles, spins her around his head and throws
her off the top of the building.

For some reason, the bomb doesn't go off at midnight.
Soon we find out that someone stole it. We look around fran-
tically through a maze of doors, corridors and gates. Who has
the bomb now?

I am an envoy to negotiate with Saddam Hussein. He's
completely intransigent. He's in three-point restraints when I
begin tying his last leg. He says that if I tie all his limbs, he'll
unleash chemical and nuclear weapons and there will be a huge
holocaust.

I pause—leave the room to meditate on this for a few
minutes. I decide to call his bluff. I know this is a precarious
decision, that I will be co-responsible for the holocaust if he
acts. I tie his other leg, feeling dizzy. I feel a strange vulnerability

*that borders on giddiness in sharing his power, influencing his
decision. There is an element of liking it—a grave pleasure:
this world I could destroy.*

*I am the General, a gentleman/saint who presides over
the apocalypse—calm and benevolent; everyone wants to
negotiate with me. In each of my hands, I hold a sheaf of wheat.*

The one who would destroy the world has such a consis-
tent character, regardless of the dreamer, and is so consistently
paired with the one who would save it that I contend that these
two personae enact the central drama taking place in the apoca-
lyptic heart. Though they form an indivisible dyad, I am go-
ing to examine them singly at first and then see if I can puzzle
out in a rudimentary way the pattern in which they dance
together. Although the Bomb's radiant presence has thrown
these two personae into vivid relief within the apocalyptic
psyche, we have no reason to presume that their dance will
not continue within the twin impulses we carry to ravage nature
and to protect her.

"I try to negotiate with the man who wants to blow up
the world. He is dressed in a business suit, somewhat dapper,
but has totally crazy eyes and is beyond negotiation on any
level." "Saddam Hussein . . . completely intransigent. He's in
three-point restraints when I begin tying his last leg. He says
that if I tie all his limbs, he'll unleash chemical and nuclear
weapons and there will be a huge holocaust." "We were going
to die—which was hard to accept. I pushed a bullet out the
window that would explode and destroy us and the world."
Worldly, boundlessly enraged, with a crazy pleasure in destruc-
tion and utterly beyond negotiation, this persona carries a pro-
found seduction, for he/she exists at the epicenter of apoca-
lypse. Homicidal and suicidal in equal measure, this being is
unconcerned even with its own survival, as if its immolation

and the world's were, ultimately, a single act. As a self-consuming fire, then, this being—personifying the Bomb itself—constellates a black hole of ferocious gravity around which we trace our orbit of fascination and fear.

In chapter five, I speculated that the psyche, as it faces ecological catastrophe, might shift in its imagery from a vertical axis to a more horizontal, engulfing imagery of helplessness. In the Bomb dreams, however, the phenomenology of "above" and "below" is crucial and allows us the sharpest possible portrait of the figure in us who is out to destroy the world. In the first dream, even though the scenario is an underground city, the ceramic bombs drop from tops of buildings and the woman who would destroy the world flies in an airplane from which she "can see into the windows of the highrises and destroys buildings with the ease and fervor of a child playing a computerized game." And in the second dream, the one who threatens the earth with matricide inhabits the penthouse of one of the largest buildings in New York. "To prove to us he is crazy enough to blow up the world, he grabs his mother by the ankles, spins her around his head and throws her off the top of the building." The potency, and sometimes the omniscience, of the one who would destroy the world is amplified by this quality of being "above it all," so that the enemy is not merely a crazed human being, but something of a demigod, a furious force of nature masquerading as a mortal.

Bruno Bettelheim noted the remarkable occurrence of this same leitmotif of aboveness versus belowness in dreams of citizens in the Third Reich. Commenting in Charlotte Brandt's book *The Third Reich of Dreams*, he writes,

> Thus the author speaks rightly of the warnings in dreams as being like voices from above. It is the infant who feels that every step he takes is observed by those who tower above him, that every secret thought he thinks is detected and known. The power of the parents over the very small child resides in the child's dependence on them for sheer survival.

> Since they hold omnipotent power, he also believes them om-
> niscient, able to read his most secret thoughts. To feel this
> same way in adulthood means a return to an infantile con-
> stitution of the psyche. (Brandt, 1966:164–65)

The demigod that hovered over the citizens of Nazi Ger-
many is a near-twin to the being that has stood above us in
the nuclear age, leaving little doubt that the domain of fascism
and the country of nuclear apocalypse border one another.
However, the character of these demigods differs somewhat.
Fascism emphasizes his omniscience—no refuge under the
scrutiny of Big Brother's ever present gaze. Under the Bomb,
it is the power of destruction longing for omnipotence that is
our bête noir. In either case, we are infantilized—both in our
helplessness and in its vicarious compensation in the persona
of Big Brother or bigger and better bombs. To put it more sim-
ply, vulnerability and longings for omnipotence are the two
poles of the infant's psyche; and both fascism and the Bomb
have located us in the elemental dramas there. These two faces
of the same psychic totality give us some sense of our sym-
biotic—one might say umbilical—attachment to the desperate
hopes of being protected from or defeating the enemy that the
Bomb emblematized. The Bomb became our dark mother to
which we were primally connected.

As the first section of this book shows, the mythological
grid of Western culture that shapes this infantilized psyche long
preceded the Bomb and may long outlive it in our war against
the natural environment. In this century, these mythological
patterns have framed the modernism of the Third Reich in
much the same way as they have the technological positivism
of nuclear weapon development and the merciless milking of
the earth's resources in the name of progress. In each case, "the
one who would destroy the world" presents first the face of
the Messiah who will usher in the golden age. These dreams
show us the other side of this immensely seductive figure.

"She is evil, dark, seductive and strong. She is in the world

and in me. If she destroys the world, she destroys herself." This dreamer, horribly violated both sexually and physically by both her parents when she was a child, has to contend now with the knowledge that the one who would destroy the world is in herself—*is* the "other" in herself. Of this "other," Adolf Guggenbühl-Craig writes,

> The joy of destroying others is related to self-destructiveness. Thus it is not surprising that sadism and masochism appear together; the self-destructive killer is the center of the archetypal shadow, the center of irreducible destructiveness in human beings. (Zweig, 1991:98)

Severing the cord that binds us to these dreams of destruction means first and foremost following it like Ariadne's thread down toward its dark source, from what we are conscious of to that otherness in ourselves or in our past that is so disturbing. Descending into the center of the archetypal shadow, into the heart of the Bomb, meant, for this woman, that she sink into the unbearable realities of her parents' unconsciousness and declare there her right to live. It is significant that the mysterious guardian of energy, the pellet that the dark mother would use in her orgy of destruction, is exactly what the dream ego needs to save the world.

This archetypal shadow at the core of world/self had a complicated and revered presence in Greek and Hindu mythology long before J. Robert Oppenheimer recognized Vishnu in his destroyer aspect at Trinity. If one follows the thread to the bottom of the abyss, sooner or later one discovers that the shadows cast by one's parents are coextensive with the Dark Mother and Father who inhabit the realm of death and regeneration.

The extreme complexity and ambiguity of the gods of the Underworld are necessarily confusing from the perspective of a mythology that so radically separates God from Devil, Good from Evil. It can hardly be surprising that the realm of these

gods was diabolicized in the Christian era. But from the Greek point of view, Hades was both tomb and womb, the end of life and its very source. The fruitfulness of the earth depended upon performing the rites of Demeter, the cyclical descent into and return from the realm of death, mystery and richness that retraced the ordeal of her beloved daughter.

The true mystery of this core archetypal shadow is that encapsulated in it lies the seed of our most radiant vitality. The self-consuming fire of the Bomb is not only an image of destruction, but also of the aliveness that is within existence itself. Greek mythology named this aliveness Dionysus, the ecstatic god, whom Walter F. Otto called "the firstborn child of life and death" and whom Heraclitus identified with Hades: "For if it were not Dionysus for whom they held their processions and sang their songs, it would be a completely shameful act to be reverent; Hades and Dionysus, for whom they go mad and rage, are one and the same" (Otto, 1965:116).

Persephone's name, in Greek, means "the destroyer"; in her embrace, everything one imagined oneself to be is turned to ash. At the bottom of Hades, mystery is as all-consuming as the blackness of Persephone's womb—neither the images that flicker in the dark nor their explanations diminish that mystery in the least. What is destroyed by the destroyer, in other words, is all that stands between us and mystery itself. Our fear of death gets translated into literalism, dualism, positivism or fantasies of power. These things burn up in the destroyer's embrace, and the mystery which they eclipsed is revealed.

In Hinduism, the Dark Mother goes by the name of Kali, the Black One. Standing on a boat in an ocean of blood, she has four arms. In her right hands, she carries the instruments of death which she wields without mercy: a lance, a noose, a hook to snag her victims to their inevitable end. In her left hands she bears mercy itself: a bowl of fruit, a rosary, a prayer book or the lotus of regeneration. Her consort is Shiva, the

Hindu equivalent of Dionysus and Ecstatic Lord of the Dance. His dance is the very display of creation and destruction that is the phenomenal world, just as Kali is the infinite blackness out of which the phenomenal world appears and disappears. Shiva and Kali were worshiped in the cremation grounds, sometimes associated with Chidambaram, the center of the universe in the heart. "Because thou lovest the burning ground," says the hymn to Kali, "I have made a burning ground of my heart, that thou, dark lover, haunter of the burning grounds, mayest dance thy eternal dance."

The world-destroyer draws us inexorably toward the charnel grounds—prepares the dance floor for the ecstatic god by turning everything into ash. In one of the most eloquent descriptions of this pairing in literature, Kazantzakis's Zorba dances out the anguish of his child's death, knowing that there is nothing else he can conceivably do but dance.

The dream with Saddam Hussein indicates how much intelligent vitality we have ceded over to the archetypal shadow by pretending it is only the "other" that would want to destroy the world. Hussein threatens nuclear and chemical holocaust if the dream ego ties his last limb. Placed on uncertain ground— is Hussein bluffing or not?—the dream ego chooses to restrain the shadow, even though he knows he might thereby participate in the world's destruction.

Here a brilliant psychic compromise is reached: one is determined to prevent the shadow from acting out its viciousness, but, at the same time, the quintessence of that viciousness energizes the dream ego: "I feel a strange vulnerability that borders on giddiness in sharing his power, influencing his decision. There is an element of liking it—a grave pleasure: this world I could destroy."

This dream inextricably intertwines the drama of protecting the world with the recognition that the one who would destroy is ultimately no different from oneself. Rather than denying fantasies of destruction (and consequently demonizing Hussein) or moralizing them away, the dream ego takes "grave

pleasure" in his kinship to the shadow. In doing so, he realizes a strange and lively vulnerability that runs exactly parallel to the responsibility of not letting the holocaust happen. The inflated ecstasy of destroying the destroyer is replaced here by something far more honest.

When the dream ego owns the shadow, the "other" suddenly has human dimensions and is no longer a demigod—is, in fact, restrainable. An equilibrium—one might even say the beginnings of a friendship—takes shape.

This equilibrium finds its perfect expression in the final fragment of a dream: "I am the General, a gentleman/saint who presides over the apocalypse—calm and benevolent; everyone wants to negotiate with me." The friendship between the destroyer and the world-saver ripens in this singular persona, for he has located the balancing point between these two psychic tendencies. L. R. Farnell ascribed to Hades a "mildness joined with melancholy" (Hillman, 1979:45) that might well define the General's disposition as people come to negotiate with him. Just as Demeter gave grain to humanity after her daughter returned from the Underworld, so does the General bear a sheaf of wheat in each of his hands. The god who is the giver of wealth and the taker of life can be met, at last, in his kindest form.

ELEVEN

Saving the World

❧❧❧❧❧❧❧❧❧❧❧❧❧❧❧

I'M ON THE *shore of Lake Michigan. I'm being pursued because I have the key to the red button that will make the Bomb go off—and these people want it so they can destroy the world. I pretend to give it to a friend as a ruse to elude them—and then run off into the woods.*

Soon I'm in a huge building in New York—still being pursued. I climb floor after floor looking for someone to give the key back to and prevent the war. I go into a room with several small clusters of people, speaking different languages. For some reason, there are large puzzles on the wall.

I sneak down a very dark stairway to an elevator and go up to the roof of the building. There is a huge party of Israelis in army uniforms listening to a speaker. I feel small under the dark and ominous sky. Near the edge of the roof, two Palestinian children beat each other mercilessly. I pretend I'm Palestinian and ask them to stop. They try to convince me to plead on their behalf with King Hussein, who will soon be cracking down on Palestinians. Later I confess, with embarrassment, that I'm not really a Palestinian.

In a few moments, everything becomes light. The Bomb has fallen.

I'm walking around Lake Atitlan in Guatemala with a couple of women whom I swim with and flirt with. I find a small cubicle made of cement that is some kind of nuclear bomb facility. Without letting my friends know, I sneak in it, disconnect the alarm and sabotage its capacity to destroy.

Myself and hundreds of others are present on the grounds

of a grammar school. Guns are emerging from an old oak overhead. Someone tells me that negotiations are failing and that nuclear war is imminent.

I feel like I could mediate a reconciliation. I rush to a giant driving a jeep. Suddenly I'm horrified to see the guns going off.

I stop, sit down and weep. Bodies surround me. A fallen woman nearby is also crying. Ronald Reagan comes crawling by, blood streaming from his head. He also is crying. "I didn't realize this would happen; I didn't know it would be like this," he cries.

The dance partner of the one in us who would destroy the world is, of course, the one who would save it. Because these two form a tandem, this chapter will rely on some of the dream material of chapter ten. Like the destroyer, this persona is remarkably consistent in character, a being honed for survival. And though their intimacy displays the fiery spontaneity that we would expect when the passions of destruction and survival are so fiercely animated, there emerges, nonetheless, a discernible pattern that is danced out between them.

What is striking in its absence in the persona of the world-saver is altruism. Selflessness does exist in apocalyptic dreams—usually arising *after* the holocaust. The "saver," however, is less motivated by altruism than by the raw animal instinct to survive. He/she is a trickster figure, master of pretense and subterfuge, a stealthy animal of the night, negotiator of labyrinths and sometimes labyrinthine negotiations; a cunning shapeshifter, breaker and enterer, spy. Lacking naivete, he/she is a master of complexity, illusion and eluding. The destroyer sometimes displays intelligence, but his/her dominant characteristic is usually simple blunt destructiveness. The one who would save the world, however, is subtlety itself; he/she would outwit, rather than fight, the destroyer.

"I surreptitiously break into a nuclear bomb facility on Lake Atitlan in Guatemala, disconnect its alarm and sabotage its capacity to destroy—then return to my friends without telling them I did this." "I pretend to give the key to the 'red button' . . . to a friend as a ruse to elude them—and then run off into the woods." "I had to pretend to beg for some food for my dog. She slipped me a pellet thinking I would deliver it to her forces without knowing what it was." "I have to pass as one of them, but I must subvert them and their nuclear danger." "I was tough-as-nails, good—with the right values, able to easily infiltrate into groups."

Sometimes the world-saver brings his/her considerable skills to the bargaining table. The subtlety of the negotiating mind—and its deviousness—belongs to this persona. As noted in the Saddam Hussein dream in the last chapter, negotiation enters into the fray of bluffing and counter-bluffing. Usually, however, the destroyer is described as "beyond negotiation on any level," in which case the way of cunning and subversion is pursued—or the world is destroyed.

"Negotiating" is the key quality of this persona's character, whether he/she is negotiating with the enemy or negotiating the dark labyrinth of a world on the verge of destruction. And, not surprisingly, in the Bomb dreams the world he negotiates is "down under," away from the realm of "aboveness" where the destroyer hovers like a bird of prey. "A friend of mine is in the underground—and quite literally under the earth—where he is carrying out reconnaissance." "I join a secret group in the city to stop the devastation." "I feel small under the dark and ominous sky." "The canals were my veins, the rivers of the world, my interior landscape of world/garden/body. I dove into the water, buried the pellet, neutralized her rage and woke up." This persona is a serpent darting quickly in and out of shadows and sometimes beneath the ground. The whole length of its body is on intimate terms with the earth itself.

Whether it's hiding in a tree, stalking the dark halls of a skyscraper or shifting beneath a mask of pretense, the animal aspect of this persona cannot be exaggerated. All of its actions

are animated by the instinct of survival. "I am fighting for my life in this dream. If I lose, I won't wake up." Far from the infantile helplessness of being "below" noted in previous chapters, this persona inhabits the ecology of apocalypse with animal intelligence: a coyote foraging in the night, a hunted fox, a hare eluding the swooping hawk.

Although Christ advocated that his disciples be as "gentle as lambs and as clever as serpents," this serpentine intelligence has sunk to a despised position in the hierarchy of Judeo-Christian values—now exiled to the domain of the sociopath and the white-collar criminal. The innocence of the child, the docility of the lamb, the simple earnestness, altruism and directness of the "man of righteousness" presumably elevate human beings above the beasts of the field.

In his study of concentration camp survivors, Terrence des Pres contended that the animal hunger to live that possessed those inmates whose souls had not been sucked dry by circumstance is often dismissed as subhuman and ignoble under the lens of these transcendental values. But the instinct in the human animal to survive—enlivened both in the camps and the country of apocalypse—places one within an ethical and psychological complexity that these idealized values could scarcely do justice to.

Just as the destroyer in the dreams of German citizens under the Third Reich closely resembles the destroyer in Bomb dreams, so also is the survivor of the death camps, as understood by des Pres, almost a twin to the one who would save the world. It's as if the Bomb turned the whole world into a vast death camp, the ovens stoked with the accumulation of weapons. And under the vigilance of the destroyer who looks down from the guard tower, we inmates stagger, either stuporous or scheming to survive and undermine the powers that be.

As intimated previously, the labyrinth is the home territory of the one who would save the world. He/she negotiates the maze of complexity with a combination of native wit, street wisdom and animal intelligence. Dream images of the labyrinth are numerous. "Ceramic bombs being dropped in a computer-

ized pattern. I try to find out what the pattern is so I can run between the bombs." "We look around frantically through a maze of doors, corridors and gates. Who has the Bomb now?" "I go into a room with several small clusters of people, speaking different languages. For some reason, there are large puzzles on the wall. I sneak down a very dark stairway to an elevator and go up to the roof of the building."

In Greek mythology, the labyrinth was the "House of the Double Ax" or *labrys*, "the ceremonial axe used to sacrifice bulls to the Cretan Moon-goddess" (Walker, 1983:523). In the labyrinth at the palace of Minos dwelt the dread minotaur, the godbeast birthed by Queen Pasiphae after she was mounted by the black bull of Poseidon. More generally, however, the labyrinth is a near universal image of the Underworld and of the sacred rite of descent, death, rebirth and return.

In Greek myth, Hermes is the god who guides the initiate down into the labyrinth; and it is clear that the one who would save the world is his child. "The friendliest of the gods," a trickster and shape-shifter, the fleet-footed spirit of the night, he is the god of both truth-telling and of lying, of thieves and of merchants, of sudden luck and sudden loss. As Lord of the Roads, he is both the pathfinder and the one who will lead the traveler astray. Because of his elusiveness and unpredictability, the alchemists identified him with the element Mercury which slips through the fingers, and C. G. Jung considered him the archetypal personification of the psyche.

Like water which, in its very liquidity, seeps into the depths, Hermes in his elusiveness draws us down into the maze. The one who would save the world is a hermetic personality— as surely as the animal is awakened in him, so is the god Hermes. If we follow Jung and take Hermes to be the quintessential image of the psyche, then we can say that the threat of destruction awakens the psyche itself. In other words, the psyche is the soul of the human animal, and the animal intelligence of this soul has been animated by the felt threat of extinction.

Within the hermetic sphere—in the labyrinth itself—everything is relativized, including being lost and being found, eluding or meeting the destroyer. The process of soul-making is served either way, but if one clings to a very literalized notion of saving the world, Hermes is more than an unreliable ally. As Hermes psychopompos, he is the escorter of souls who leads one down to meet the Lord of the Dead. Snatching one's life out of the jaws of death—the leitmotif of the child of Hermes who would save the world—paradoxically meets its opposite— or perhaps complement—in Hermes himself, for this god delivers one to those very jaws in the rite of initiation. Unsurprisingly, then, in these dreams, often as not, the one who would save the world fails. "You win some, you lose some" is a thoroughly hermetic point of view; Hermes' oracle was the toss of the dice.

If I isolate, in a few of these dreams, the points of contact and escape between the Destroyer (D.) and the Saver (S.), then maybe behind these moments I can see the shape of their intimacy, the steps of the dance itself:

Destroyer drops bombs in computerized pattern
Saver tries to figure out the pattern
 (D. leads/S. follows)

S. pretends to beg for dog food
D. gives pellet to S., thinking S. will unknowingly give
 it to her troops
 (S. leads/D. follows: bluff/counter-bluff)

S. negotiates with D. in penthouse
D. throws mother off top of building
 (S. leads/D. takes over lead: no negotiating)

D. pursues S. along shores of Lake Michigan
S. keeps a few steps ahead of his pursuers
 (D. leads/S. eludes: D. continues leading)

S. pretends to give the key to the Bomb to a friend and runs
 off
D. sees through pretense and continues pursuit
 (S. tries to take over lead/D. continues leading)

S. escapes into tall labyrinthine building and goes to top
D. disappears altogether; then, unexpectedly, bomb drops
 (S. thinks he's completely eluded D./D. immolates S.
 and world: dance ends)

A finite, if extravagant, pattern begins to emerge between
the instinct to survive and the appetite to destroy. At the dance's
core seems to be a drama of trying to wrest the lead from the
other party—the Destroyer according to his/her particular
nature and the Saver by means of swift intelligence and cunning.

The Destroyer has laid out the pattern of the dance floor,
and it is he/she that calls the Saver to the dance. The latter
moves within the Destroyer's domain and so must fiercely at-
tend to both the nature of the terrain and every step the
Destroyer takes. It's as if the Destroyer knows the dance already,
and the Saver is being initiated into its form.

Although the Destroyer is by far the more forceful of the
two, the Saver's complexity (which probably comes from the
necessity of puzzling out the dance steps under the threat of
death) allows him or her to sometimes take the lead. This he/
she always does by pretense: donning a mask, bluffing, eluding
the Destroyer or hiding out in a dark place. Sometimes the at-
tempt to take the lead is foiled—the hiding place is found out
or the bluff is seen through—and the Destroyer resumes control.

Other times, Saver and Destroyer dance out a drama of
bluff and counter-bluff. If the Saver outbluffs the Destroyer,
then some secret substance (the pellet or a portion of Saddam
Hussein's vitality) passes from the Destroyer to the Saver, unbe-
knownst to the Destroyer. Critical in the dance of outwitting
death, this substance can "neutralize the rage" of the Destroyer
or effect an equilibrium between Destroyer and Saver that

borders on affinity. This is one way—and a rather durable one—that the dance can end.

As far as I can tell, there are only two other ways. The Saver, in the steps of eluding and hiding and pretending, can move right off the dance floor itself—at least until the Destroyer insists on another spin. This can be treacherous because it is not uncommon for the Destroyer to meet one from behind when one feels at last safe. And, of course, the dance can finish when, perhaps lonely for a true dance partner or perhaps taking that true partner into a fiery embrace, the Destroyer self-immolates and the world comes to an end.

The dance at the end of the world is as passionate and intricate as that between the bullfighter and the bull. Relying on force and cunning, fire and mask, feint, counterfeint, negotiation and the eros that exists between the hunter and the hunted, this is the dance that transpires in the heart of the apocalypse—in the apocalyptic heart. It is the most elemental expression of how we carry in the intimacy of our souls the drama of this historical moment when human beings seem so unconsciously compelled to destroy the world. In witnessing this dance, one confronts the mystery that the one who would destroy the world is very alive in each of us and the animal intelligence that would save the world has been awakened in all its subtlety. If apocalypse is a rite of initiation, the essential gnosis it conveys is danced out between these two aspects of our nature. In recognizing that each of these two personae bears a portion of who we are, we are initiated into the possibility of responding tenderly and responsibly to the dire realities of our time.

TWELVE

The Emergence of the Sacred

꧁꧂꧁꧂꧁꧂꧁꧂꧁꧂꧁꧂꧁꧂꧁꧂꧁꧂꧁꧂

IN MY DREAM, *a friend tells me that a nuclear exchange is imminent between the United States and the Soviet Union. I am shaken with disbelief—but looking up in the sky, I see two missiles collide in mid-air and a mushroom cloud rising up in the heavens. When the cloud disperses, I see the Pleiades. It's as if somehow the nuclear explosion itself created the stars.*

A B-52 takes off with its nuclear payload. Instead of the roar of a jet, the sounds coming from the exhaust are similar to the harmonious chants of the Gyuto Tantric monks of Tibet. The overtones of the prayer are very haunting.

The B-52 reaches its target, drops its atomic bomb and veers off sharply to the right. A Doppler effect occurs which momentarily alters the pitch of the Gyuto-styled chant. Then I see the face of a beautiful Cambodian child that I saw during my visit to that country in 1973, when I was in the service in Thailand. In the dream, I wonder if she survived that holocaust only to be vaporized by nuclear weaponry.

I was sitting in a car, parked in Los Angeles. On either side of me were two other parked cars and in them two men I didn't know. All three of us had an A-bomb in our front seats! I was completely nonchalant, as if it were an everyday, common thing.

Then we all started banging our bombs with hammers! To test them! Mine went off and everything became pure, white, bright light. A sizzling, desert-like sound was all I heard. But I was not there! I knew that in my dream I was gone, but I could still observe, see the light and hear the sound. It was

so real. I was disembodied, but still able to observe. It was very peaceful.

I was observing a group of scientists who were standing in a circle. One of them had frizzy hair like Einstein. He was the head honcho. They all wore business suits. They were conferring, trying to figure out what to do because a chain reaction had gotten out of control. When I realized we had only a few moments left, the reactor blew and I saw the mushroom cloud.

That started a chain reaction with other reactors. The frizzy-haired guy was still alive, but most of the other scientists had died. He was trying to figure out what to do when the second one exploded. I saw the scientist simply dissolve into light. The air was intensely hot and cold at the same time. Metallic.

When the third reactor blew, I was there. It was in the desert. I ran with giant leaps across the sand. I wanted to live. I really panicked. Even as I tried to get away, I knew it was futile.

Then it went. Everything dissolved at that moment and I experienced dissolving. "Nothing" existed. No self. Yet, paradoxically, some quality of consciousness that felt like me reconvened in deep space—looking down at a little blue planet about the size of an orange. I looked more with my heart so I could see it clearly. The thought came to me, "Isn't it interesting that the greatest suffering I experienced in this moment of transition was in trying to escape. Grasping to my life was a very intense kind of suffering—dying was not."

On the planet, I saw burned people and babies crying. Hiroshima-like scenes. I saw the future in the present—the charred bodies but also the mutations and diseases and the work needed to pull it together 'cause the people would not be human as we know it. What a great gift to me that I could die immediately. I was relieved that it wasn't my work to be there.

I'm in the desert near Alamogordo, New Mexico. Opening the door of a small ramshackle house with a tin roof, I see my father. His face is radiant, soft with pure sweet benevolence and he carries a poise very different from the drunken dissipation of when he was actually alive. He tells me, "It is time" and directs me to the door. I'm puzzled and excited—not knowing what I'm excited about.

I climb on a rusty bicycle and rush down a slight slope to the desert below. The whole horizon is visible, and under the darkening skies the lights of the city flash on and off. The air is charged as if lightning will soon strike. I realize the Bomb is about to drop, and I race, ecstatic, toward Ground Zero so that I can meet it fully. In my waking life, I've never felt such ecstasy.

At "Ground Zero" there is thunder without lightning. Instead of the Bomb, an odd frog-like creature drops out of the sky—floating down as slow as a feather, using its large webbed feet as wings. It's about three feet tall.

As soon as it lands, it is attacked by local people. They beat it mercilessly. I intervene just as they are about to douse it with gasoline and light it.

I sit with it and read it a children's book, trying to teach it English. It is very wise, but most of its wisdom seems in its capacity to play. It darts in and out of rabbit holes. I find myself frustrated even though I know that somehow the specialness of its intelligence is bound up with its playfulness—like a child's.

My most salient dream about the Bomb was a healing one. I was living with a man who had two daughters and shared their care with his ex-wife. There were inevitable tensions and cross-currents.

In my dream, the five of us were thrown together in the aftermath of the holocaust. It was clear that our interests were one—trying to survive. We were all on the same side. This awareness has stayed with me to the present day—and in the

broader sense has nourished my understanding that all people are in harmony.

That the Bomb has often been incorporated into the psyche as a symbol that connects to a profound experience of the sacred should by now be no surprise. As chapter one shows, the Bomb's sacrality was a very real and spontaneous experience among many of the observers of the first atomic test.

The Bomb crammed all nature's wildness into a single localizable icon that has evoked in our dreams true religious feeling. Technology has long usurped the awe that belongs properly to the natural world, and the Bomb is the apotheosis of this usurpation. Perhaps as the Bomb recedes as the archetypal dominant presiding over apocalypse, this religious feeling will reconnect to nature. In the midst of ecological disaster, it seems likely that the transcendentalism of many of the Bomb dreams may give way to imaging the preciousness of our lives within the threatened web of nature: again the vertical axis of above and below shifting toward a more horizontal world view.

In spite of—or beneath—the often transcendental imagery of the Bomb, the previous chapters show that the specter of apocalypse itself draws the soul "down to earth" or, down further, into the Underworld. This seems true regardless of the metaphors the dreams employ for the end of the world. Being "razed to the ground" by the Bomb, the helplessness of the children of apocalypse, "holing up" in the place of refuge, the ground beneath one's feet giving way, the environment saturated in the invisible poison, the mutant creatures looking up at us from below and thereby drawing our imaginations downward into the unimaginable, and, perhaps most significant, the enlivening of the animal instinct to survive exemplified in the persona of the one who would save the world—this imagery creates a complex matrix in which the sacred is reimagined in a specifically horizontal or earthbound fashion.

The dreams that are collected here sacralize the Bomb in these two primary ways, as an image of transcendence or the catalyst that draws us down to earth. Though these ways apparently contradict each other, sometimes they commingle in an exquisite coherence of interrelated images.

In the first instance, the Bomb delivers us to the realm of transcendence. Perhaps the mushroom cloud presents itself as an icon of unsurpassable beauty, a *mysterium tremendum* that inspires awe and a mute reverence. Or perhaps it reveals the cosmos that had been eclipsed by the narrowness of one's day-to-day concerns: "It's as if, somehow, the nuclear explosion itself created the stars." Or, most radically, one is consumed in the white light, and all the limits of separateness yield to simple presence: atonement.

Another kind of sacred revelation that the Bomb offers in dreams stands at quite the other end of the spectrum from the transcendent. The love that exists in "minute particulars," which William Blake noted, sometimes vividly displays itself to some who have suffered the holocaust in their night life. "I never knew how much I cared for my wife and daughter until we were huddled there, weeping, waiting for the Bomb to drop," wrote one of my informants. It is this way of being faithful to particularity that I think ecological apocalypse may be beckoning us toward.

In the transcendental dreams about the Bomb, certain motifs tend to cluster together, outlining a particular psychic topography.

First, one notices a very specific posture of observation, a simple and dispassionate watching of phenomena—being at the periphery looking in. "Some quality of consciousness that felt like me reconvened in deep space—looking down at a little blue planet about the size of an orange." "I was gone but I could *still observe*, see the light and hear the sound." "When the cloud disperses, I see the Pleiades." An open-endedness of awareness takes the situation completely in without action or intervention. One senses a certain measure of silence in the heart of the observer—and a lack of judging. As in the dream

of "chaos" examined at the end of chapter seven, the mushroom cloud is received as an image of ecstatic presence to the degree that it is looked upon nakedly, selflessly.

Second, there are recurring figures representing wholeness. His father's face is radiant and soft, carrying "a poise very different from the drunken dissipation of when he was actually alive." The harmonious chants of the Tibetan monks are an undercurrent not even significantly disrupted by the nuclear blast. In one dream, this figure of wholeness comes as a beautiful Cambodian child. In another dream, instead of the Bomb (which promised to deliver the dream ego to ecstasy), a childlike "frog-Messiah" drops out of the sky.

This frog-Messiah is an overdetermined image of wholeness. Being amphibious and capable of flying, he can move flexibly through the three realms. Though he comes out of the sky, he nonetheless darts playfully in and out of rabbit holes. Childlike, he is nevertheless the bearer of great wisdom. In Jungian language, he represents the archetype of the divine child which stands at the nucleus of so many myths of the culture hero or Messiah.

Another curious image of wholeness is the mid-air meeting of the Russian and American missiles—thereby giving birth to the Pleiades. According to Jung's books on alchemy, the divine child, this primordial image of wholeness, is born from the sacred marriage of opposites. Here, when the opposites are destroyed in mid-air, out of the fire comes great beauty.

Third, these dreams of the transcendent return to the topography of the desert. "It was in the desert. I ran with great leaps across the sand." "A sizzling, desert-like sound was all I heard." "I rush down a slight slope to the desert below." The desert is a multifaceted symbol in these dreams, giving a quality of aloneness and lack of refuge—especially as compared to the rather crowded nuclear dreams that transpire in the city where the citizens are scrambling for shelter. Related to the solitariness and vulnerability is the simple vastness of the sky: "The whole horizon was visible."

The desert and the vast sky are analogues—"as above, so

below." These dreams show an extreme externalization of self—exactly the opposite of the dreams noted in the chapter on finding refuge. Instead of curling up in a bomb shelter or in the nethermost corner of a large house, here the dream ego rushes outdoors, ultimately turning inside out and identifying with the vastness of the circumstances in which it finds itself.

"I realize the Bomb is going to drop, and I race, ecstatic, toward Ground Zero to meet it fully. In my waking life, I've never felt such ecstasy." "We all started banging on our bombs with our hammers. Mine went off and everything became pure, white, bright light." If we superficially denigrate this transcendental impulse as suicidal, we mistake the Bomb situated in people's psyches for the perniciousness of the actual Bomb. Nothing in these dream narratives can one associate with suicidal despair. The moth simply hungers for the heart of the flame.

Although it is a large step to go from the intimate complexities of one's dream life to the kind of literalism that insists on manifesting one's fantasies technologically, oddly this dream topography overlaps significantly with the Messianic dream realized at Trinity. The desert with its vast sky and open horizon, the dispassionate and contemplative disposition of many of the physicists, the divine child, the Messianic hope, the ineffable beauty of the mushroom cloud that seemed to bring some observers a felt sense of connection with the cosmos—over the ensuing decades many have dreamt this same compelling configuration of images.

Whether or not their dreams carried the dream ego to a sense of ecstasy or egolessness, several of my informants noted that, over the years, their night image of the Bomb has shifted from an object of horror and panic to one they look upon tranquilly, albeit often with great gravity. One woman, an anti-nuclear activist, expressed it to me this way:

> It was weird, but in the dream the feeling was—well, this is it. It was not like we were freaking out. It was very "Zen."

This is it. I feel like in my dreams, I've progressed from panic and denial to accepting that the Bomb is "in me." Out of that, I feel empowered to meet it.

The Bomb, in effect, can be incorporated into the psyche as an agent of transformation, as the fire that burns away possession by "fight-or-flight" mechanisms that define narrow ego encapsulations. The issues of surviving or not surviving also burn away, so that one does not enact one's life from fear or despair, but from somewhere inside that is more encompassing. The Buddhist poet Gary Snyder wrote of this in 1969:

> . . . to go beyond the idea of "man's survival" and "survival of the biosphere" and to draw our strength from the realization that at the heart of things is some kind of serene and ecstatic process which is beyond qualities and beyond birth-and-death. "No need to survive!" "In the fires that destroy the universe at the end of the kalpa, what survives?"—"The iron tree blooms in the void!" Knowing that nothing need be done, is where we begin to move from. (Snyder, 1969:102)

I imagine a broad arc of continuity between the Bomb dreams where sacrality inheres in giving oneself over to the white light to the dreams where one recognizes the sacred in the heartbreaking love one has for threatened particulars. In no way can this epiphany of love be diminished alongside the cosmic display of the transcendental dreams. One of the Chinese ideograms for enlightenment means, literally, "human heartedness." With this as a definition, these dreams represent the essence of enlightenment itself—the Bomb being the bell that awakens the heart to the preciousness of life in all its fragile specifics.

The dreams of the frog-Messiah and of the young Cambodian girl show the moment of awakening with great clarity. In the former dream, the dream ego peddles furiously to his anticipated ecstasy at Ground Zero only to find instead an ex-

tremely vulnerable being delivered into his arms. He protects
this creature from the world's mindless violence and extends
to it a benevolence not unlike that of his father's encountered
earlier in the dream. Hunger for the ecstatic moves into sim-
ple tenderness toward the finite, without a glitch or even a mo-
ment of disappointment. The uncontained desire for the fires
of ecstasy becomes, in a very quiet manner, the contained fire
of fatherly kindness which protects and educates this little be-
ing which so clearly embodies the hope of the future.

Around some dreams, it is best to tread very lightly lest
one violate their beauty and their radiant, impenetrable signi-
ficance. The meaning is embedded in the images themselves,
and interpretation can easily diminish or flatten it out. The
deep and haunting enigma of the chanting of the Gyuto monks
coming with the exhaust of the bomb-laden B-52 carries its
own profundity—which should not be disturbed. This dream
reminds one of the equally enigmatic and profound Tantric
scripture: "The sky will collapse and the earth will burst into
flames—therefore cultivate compassion."

The dreamer, a Vietnam veteran who participated in the
1972 Christmas bombings of Hanoi and who visited Hiroshima
as part of his healing from that war, is nowhere to be found
in the dream itself. Here again one feels the presence of a dispas-
sionate observer—dispassion perhaps echoed in the continual
chanting of the monks. Yet within this openness, the Cambo-
dian girl coheres as a "minute particular," and alongside her
coalesces an unmistakable tenderness and concern. It seems
crucial to me that it is not Pol Pot's autogenocide of Cambodia
or nuclear devastation per se that inspires the awakening of
the heart—but this specific little girl. In these dreams, as in
life, love is not a global concern—or, rather, the global is met
only by way of the particular. Love is realized by passing it,
like a thread, through the eye of a needle. Love is specificity
itself.

If the Bomb in the transcendental dreams burns away all
that stands between us and the vastness of the universe, in these

dreams the Bomb burns away what comes between us and the particulars of what we love: my child, the grassy hill above my house, my kin or friends. "I threw myself down in the hillside covered with yellow mustard flowers," one man dreamt, "and I felt peaceful as I embraced the earth. Then the end came." Another informant wrote,

> When I have dreamed of nuclear explosions, usually I am looking right at the mushroom cloud. At that moment, there is a sense of horrific freedom—awareness of the obscenity and violence, but also an ineffable nowness that this thing so long feared has at last come to pass. My contrary nature is also glad that the screaming numbness we have learned to call civilization will be quieted to a whimper; that we will be forced to live closer to the wounded earth.

"In my dream, the five of us were thrown together in the aftermath of the holocaust. . . . We were all on the same side. This awareness has stayed with me to the present day," writes the last dreamer of this series. In her dream, the splits and tensions in her household are rendered irrelevant by the overarching project of survival. Her little household easily becomes emblematic of the earth itself and its survival with the survival of the planet. The mythology of the "other," the "enemy," has become obsolete. Nuclear weapons have, in effect, put us all under the same roof, and these dreams indicate that under our particular roofs is where we most intimately realize this.

Ecological depredation displays human grandiosity as surely as the accumulation of nuclear weaponry. But in apocalyptic dreams that grandiosity is defeated by its very embodiment, and out of that defeat one learns to "live closer to the wounded earth" with tenderness of heart and a measure of humility.

In all of these dreams, the Bomb brings us into the immediacy of the present moment which is the dancing ground of the sacred. This *"apokalypsis"*—this revelation of light when

the veil of darkness finally parts—was ritualized in the Eleusinian mysteries as the birth of the divine child. Light is born out of darkness. New life is born from the place of death, and one emerges from the Underworld bearing the gift of having seen the ineffable light. Of this archetypal moment of return, my wife, Deena Metzger, wrote this poem:

> When you go
> to the dark place
> you must come back singing
> the note inscribed
> on your palm the song written
> on your hand
> the way trees
> grow about the
> shape of the wind.

<div align="right">(Metzger, 1981:45)</div>

Therefore Cultivate Compassion

WITH STEVE. THE *Bomb is supposed to fall. I see the mushroom cloud between the skyscrapers. Steve pulls me gently into its light with him so that we'll die quickly. He's ready to go. Suddenly, I remember that I said I would be around to help people put it together afterwards. I wish I hadn't agreed, but I had. I stay in the shadow to protect myself. I will have to do this work while I am also suffering radiation sickness. I don't feel well, but there is my promise. I call the police to tell them where I am and that I am available. So is Steve. He remembers now what we're supposed to do.*

A bomb has dropped that splinters reality. The whole town —the whole world—is intoxicated by separate dreams, realities, hallucinations as if everyone were on drugs. No one shares the same version of what is real.

I am cautious to drink the water. I play the "Christ," the servant to others, trying to help them weave together provisional meanings even as things unravel. People come to me. I work out of a ramshackle house on the outskirts of town. Mostly I am a storyteller.

There is this extraordinary fragmentation of community and yet a collective effort to help each other through the realms of hallucination. I worked not knowing when I myself will succumb—aware that I wouldn't even know when I was taken by other realms because the hallucinations are utterly real. I walk up a dirt road toward my house and find a little girl about my daughter's age sleeping in the branches of a tree. I take her in my arms and lay her cheek against mine, feeling such tenderness for her, immense sadness and compassion: so this is how it all ends. . . .

I dreamt the world came to an end. There were tidal waves, earthquakes, war, hurricanes, volcanic eruptions, tornadoes, storms, pestilence, floods. The trees were torn up by their very roots. People are scattered around, dead, or are like zombies, walking dead, soon to be dead. I see all my past friends, relatives, family, visions before my eyes; my life flashes before me and disappears. There are these large cracks in the earth and suddenly, from out of these cracks, come children, like seeds from the earth. But they are hurt, and burnt terribly, suffering, tired and frightened. I only know I must get them out of the wreckage.

I am tying leaves around their feet because their little feet are so battered, and we have to go a long distance to get to new ground. I am carrying the smallest ones that can't even walk yet. I am not sure where we are going. It is a place that is warmer, I tell them. I must keep their spirits up. The children must be saved so that they can start a new world.

But they are so weak, so tired, so little. I keep telling them this new place is just a little farther. Once there, they can rest and sleep and heal and play. They are crying and saying, "But we are tired. We hurt all over. We're burnt and bleeding. We can't walk anymore." And I am desperate, because I know we must get out of the forest, out of the devastation that surrounds us, or I will lose them all.

I, too, am dying and must stay alive enough to lead the children to the new place, then to teach them how to take care of themselves and the world so they can begin anew. I am not afraid of dying in this dream, only afraid of dying before I can impart enough information to the children. My life has become unimportant to me beyond this. I am profoundly aware that when I die, I will continue to be there in the children, but first I must get them to a green place where they can learn to play again. I tell them stories, always, so that they will envision a greener land.

In the last chapter, I speculated that the tenderness with which the dream ego in some Bomb dreams reconnects with the small particulars of his or her life might well be the leading edge of reimagining spirituality in the face of ecological catastrophe. In this chapter, in which apocalypse is played out through the metaphors of the Bomb, environmental disaster and the disintegration of meaning, this quality of kindness comes to full fruition in compassionate activity.

Once one has followed the *via negativa* of descent down to the bottom, compassion is possible. One cannot behold the birth of light out of darkness without having been first rendered naked. The descent itself burns away the opacity of self-concept and self-protectiveness by means of facing elemental fear, helplessness, animality and all those difficult qualities in ourselves that we ascribe to the "other." The light is revealed when one no longer knows who one is—when who one is is a mystery to oneself.

This very process of burning away opacity also eliminates what stands between us and the way of loving kindness. From a Buddhist point of view, compassion is not something one achieves or a foreign quality that one somehow acquires, but rather one's essential nature, the activity of the natural spontaneous self—unimpeded by running away from things or clinging to them. As a rite of descent, the dream at the end of the world animates to the nth degree this escapism and attachment so that they can be suffered fully, seen for what they are and discarded into the fire.

In this *via negativa*, the passion to survive is the last thing shed before we stand naked before the mysteries. At the mouth of Hades, the human relinquishes his/her persona to reveal the animal underneath; at the bottom of Hades, the animal sheds its skin, beneath which is a being of light. The compassionate one is born the moment that self-preservation is no longer one's reason for being.

Unsurprisingly, apocalyptic dreams sharply distinguish between the one who would save the world and the one who practices compassion. Aside from two exceptions in my infor-

mants' dreams (these both being figures that hollow out a refuge and gather people into it immediately before the Bomb drops), the compassionate one inhabits the landscape of apocalypse only after it has been devastated. (I should stress here that I take "before the holocaust" and "after the holocaust" to be alternative perspectives on where we are now.) The compassionate one has passed through the fire and knows that saving the world is a moot point. "I see all my past friends, relatives, family, visions before my eyes; my life flashes before me and disappears." The task at hand is to shelter and nurture those who survive and to reweave meaning when everything has lost it.

In some dreams, this work hopes to recreate a world out of the shards of what's left. Other times the dream ego knows full well that this little remnant that he/she protects will be overtaken by the invisible poison in its own time. In either case, the survival of the dream ego matters only so that one can be useful. "I stay in the shadow to protect myself. I will have to do this work while I am also suffering radiation sickness." "I am cautious to drink the water. I play the 'Christ,' the servant to others. . . ." "I am not afraid of dying in this dream, only afraid of dying before I can impart enough information to the children. My life has become unimportant to me beyond this. I am profoundly aware that when I die, I will continue to be there in the children. . . ."

In these dreams the work of the compassionate one is consistently to provide refuge, sheltering the remnant of life—or the seed of rebirth—after the apocalypse. He or she is the "ingatherer," the nucleus around which a new world begins cohering. If the citizens of the country of apocalypse are in constant fission, disintegration, fragmentation from which there is no escape, then this persona lives at the very edge of that country, on the border of another reality altogether. "I remember that I said I'd be around to help people put it together afterwards." The compassionate one is the archetype at the core of religion itself in the original sense of the word: *religare*, in Latin, "re-binding."

"I am tying leaves around their feet because their little feet

are so battered and we have to go a long way to get to new ground." Re-binding the wounded body or the wounded psyche or the fragmented community—this is the way of compassion in the apocalyptic world. Strikingly, in two of these dreams the act of re-binding is storytelling.

"A bomb has dropped that splinters reality. The whole town—the whole world—is intoxicated by separate dreams. . . . No one shares the same version of what is real." Here the invisible poison disintegrates shared meaning, thereby dissolving the sacramental binding together of community—that sense that our lives transpire in the same world. The dream ego plays "the servant to others, trying to help them weave together provisional meanings even as things unravel. People come to me. Mostly I am a storyteller." In a "ramshackle house on the outskirts of town" the compassionate one gathers the atomized community and their disparate meanings under the canopy of his story. While doing so, he swims against the current of his own disintegration, knowing that there is no way for him to tell when his own story will succumb to incoherence.

After the end of the world, the other storyteller, having witnessed the holocaust and her own life disappearing before her eyes, finds herself at the edge of large cracks in the earth. Then, "suddenly, from out of these cracks, come children, like seeds from the earth. But they are hurt and burnt terribly, suffering, tired and frightened." Meeting them at the edge of the country of death, the dream ego knows that her task is to "lead the children to a new place and then to teach them how to take care of themselves so they can begin anew," a place "where they can learn to play again." "I tell them stories, always, so they will envision a greener land."

In the first case, the story provides provisional shelter in the heartland of apocalypse within which the community, at least temporarily, can "re-member" one another. Further, the storytelling is an intimate and necessary part of the process of conveying the children to the new world. Like a raft, it carries these fragile seeds of rebirth toward the other shore.

Robert Jay Lifton, in his study of Hiroshima survivors,

Death in Life, relates the story of one old woman who, having passed through the fire herself, became a folk healer among the *hibakusha*. After twenty months in the hospital with multiple fractures and other injuries, she finally emerged with a foreshortened leg only to spend the next six years suffering upper respiratory, gastrointestinal and skin conditions she associated with lingering radiation sickness. "There were at least ten times when I thought it was all over with me, that I would not live," she told Lifton. Her condition began changing, however, when—hospitalized and on the verge of death—she had a vision of a huge black Buddha in "a zazen position. . . . The more I looked at it, the bigger it seemed to get—and the strange thing was that it was absolutely black. I thought . . . I was about to die, so I said: 'It's all over with me. I am now praying before a black Buddha' " (Lifton, 1967:216–17).

Later, she returned to a hot spring resort where she had often gone to seek solace and healing for her condition and "learned that there was a shrine nearby for a Buddha who was said to come out of the hot springs about two thousand years ago, containing a statue of him that could be seen and worshipped only once in thirty years," writes Lifton. "She then inquired as to whether it was black and covered with dust, as had been the one in her vision, and was told, 'Yes, it is buried in dust, since it is exhibited only once in thirty years' " (ibid.:217).

When she realized that this was the same black Buddha she had taken to be an image of her impending death, she was miraculously restored to health. Soon thereafter she began her ministry of healing in which she escorted elderly *hibakusha* to the three springs of the black Buddha "to relax, do traditional dances together and unburden themselves on one another" (ibid.:217). Some, like her, experienced astounding cures —low white-blood cell counts were normalized and other symptoms of A-bomb disease were alleviated. Writes Lifton:

> Hence we may say that she emerged as a leader through an
> ordeal of illness in which she seemed to enter the realm of

the dead and return from it, and to do so in a way that made
contact with widely shared themes in her cultural tradition.
This is the classical mode of the shaman and of the mystical
healer. (Ibid.:218)

This elderly woman herself claimed that her adult life had been
unremarkable until "Little Boy" changed everything. The bomb
was "the greatest event in my life. . . . I thought I had come
to the extreme point—the very end—and there was absolutely
nothing to depend upon but religion" (ibid.).

Lifton notes the dilemma of marginalization in his story
of the Hiroshima folk healer, for she, in her own way, was
forced to practice on "the outskirts of town"—very much like
the dream ego who wove together provisional meanings as so-
ciety disintegrated into a hive of separate, hallucinatory realities.
"She was troubled by an incomplete 'fit'," he writes, "between
the personal myth and the social field in which it is expressed"
(ibid.). To put it more simply, in the apocalyptic world, compas-
sionate activity has been exiled to the edge, where, god will-
ing, the capacity to "re-bind" and the willingness to be healed
might somehow meet.

Joy of Man's Desiring

A STREAM COMES *out of the nearby mountains, forms a small, tranquil pool and then continues into the forest. A small group of us gathers by the pool to listen to the Messiah. It is somehow clear that it is "him," although he is in some respects very ordinary. Displaying no discernible radiance or "holiness," he is nonetheless exceedingly kind.*

Suddenly, out of the forest, comes a stranger with a grotesquely bulging forehead. I start toward him in anticipation of something violent and bloody, but before I take three steps, his forehead bursts open. A bird of prey, a hawk or eagle, I think, falls with a thump to the ground. Its wings are wet like a newly hatched moth, and it can't yet fly.

There is something essentially evil about this bird, but in an unformed, infantile way. It is evil that is innocent of the knowledge of its own evil. The Messiah takes it into his arms, and it is clear that he knows it is his obligation to raise it as his child. Though he doesn't hesitate to father the bird, I sense in him a deep sadness, for he knows that his fathering will not alter the essential nature of a bird of prey, and in fact will only make room for its eventual ripening.

I'm in the desert somewhere in Israel. There are many disciples of the new Messiah walking around wearing white muslin. The desert is darkened, weather-worn and immensely dry. Someone explains the recent "Christian deluge" to me (as opposed to the Judaic deluge in Genesis), and, suddenly, I notice a waterfall flowing down the side of a previously dry cliff. The once dry grass is covered now with green, and wildflowers are everywhere. I walk a little farther and notice

that what was a dry riverbed is filled with crystal clear water and small ponds.

Back among the disciples, I briefly hear the Messiah sermonize, and his voice is hypnotic, transporting, quiet and quietly penetrating.

A wild boar runs up the hillside, and I yell to everybody, "Run, run; climb up a tree," and I myself climb a small leafless tree. Beneath the tree, a small child plays with the boar as if it were a pet, and I yell to the child, "Run, climb up here with me." I am seriously afraid for the child's life, but she is oblivious to me. I take a long sharp stick and use it to spear the boar, but scarcely do I touch it with the end than it dies with watery blood pouring from its side.

I decide that we should eat it immediately, but I'm not sure whether the people here eat meat or whether the boar is kosher. I ask and am told that in fact boar is the only meat that they eat. Thinking of pork and hot crackling, I slice open its belly with a Swiss Army knife. All of its guts are edible. I briefly hold the heart and then the liver in my bare hands, and then lay the pig, belly up, on a fire. I am delighted to be able to offer food to these people and wonder to myself what became of the Messiah and whether he will join us in this modest feast.

The television and radio were buzzing and melting. A snake that slithered out of the television said, "The reason you are seeing all this is because it's the beginning of a nuclear war." It was a peace snake.

I started looking for the snake when the Bomb blew up. Me and a few other kids were the only ones left. There weren't any adults alive.

Me and my friends had to take the parts of broken-up houses and make a new shelter. When I was looking for wood, I found the peace snake, but it was dead. We dug a deep hole where we buried the snake, and we built our house over it.

At night, blue and silver and black and red dust blew in.

We thought it was good dust, but it turned out to be radiation dust. It coated the house. A kid who had helped us build the shelter died. Later a few other kids died, too, so we had a small graveyard.

Sparkling white dust blew in the next night. We thought it was bad dust, too, but it wasn't. It flew into our house. There was a big pile of it near the hole where we buried the peace snake. We heard these murmuring words from the hole saying, "Put some of this white dust in the hole and you'll cure me. It's peace dust." So we did.

That night it grew into a beautiful big snake with all these different colors, and it curled around the whole house. It told us whenever there was going to be a radioactive storm.

A peace storm came that made the snake grow and covered the ground with white dust like thick snow. We found that, if we put a little peace dust on our plates, we'd have fruit and things to eat. And when it melted, it dissolved the radioactive dust with it.

After the peace dust went away, there was a big forest and a few houses and people. Different wild animals walked around and weren't afraid of people. There were no big buildings or apartments. The peace snake became our pet.

In my research, I didn't solicit dreams about the "New Age" or the coming of the Messiah. These three came to me nonetheless. Since the dream at the end of the world clearly articulates a myth of cosmic death and rebirth, this book appropriately follows the natural path of "dreaming the myth onward" to the psyche's spontaneous images of the new world.

Myths of the Messiah and/or the messianic age have a strong cross-cultural presence. Borrowing from the Jewish tradition and prophecies (still upheld by Hasidic Orthodoxy), Christian fundamentalists avidly await the Second Advent of Christ and the establishment of the New Jerusalem. Certain sects of

Mahayana Buddhism anticipate the coming of Maitreya Buddha. In the early 1500s, the Aztecs initially mistook the conquistador Hernando Cortes for Quetzalcoatl, the plumed serpent who would emerge from the east and establish his kingdom of peace—until Cortes began shedding blood and smashing the images of the Aztec gods. In the 1890s, the Indian prophet Wovoka founded the pan-tribal cult of the Ghost Dance which believed that, by donning the Ghost shirt and dancing until one collapsed into a visionary state, the buffalo would return, trample the white people and inaugurate a new age. And, as mentioned in chapter one, the dreams of the advent of a millennial age were fully secularized into the Marxist eschatology of the coming workers' state and into the scientific and nationalistic positivism that imagined the Bomb as Messiah.

Typically, in these myths, there was a time before history when humans inhabited paradise, and there will be a time after history when paradise will be re-established—often, but not always, by a Messianic figure. In the "in-between time," the community of believers, the cult, the tribe or, perhaps unknowingly, humanity awaits redemption from the fallen world.

For some groups, awaiting redemption means patiently submitting to the inscrutable timing of the gods and/or deciphering the mysterious language of prophecy, oracle and dream. Sometimes the "signs of the time" are read as an oracle, the "writing on the wall" in the Hebrew Book of Daniel.

In other groups, the gods have spoken through a seer and revealed ways to take a more active role in drawing down the millennial age. One sees this in the Kabbalah of Isaac Luria, for example, and in Wovoka's Ghost Dance. More ominously, this initiative appears as a strong trend in political ideology expressed in the social engineering experiments by the right and the left that have so radically altered the world since the French Revolution. And, of course, this activist catalyzing of the new age was a primary tenet of faith in the messianic cult of the Bomb in the early forties.

Another important recurrent theme in millenarian mythol-

ogy is that of the final crisis that precedes the new age. Many Jews, even in the death camps, saw the ovens as evidence that the Messiah would soon come, and some Christians saw Hitler as the Antichrist or Beast that would be defeated in the final conflict. The Neolithic myths of the sky god defeating the beast of chaos were fundamentally myths about the beginning of the world—not its end. In apocalyptic mythology, however, they have been incorporated into a cosmic drama of the end of one world and the beginning of another, far better one.

While I could speculate that the Messiah represents the full ripeness of the compassionate one examined in the last chapter, my inclination is not to personalize this figure, not to regard the Messiah as an exalted aspect of anyone's personal psychology. The Messiah strikes me as a truly transpersonal presence that gathers the plurality of self and world into a field of peaceable relatedness. Not "of this world" in a personalized sense, the Messiah embodies the soul of the world that lends everything its exquisite coherence. In that respect the Messiah seems to come from "elsewhere" the moment we perceive that the world has a soul.

What intrigues in these three dreams is how much their vision of the new age diverges from the Judeo-Christian/Neolithic mythology of the final defeat of the beast and the Underworld. Here, the Messiah does not transplant the Kingdom of Heaven from the sky to the earth, but rather mediates tenderly between earth and the Underworld. Far from casting the beast into the lake of fire, the Prince of Peace takes the beast in his arms in one dream and in the other two is either ambiguously or explicitly identified with it. These dreams suggest a myth that is an alternative to the dominant neolithic paradigm that has brought us to the very edge of history—a new myth in which the soul of the world inhabits the beast and our willingness to relate to it in a respectful way.

A small group gathers around the Messiah near a tranquil mountain stream. The Messiah himself embodies the tranquility of this idyllic scene—ordinary, not "holy," but ex-

ceedingly kind. Suddenly, this placid circle is penetrated by the grotesque and unimaginable—a stranger from the surrounding wilderness gives bloody birth to a bird of prey from his bulging forehead.

Whether or not a bird of prey—or this bird of prey—is in fact evil is a moot point. Evil or not, its nature stands exactly opposite that of the Messiah, just as the tranquil clearing in the woods is separate from the wild surrounding forest. Wilderness, cross-culturally, has been a primary image of the Underworld. And the eagle is the representative animal of Hades in Greek mythology. Without hesitation, the Messiah takes on the sacred task of fathering this being, with the grave knowledge that he cannot—perhaps *must* not—alter its wild nature. His fathering will necessarily alter the entire ecological balance between tranquility and wildness in unforeseeable ways. As the new age becomes permeable to the realities of the Underworld, simplicity gives way to an extraordinary complexity. Kindness is extended to the one taken to be—or bound to be—the primordial "other."

In Isaiah's vision of the Messianic age, a very different kind of peace is struck with and within the realm of the wild:

> The wolf also shall dwell with the lamb,
> And the leopard shall lie down with the kid;
> And the calf and the young lion and the fatling together;
> And a little child shall lead them.
> And the cow and the bear shall feed;
> Their young ones shall lie down together;
> And the lion shall eat straw like the ox.
> And the suckling child shall play on the hole of the asp,
> And the weaned child shall put his hand on the
> cockatrice's den.
> They shall not hurt nor destroy
> In all my holy mountain:
> For the earth shall be full of the knowledge of the Lord,
> As waters cover the sea.

Unlike in the biblical vision, this dream's Messiah does not reform or pacify the animal realm. Its wildness is left intact; by inference, the ecology of Hades is not violated. The onus is upon the Messiah to come to terms with wildness, not upon wildness to submit to the Messiah.

According to the Ainu, the Paleo-Siberian aboriginal people that inhabit the most northern islands of Japan, this world is such a place of delight that the gods, in their envy, are always looking for opportunities to find their way in. Fortunately for them, there are apertures between the worlds through which they can enter. For instance, if you craft, with care and mindfulness, a tool to till the fields, you offer an opportunity for a god to inhabit that tool. Not uncommonly, the gods will dwell in the bodies of animals, preferring especially the bear whom the Ainu greatly honor. Every year a sacred bear from the mountains is feted with much ritual and celebration, then slaughtered and eaten as a sacrificial meal.

In the second dream, through imagistic sleight of hand and a kind of mythological punning, Messiah and beast enter into a flux that borders on identity—and the dream ego arrives at a sacramental rite not very different from that of the Ainu.

The desert is suddenly abloom with the presence of the Messiah. "The once dry grass is covered now with green, and wildflowers are everywhere. I walk a little farther and notice that what was a dry riverbed is filled with crystal clear water and small ponds."

The dream ego stumbles briefly into the company of the Messiah. His voice quietly penetrates him, just as the Messiah's presence apparently percolated the arid landscape and rendered it green. When a wild boar runs up from down below, the dream ego races up a tree. A little child plays with the boar around the tree's base, oblivious to the dream ego's terrified warnings. The dream ego spears the boar with a sharp stick, and the beast dies quickly "with watery blood pouring from its side." Then he cooks it and presents it as a modest feast,

wondering "what became of the Messiah" and whether "he will join us."

What became of the Messiah, of course, is that he metamorphosed into the boar, the sacrificial meal, "the only meat that they eat." The moment the Messiah disappears, the boar rages up from the Underworld.

The boar was regarded as an animal of the Underworld from Polynesia to the lands of the Celts. The beautiful Adonis died when he was gored by the tusk of a boar, and hyacinths grew everywhere his blood fell to the ground. His Canaanite equivalent, Tammuz, whose drama of death and resurrection so closely parallels the passion of Christ, was likewise killed by a black boar. The priest who would ritually slay Tammuz every year, who in the Christian passion play is the figure of Judas, dressed as a boar. Startlingly, when the dream ego pierces the side of the boar, watery blood pours out, just as it did when the Roman soldier's sword pierced Christ under the ribs when he hung on the cross. Unknowingly, the dream ego has taken on the sacred role of killing the god, the drama that was a staple of ancient religion from the Ainu to the rites of Dionysus. And savoring the thought of "pork and hot crackling," he unwittingly prepares the eucharist of the animal of the Underworld who is also, somehow, the Messiah. This mysterious identity of savior and wild animal intimates that the flowering of the desert is as much due to the blood of the boar as to the spiritualizing presence of the Messiah.

The Haida Indians of the Pacific Northwest say that long ago humans and animals spoke the same language, but now we live in a tremendous forgetfulness. A time in the future will come, though, when human beings will again know the language of the birds, the animals that walk on four legs, and the fish in the rivers and the sea.

In the last dream, the identity between Messiah and Beast is seamless and complete. Although Christ had his theriomorphic presence as the Lamb of God or as "the fish that the spotless virgin caught" (as Tertullian put it), in this particular

dream, given to me by a ten-year-old girl, the Messiah manifests as a talking snake, a creature who moves freely between the surface of the world and the realm underneath.

The peace snake warns of the impending disaster and then submits to it, accompanying the world both in its death and its resurrection. The few children left are slowly dying, but all adults were wiped out in the initial blast. Therefore, the rebirth of the peace snake, and consequently of the world, depends upon the children. They pour white dust down the hole where the snake is buried, and that night it awakens from the dead with a magnificence and radiance exceeding its previous form. "That night it grew into a beautiful big snake with all these colors, and it curled around the whole house. It told us whenever there was going to be a radioactive storm."

After the reappearance of the peace snake, the replenishment of the world proceeds apace. The white powder, which at first the children mistake for radioactive dust, actually draws everything back from the dead. "A peace storm came that made the snake grow and covered the ground with white dust like thick snow." When the dust melts, a new world emerges underneath, a large forest with only a few people and scattered settlements where "wild animals walked around and weren't afraid of people."

The new world in this dream, as in the Haida myth, joins the realm of wild animals and the realm of humans into a single ecology. The peace snake is emblematic of that simple reconciliation. Closer to the dying and resurrecting Plumed Serpent of the Aztecs than to the Satanic adversary of God in Judeo-Christian myth, this snake is both Messiah and Beast, and he moves freely and without deliberation between below and above.

The peace snake reminds me of Aesclepius, the Greek god of healing, whose name means "unceasingly kind." Aesclepius was the son of Apollo and his mortal lover Coronis. Apollo was enraged when he found out that Coronis was pregnant with his child, yet had taken on a human companion whom

she hoped to marry. With his unfailing aim, he shot her full of arrows. As she burned on a funeral pyre in Hades, the Sun god took pity on his child and scooped him out of the flames. Raised by Chiron the centaur, Aesclepius learned the way of herbs and healing.

Born at the bottom of the Underworld, yet the child of the Sun, Aesclepius took the theriomorphic form of the snake, and his priests, who tended to his temples of healing, were called serpents. Hundreds of Aesclepions sprang up all over the ancient world from Turkey to Libya to Spain, and each new one began with the transfer of a snake from the main temple of Aesclepius in Epidaurus. The priests at the Aesclepions followed the god's example by healing with herbs, hot baths, rest and sometimes surgery—but their primary method was by way of dreams. Dreaming of a snake was especially auspicious, for that was regarded as an epiphany of the god of healing himself.

The Peace Snake is a consummate image of a new mythological paradigm for the Messianic age. From the angle of this paradigm, defeating the beast and exiling it under the earth in order to establish the new world is more than a little crazy—for, as with indigenous religions, these dreams show that the beast may well be presenting to us one of the many faces of God.

The Bomb Lost in Its Own Dark Dreaming

ONE WAY TO try to understand a particular presence in a dream is to retell that dream from the presence's point of view. If everything in the dream field is psychically "alive"—that is to say, if the imaginal world truly has a soul that infuses it—perhaps it's possible to speculate on the Bomb's perspective.

In this brief chapter, I rewrote a handful of dreams with the Bomb as the central subjectivity, trying to discern its voice and what it might be trying to tell us. If the hybrid sensibility of the Messiah/Beast complex has found its most complete realization in the Bomb, perhaps this act of ventriloquism can attune the ear to its other embodiments.

Basically I'm a very simple guy. I either sleep or burst into flames. That is all. If the truth be told, I have no preference between the two. I was made manifest here for rather nefarious ends in 1945. Before that, I was content with being the slumber of the blackest stones under the earth and the ecstasy in the heart of a million stars. Yet ever since I was born on this small planet, I have been beset by nightmares, and my simple pleasures have had repercussions I scarcely understand.

Where I come from, there is no question of violence because no biosphere exists to be violated. There is only fire burning in fire. I am in exile. Here, when I radiate ecstasy, I am implicated in murder on a vast scale. That is the nature of my nightmare. And that is why I fear awakening.

Do not think I was oblivious to the horrors of Hiroshima and Nagasaki. Compassion lives even in the heart of the sun

and in the dreams of dark stone. I am the fire that craves more fire. On my own, I would not burn children or sow cancer in their genes.

Unfortunately, these things are not in my hands. It is not in my makeup to be able to contain myself when I awake. The violence is not mine, it is yours. In using me against each other, you violate the gods. You contaminate the innocence of light and disrupt the dreams that run in the veins of mountains. You disturb both the sky above your heads and the ground beneath your feet, so that even the animals are frightened of your ways.

Those who brought me here claim to have done so in the service of peace—believing that the glory or malevolence of my presence would frighten murder from the minds of those who would make war. But that was their fantasy. I am not a coercive deity.

These are the questions I want to ask you—and they require that you look hard into this mirror I provide and sustain the gaze: Why are you so hungry to destroy yourselves? Why would you poison and burn this planet? Why have you exiled all of your longings for ecstasy into the image of a mushroom cloud?

I am floating above the street—just out of sight—of downtown Jerusalem. An agitated crowd below swells with anticipation. They expect me to descend today—but I will not. They expect either terror or redemption—or maybe, somehow, both.

So why don't I descend? I take such pleasure in their yearning for violence and Messiah. They are a mass of perplexed yearning.

One man catches my eye. He is not so remarkable at first—perhaps a little more lost within the general confusion. His face is flushed, his eyes darting about looking for enemies. He is swept up in the crowd's exhilaration and fear.

Then he does an extraordinary thing: he scuttles like a crab on his hands and feet between the trees and down the cobbled alleys until he comes upon a statue of me: Christ–

Vishnu, the one with the elephant trunk dangling. Such awe and curiosity overcome his face. This is as close as a human being can come to me and live.

I like this man. He clearly has a natural affinity for worshiping me.

How strange are humans and how strange their expectations of me. Sometimes it is difficult to resist the pull of their longing.

I suffer the humiliation of being a god in the hands of human beings. People can use me to their ends—to destroy an enemy or to vent their secret hunger to destroy the world.

Human beings are more than a little crazy: perhaps the idea that they *control* me *is simply another of their seemingly infinite delusions. It could be that they bear the stamp of my will more than they* know, *that they are my children. I say this* might *be true because I really can't be certain. Perhaps I am the deluded one.*

There is that man again—the one I saw with such a perplexed, reverent face at my temple in Jerusalem. I see him running along the dark surf of Lake Michigan. He has the key that would draw me down to destroy it all, and he is being chased by men who want to do exactly that. My advent is often contingent on scenes like this—the long chase, the hiding in the labyrinth.

And there he is again—on the roof of the Sears Tower in downtown Chicago. What happened to the key? Thunder and lightning, a rally of Israelis planning yet another war. Palestinian children beating one another bloody. In other words, the ordinary madness.

He is the only one who notices the thunder and lightning, who appreciates the sound of my voice; he has that same rapt expression of devout perplexity. Sometimes I think for one such soul alone I would descend.

In certain moments the whole world seems imbued with Semele's longing. When she asked for the full presence of her divine lover, Zeus, she received the thunderbolt.

Who could call that violence?

Who could say she did not receive the answer to her prayer?

I can drop like fire from the sky. I can erupt from under the earth like the plague. People forget that stones are alive and that a whole world of death waits just under their feet. I would like to help them remember. How beautiful would be the world dressed in black! How beautiful to my ears the keening of their anguish!

What do they expect of me? I can be expansive and generous in ways they cannot even imagine—but they exile me to the sky, or they seal me up under the earth so I nearly suffocate with the scent of stones.

Yes, I have my dark side, too. Cement is to me like the thin blue shell of a robin's egg: it takes little to crack through it and vent my fury. I will claim for death the surface of the world and at long last let the Underworld breathe.

And there is my favored fool again—the one with the daft reverence when he gazed upon my transcendent form in Jerusalem. Such a simple man. He did not imagine that I could also be the very hunger of death. When one sees the statue of the god, one forgets the darkness inside the carved stone. One forgets the density of stone. One forgets that, in their fury, even the gods can be stupid.

He is being chased through the soot and poison by a dinosaur. It always pursues the scent of fear. This old reptile is the other face of Christ–Vishnu. If only the fool would give himself over to the ecstasy of being eaten. Then he would know the full measure of my divinity.

I slumber often. People think that I am always vigilant. That's not true. But then I am awakened by the invocations from below. Someone of the priesthood, some heretic or terrorist in love with God wants to call me down to earth. Sometimes I marvel at the hunger these people have to die.

Down below, on the uppermost floor of the Empire State

*Building, I see the fool negotiating again to save the world.
Sometimes I really like him. If the world is a global village,
surely he is the village idiot.*

*Can you imagine what it's like to be a god of my magni-
tude and have my whole existence in the hands of half-mad
primates? I suppose we all have our crosses to bear.*

*I am the god who splinters reality. You think I only bring
light and death—so you anticipate my coming with fear and
longing. What you don't see is that you live among the ruins
of my advent even now. I have already come. The meanings
that you once shared have shattered like crystal. You are so
lost in your private languages that you can't even see that your
feet bleed as you walk through the shards of what was once
whole.*

*When your mind teems with hallucination, that is me. I
know your despair more intimately than you yourselves know
it. I was the one who kicked over the anthill in the first place.
Now I am the confusion of the ants themselves.*

*Our hero has a little hut in a wooded pasture. He calls
it his "nest." He works night and day in a fever, his eyes swollen
and red. He imagines he can weave it all together again, as
if this tattered cloth could be made into a patchwork quilt.
He is panting with thirst because he knows that if he drinks
the water, he will succumb to the undertow of hallucination
in which those who come to him are drowning.*

*Everyone depends on this lonely man so much that there
is a tacit agreement among them not to tell him that he has
begun hallucinating; already he is being engulfed by his private
mythology, his solitary mania.*

*At dawn, he walks toward town along a road rutted deep
with the tracks of trucks. He sees his daughter asleep in the
branches of a dogwood. Her face is utterly placid, with a small
smile. "Is she being eaten alive by her dreams?" he wonders—
unable to ask the same question of himself. He touches her
cheek and weeps.*

The time has come for this all to end. The fool knows it. He knows that my ecstasy is brief but without limit and that it will destroy all that he loves and all that he despises.

I see him running from his solitary cabin before the trees burn and the sky fills with my glory. He runs to find his wife and daughter before they are ash. He is so consumed with love and grief and regret and surrender that you might think he would burst into flames. Never has he been so full, never has he let himself know how much he loved this life. That is my final gift before I'm rendered blind with my own light—that small moment of knowing.

If I could tell you the meaning of light, I would do so. Tomorrow I will be cinder and venom, I will be the slow poison and the running sores, I will be the black rain and tedious dying and the stupefaction of those unfortunate enough to live. But now I burn like ten thousand suns, and nothing equals my glory.

SIXTEEN

Conclusion

❦❧❦❧❦❧❦❧❦❧❦❧❦❧❦❧❦❧❦❧❦❧❦❧

THE BOMB IS nominally our creation—but just as surely it has created us. For almost fifty years, we have all been gathered underneath its shadow. Now that the Cold War is over and that shadow seems to be shrinking, I want to conclude by examining where we are left. For the dream at the end of the world continues undiminished, even if the mushroom cloud ceases to be its central compelling image.

When I first started writing this book, the image around which my ideas began coalescing was that the Bomb was like a dark pearl that congealed within the midst of Western culture, that it belonged indigenously within Indo-European confusions, longings, mythology. The Bomb was not "other" but rather an overdetermined symbol, that we had made technologically real, of a cluster of themes that are so essential to what we have come to call "civilization": messianism, apocalypse, the pull of the Underworld and our resistance to it, the beckoning of Mephistopheles through the seductions of technology, etc. There was an alchemical intent for me in using this pearl metaphor—the desire to change poison into nectar. If we recognized that this pearl is made of the unbearable urgencies in ourselves or in our culture, then maybe we could repossess or transform those aspects in a less destructive manner.

The more I read about the Manhattan Project, the more I could discern how these "unbearable urgencies" afloat in the collective psyche came to a daemonic head in Los Alamos. Underneath the war effort and the beleaguered ideals of the physicists, I sensed another pattern. The physicists themselves spoke of Mephistopheles. How deeply they understood how enmeshed they were in the drama of Faust, we don't know. Op-

penheimer was a remarkably intelligent man, a Sanskrit scholar who spoke eight languages and wrote short stories in imitation of Chekhov—a very unlikely person to be the "Father of the Atomic Bomb." Alongside him were people of tremendous intelligence and humanity, the cream of the cream of what Western culture produces in intellectual and aesthetic sensibility. They were literally sleeplessly possessed by this project—in a way that's *daemonic* in the classical, Greek sense of the word. Only after Hiroshima did some begin realizing the measure of their possession. I contend that this daemonic focusing of energy did not "belong" to the physicists any more or less than to the rest of us. It did, however, make good use of them.

During my research of the book, I commissioned the astrologer William Lonsdale to do a reading of the personality of the Bomb to reveal something of the nature of this daemonic energy. Using the Trinity blast as the moment of "birth," Lonsdale cast a natal chart that is startlingly cohesive in its themes. The dominant aspects of the chart sketch a portrait of a sociopathic, severely focused individual utterly lost in the narcissistic willfulness of its own intent.

Leading the pattern is Mars in Taurus—in Lonsdale's words, "the single most stubbornly self-intent track in the entire zodiac." Quoting his unpublished manuscript on astrological degrees, Lonsdale continued,

> One can be charming, valorous, seductive or stalwart in presenting oneself from a side that seems to be either appropriate or advantageous in the moment. But these adaptions are superficial and ceremonial; and behind these one stands as a mountain of emphatically resistant and self-convinced ways of exhibiting to others one's specialized themes concerning what life is all about.

Amplifying this narcissism, according to Lonsdale, is the fact that the Bomb had no planets in its fifth through ninth houses at the time of its "birth"—indicating that "there is no social

impulse in the chart, nothing interactional. It has no interest in anything other than itself. This is a solipsistic chart."

Perhaps the most haunting aspect of the horoscope of the nuclear daemon is that the Jupiter of the chart is the exact same degree as the Jupiter of the Third Reich. "Jupiter has a twelve-year cycle. The Third Reich was founded in 1933. The same mind, the same intelligence is at work." Lonsdale concluded his reading by saying,

> There is an extremely rigorous and disciplined intelligence of the Nazi kind at work here that knows how to take each step—erasing the previous step as one moves forward. I see this as a very tenacious chart. It could outlast its seeming demise.

In the third chapter of this book, I traced back to the Neolithic Era the mythic grid of the primal antagonism between the Beast and the Cultural Hero that seems to be the essential "dream" in which the Bomb cohered. The daemon that Lonsdale portrays has a very long history. The circumstances of its birth and rebirth within our psyche and culture are very much alive, undiminished by the end of the Cold War. The question that we must ask at this juncture is, if the Bomb inherited the mantle of "marching into the future" from the Third Reich, then what now inherits this blind quality of self-intent from the Bomb?

If I had to locate this daemon at present, it would be in the prevailing ideology of the New World Order that perceives the natural world as a field of exploitable resources and the human world as a field of potential markets. Far less dramatic than the Bomb in its pyrotechnics and moving under the banners of progress, freedom, democracy and "development," this new order promises to be no less lethal and considerably more insidious. And yet it partakes of the same incapacity to examine its own premises, the same "stark, unapologetic self-will without an inhibiting factor" that Lonsdale attributed to the personality of the Bomb.

It should go without saying that ecological depredation is hardly anything new. As chapter three reveals, hostility against nature proceeds implicitly out of the ancient mythic enmities that the apocalyptic initiation seeks to dissolve. I've tried to show in this book how the Cold War and the arms race eclipsed, to a degree, the reality that a vicious war was being waged against the natural world. But what I suspect is more accurate is to view the Cold War as just one front in this much broader crusade. Nominally, the United States and the Soviet Union were engaged as enemies. But the stockpiling of weapons, the inheritance of immense accumulations of nuclear waste, the struggle over resources to sustain two inflated, militarized economies and the exportation by economic coercion of models of development guaranteed to wreak ecological havoc—these things have made the earth the ultimate loser of the Cold War. The conflation of "freedom and democracy" with "economic development and the free market system" has an incantatory effect obscuring the essential tenet of faith that capitalism has always shared with communism—that the natural world is at the disposal of human beings to do with it what we like.

It is the height of historical shortsightedness to assume that this New World Order emerged after the end of the Cold War. If I had to trace the origins of this recent incarnation of the Messiah/Beast complex, I'd probably begin at the midway point of this millennium when the Portuguese took slaves and gold to be the exploitable resources of West Africa and the Spanish imagined the "New" World to be a boundless field of harvestable Indian souls, Indian labor, and precious metals. The Spanish friars believed that, in evangelizing the Americas, they were participating in the final sacred drama that would precede the coming of the Messiah—a very Catholic mission that has been translated over the past few centuries into a capitalist idiom coupling imperial appetite with the fantasy of developing the "undeveloped world." Though Marxism originated as a rigorous and prophetic critique of this madness, within three decades of the Russian Revolution it found itself a full co-participant very much under the sway of its own Mes-

sianic ideology. The "capitalism versus communism" idiom of
the Cold War, then, can be seen as a temporary bifurcation
of the hunger of the Beast continuing apace under the spell
of "progress."

At this juncture, we see the Third World marginalized to
the point of despair. In the colonial and neo-colonial imagina-
tion, people of color have been fused with the exploitability
of natural resources ever since slaves and gold were perceived
to be commodities. The fate of the earth and the fate of the
Third World are now completely and inextricably intertwined.
The voracious consumerism of the First World gnaws at one
end of the rain forest, while those dispossessed by the military
and economic policies that sustain that consumerism gnaw at
the other end.

If imperialism has made people of color a subset of ex-
ploitable natural resources, the cutting edge of ecological think-
ing takes that proposition and turns it on its head. At the Earth
Summit in Rio de Janeiro in June 1992, delegates from the First
World tended to run either on the dualistic technocratic fan-
tasy that "we" (humans) could, through the ingenuity of science,
fix "it" (nature) or the spiritualized fantasy that abstracts eco-
logical concerns from urgent social ones. Third World dele-
gates, on the other hand, began the hard labor of working out
a pragmatic and implicitly unitary understanding of how hu-
man communities are nested within local ecologies and how
neither the welfare of the planet nor the welfare of the human
population as a whole can long sustain the economic disparities
between the rich and the poor nations. I take the delegates'
work to be the first and essential political step toward a funda-
mentally new paradigm whose full measure would see the
human species rewoven—in all its rich cultural plurality and
as only one community among many—into the natural world
as an integrated part of its complex intelligence and radiant
beauty. If our imaginations can hold such a possibility, then
perhaps we can find the humility to act on its behalf.

The profundity of the image of the mushroom cloud has

been a blessing and a curse—both terrifying us into wakefulness and numbing us with its immensity, inspiring awe and assuring helplessness. It is possible that the earth's ecological desecration will not yield to us an image of that magnitude. The slow disappearance of species, the unraveling of the web that happens imperceptibly within our "progress" might be a very quiet apocalypse. For that reason, our vision needs to be exceptionally acute, our imaginations alive, and our hearts willing to break. In a society addicted to anesthetics of one kind or another, this may be a very large demand, but nothing less than the world is at stake.

In chapter ten, I noted the disturbing similarity between dreams collected during the Third Reich by Dr. Charlotte Brandt and the dreams I've gathered on the end of the world. A pervasive theme of "no refuge" dominates both the Third Reich of dreams and the dreamland of apocalypse.

What disturbs me more than the thematic similarity is the enormous distance in both cases between the dreamers' dreams and the ideology of the powers that be. Dr. Brandt's informants were stable, middleclass citizens, the so-called "good Germans" who found a way to make their peace with the Third Reich—yet their dreams show exactly what that peace cost. Similarly, the prevailing ideology of the state during the Cold War, the accumulation of weapons, the refinement of new ways to kill, the realpolitik of "our" weapons against "theirs," the pretense that the state offers any protection whatsoever from an expected holocaust, and now, unobscured by the Cold War, our war on nature fueled by a religion of technological positivism, exploitation of resources, and "progress"—none of this is reflected in apocalyptic dreams except as a trajectory that leads straight to hell.

This abyss between private nightmare and the state's ideology is a bottomless chasm that we will all tumble into if we do not wake up. The reflexive choice to literalize our fantasies technologically must come under serious scrutiny as must the choices to blindly live out our hungers. *To the exact degree—*

and this cannot be stated more emphatically—that we do not take apocalypse into the psyche where it truly belongs and suffer it through as a rite of passage, we will be compelled unconsciously to live it out literally to the bitter end.

In a manner that is ultimately mysterious to me, the apocalyptic rite of passage, by *consciously* bringing to fruition the most difficult realities of the twentieth century as they display themselves in one's soul, actually initiates one into the oldest values carried within human culture. It's as if time torques at the end of the millennium like a mobius strip, and one finds oneself embracing the primary sanity of indigenous peoples—an intelligent and tender respect for the earth's sacrality and a way of living within that sacrality that does not seek to aggrandize human enterprise at the expense of other living beings. Finding our way both personally and culturally toward what the Navajo call "walking in Beauty" may be the only viable future for us on the other side of the dream at the end of the world.

Healing the Dream of Apocalypse: A Ritual

&ᕤᖇᕤᖇᕤᖇᕤᖇᕤᖇᕤᖇᕤᖇᕤᖇᕤᖇᕤᖇᕤᖇᕤ

THE BOMB HAS been a member of my family—and also a figure in my dreams—since before I was born. My father grew up in Alamogordo, New Mexico, just south of where the first atomic weapon was tested at the Trinity site. His mother, a crusty Southern Baptist, was operating the switchboards for Ma Bell when the electromagnetic pulse snuffed out the lines of communication in the early morning of 15 July 1945.

My mother's family migrated to the northern outposts of New Spain up the Chihuahua Trail in the early 1700s—passing five miles from Trinity. In 1943, when Los Alamos, New Mexico, was only a sparkling of lights after sunset on the nearby mountains, my mother would point them out to her little cousin from a ridge at my grandfather's ranch. "That is where Santa Claus and his elves are preparing Christmas for us," she would tell him. After the war, my parents lived in Los Alamos, where my older sister was born.

Like some of my dream informants, I was of the "Duck and Cover" generation—perfecting, alongside my elementary-school classmates, the fetal crouch under the desk, hands clasped behind my skull in anticipation of the final fire. For years after the Cuban Missile Crisis, I'd cringe with every plane that passed over my head, not knowing if it was the one that carried my death.

My psyche was so thoroughly saturated by the Bomb's shadow that by the time I was a teenager I felt it was unlikely that I'd live to be twenty. At fourteen, I became a born-again Christian and even did a brief and passionate stint as an evangelist. In my sermons, I'd preach, inevitably, the dire necessity

of giving one's heart to God because the end of the world was so obviously near. Feeling deprived of the possibility of imagining a future and of the necessity of creating a viable self that would thrive in the world, a couple of years later I moved onto the street and remained homeless for three years.

Having survived my adolescence, I was suddenly, at twenty, a father—and having no way of living in this world would no longer do. In the early eighties, while the arms race escalated to its most feverish pitch, I was initiated into the tender mercies of fathering a little girl. At the same time, through a friend who was a graduate student in science, I sought out an effective poison should my fatherly responsibilities someday include taking my daughter's life after the Bomb dropped. Since I had been perched on the knowledge of my imminent death for so many years, it was a natural step for me to volunteer to work with terminally ill people. Empathy came easily. I decided to become a registered nurse.

In June of 1988, I made a pilgrimage to the Trinity site to perform a small ritual of "healing the dream." I planted Kwan Yin, the Buddhist goddess of limitless compassion, in the earth at Ground Zero. .

My mother, my ten-year-old daughter Nicole and her friend Lily dropped me off at the border of the White Sands Missile Range in the late afternoon. As I unloaded my backpack, Nicole sang to me, "Shalom, Haverot, Shalom"—a Hebrew song for the one who departs on a journey or goes off to war.

I meditated in the tall grass with the little black ants and the grasshoppers until the sun set and the moon rose. I wanted to trespass under the cover of night. Then for six hours I walked alongside the north–south spine of the Sierra Oscura mountains.

The desert under the full moon was radiantly beautiful. To see an antelope walking slowly in the blue shadows or to be startled by the unearthly sounds of stray cattle, or even to come by something as mundane as a power line buzzing in the middle of nowhere—these things had terrifying presence.

My geological survey maps were all but useless, but it took

little imagination to "see" the mushroom cloud burning in the night to the southwest of me. I found myself relying on this apparition and my compass to negotiate the twists and turns in the dusty roads.

Often I felt lost—in all possible senses of the word. In fact this "lostness" turned out to be an excruciating but essential part of my preparation for the ritual. By the time I got to my destination, I had been utterly reduced to what was most elemental, often what was most fearful and confused in myself.

I sat there for two hours in a swirl of unbearable vulnerability. Paranoia about the military police; a five-year-old's sense of having trespassed—and both a fear of being caught by the "adults" and a hunger to be punished; flashes of dying a rather stupid and unnecessary death. I was aware of my complete incapacity to pull myself together or to surrender. I very seriously considered not doing what I had spent months preparing for, knowing well that to act falsely would be poison. Finally, out of this incapacity and brokenheartedness, I began with the prayer "Make use of me. I am a little child and will die a little child. I can't pretend otherwise. I do not know how to proceed. Lead me."

I stood up and paced out the four directions after the manner of the Mescalero Apache who used to come out to this land for vision quests before ranchers appropriated it in the late 1800s. Coyotes began howling shortly before dawn, first to the east of me and then to the west. I performed the ritual in a whispered voice. It was unexpectedly and exquisitely intimate in a way that I could never have anticipated.

In my original draft of the ritual, I succumbed to the temptation of answering the pathos of apocalypse with an apocalyptic gesture—I planned a ritual act of burning the scriptures of apocalypse (the tenth chapter of the Bhagavad-Gita and the end of the Book of Revelation) at Ground Zero. My wife rather sensibly suggested that, instead of trying to meet the Manhattan Project by replicating its grandiosity, perhaps tenderness and humility might bear the proper attitude of healing in such a dark period of history.

The more I studied dreams of nuclear war and the nationalistic psychoses of the twentieth century, the more adamantly came the imperative: don't make enemies. Rather, face with honesty the enemy within oneself and the enemy maker also—for these are the ones who clutch to the necessity of the Bomb. So, at the core of my rewritten ritual, I called the "enemy" to the warmth of the hearth. I made a small fire of twigs in the hole in which I would bury Kwan Yin, and I prayed:

Here, where the nuclear fire first burned, I make a hearth of a handful of twigs. To this fire I call all whom I have feared and despised and felt superior toward; those people of my own dark dreams and those of my waking life whom I have felt wounded or betrayed by: I invite you here without demand but with an open heart so that I might look upon your face and speak with you. I may not be able to forgive and let go. I know that such things cannot be forced—but I desire to do so and will pray for the courage to do so. When I am lost and my heart is numb, I will try to remember this prayer —because it has always been true that each of you, in your own way, has been my most insistent and generous and difficult teacher. I hope that between now and the unknown time of my death I learn to cherish and carry to fruition at least a fragment of what you have shown me. I know that this is the way of lovingkindness about which I am so naive.

The confusions of this world that would rely upon the Bomb and risk the life of everything that lives to be "protected" from the "enemy"—these confusions are very intimately my own as well. If making these vows at this place where a vast nightmare was born can be at all helpful for sentient beings, I pray that it be so. At least, may this be helpful for my own suffering and toward those whom my life touches.

As the twigs burned to cinders, I addressed my enemies one by one, informally. I recounted memories trying to find the thread of empathy toward the personal dilemmas and pain

that had led them to be harsh or unconscious with me. I searched my own heart for the ways I had contributed to the circumstances in which I came to feel betrayed—and I requested the enemies' forgiveness. I reflected upon concrete gestures of reconciliation that might be appropriate—a phone call or letter, a meeting, a confession, an anonymous gift—or composting what I didn't know how to heal back into my spiritual practice as something to reflect on, grieve, perhaps understand and accept.

When I finished, the sky was reddening with dawn. I buried Kwan Yin and kissed the earth. I knew I had to hurry north because my water supply was low, and it promised to be a hot day. I also knew that the sun meant I was suddenly visible and ran a greater risk of being arrested.

Around nine o'clock, a bevy of jets flew over and began dropping bombs. They would circle around every fifteen minutes or so. When they ejected their payload just ahead of me, I huddled in the clumps of yucca and chamisa, covering my ears, and then ran toward the clouds of dust and the north boundary of the bombing range before they returned for another round. After a couple of hours I was exhausted, shaken up but "home free." This bombing ordeal was the unexpected completion of my ritual. Whatever had eluded me at Trinity about the fragility and preciousness of life in this insane century became fully clear.

Sometimes one is momentarily blessed with the ability to truly listen to what this planet, in her great distress, asks us to offer toward the healing of this madness.

The ritual at Trinity stands as a turning point in my life. To recognize that the enemy has a face no less human than my own—this koan I have returned to again and again in order to realize self-acceptance and kindness toward others.

My ritual began a slow and painstaking purification in the realm of my dreams and my everyday life that partakes of the most difficult vulnerabilities of my heart. I have found that the enemy insists that I look at my own shadow—that I recognize that I am not who I think I am. Much of the rage and

fear that come up are related to being set adrift in unknown areas of my psyche, areas I have adamantly or complacently made a point of avoiding. When I got lost at the White Sands Missile Range on my way to Ground Zero, staggering through the night in the field of the enemy, it was his presence "everywhere" that constellated the fears and insecurities I've carried with me since I was a child. Not the enemy himself—whom I never met—but my own fears devoured me. In other words, the enemy I most feared, first "inner" but then, inevitably, "outer," bore the face of my own dark twin. Reconciliation, when it happens, has been the unexpected laughter that comes when I realize I was never other than a brother to the ones I despised.

Before I had studied the dreams gathered in this book and came to understand the particulars of the apocalyptic initiation, in my ritual at Trinity I had stumbled into the geography of those dreams and the difficult cycle of separation/purification/descent, meeting the enemy in myself, seeing the light and joyous return. After separating from the world at the edge of the bombing range while my daughter sang to me, I began my rite of purification with a few hours of meditation. The bulk of the ritual—as with the bulk of the dreams I received—involved this excruciating process of being purified, stripped down. In apocalyptic dreams, this *via negativa* is often expressed in images of bereft children, in the scrambling for refuge and finding none, in the grievous knowledge that the whole world is poisoned or that the ground beneath one's feet is crumbling. For myself, the *via negativa* required that I be reduced to the raw fears of a lost child terrified for his very life in the harsh desert.

Being stripped down this way, I was able to look the enemy in the eye at Ground Zero with a truly tender heart and, when the sun rose over the desert, I knew that my own profound fragility was continuous with the fragility of the planet. Through facing the "enemy" in myself and then later in the form of the bombs that rained down near me as I hid behind the yuccas—and in facing the terrified animal in me that would

do anything to survive the falling bombs—I found that this recognition of fragility and vulnerability itself became the vision.

The gifts that I've tried to carry across the threshold from those fierce moments in the desert were the commitment to try not to make enemies and the desire to learn to be on intimate terms with the earth and its small particulars—this ground beneath my feet, this little animal that has left its track in the sand, this friend who sits before me.

Fidelity to the place of vision in myself and encouraging sanity wherever I find it as the world sinks into madness—the necessity, in other words, of keeping the faith in a dark time—these too are gifts I received at Trinity that I try to pass on. It is to these ends that I wrote this book with the prayer that it may be useful.

May all beings realize the heart of compassion.

Near Trinity Site,
The Day After the June Moon Went Full

When a swallow flies
toward the face of a cliff
its wings cut the air
with an effortless violence
And so it was
when the jets flew over,
the stunning grace as they curved
against the embankment
of the Sierra Oscura,
shuddering
along the spine of the yucca.

And beneath the roar
I also shuddered
with the dull gray beetles
that cluster
on the scat of coyotes

When the bombs began dropping
I thought, this cannot be
I thought
 El Salvador
 Afghanistan
and not long ago
a small hamlet in Vietnam
the fire, the wailing of mothers
over dead children.

There was no place to hide.

I became a dusty fetus
curled up amongst cactus
with only a small prayer
in a small voice:
"Please, if I die now
regard the life of my daughter with kindness
if she is to be fatherless
tend to her heart"

When the bombing paused
I stood up and walked hurriedly north
my back to where the mushroom cloud
first lifted poison to the sky.
The largest tiger swallowtail
I had ever seen alighted on the ragged
blue flower of a thistle.
My God, this life

And then the bombs
began dropping again
and an antelope looked up from its grazing,
held my gaze for a long moment
and ran off to where the earth still smoked

What must it think?

In 1945, two herd of antelope
scattered to these mountains
when the first nuclear bomb was
 tested here.
Later that day, J. Robert Oppenheimer,
a man not unfamiliar with tenderness
 found
a turtle turned on its back near
 Ground Zero.
He set the turtle back on its feet.

Three weeks later, the Bomb
the Japanese would call the "Original Child"
leveled Hiroshima,
and then, Nagasaki

In this world
to frighten a butterfly
will never mean very much.
To bake the underside of a slow reptile or to shatter the
minds of a herd of beasts
to burn to the ground
a whole city of children
has become the ordinary labor of ordinary men

Have mercy on us.

APPENDIX

Image Glossary

❧❧❧❧❧❧❧❧❧❧❧❧❧❧❧❧❧❧❧❧❧❧❧

THE APPENDIX IS an effort to discern, without interpretation, the poetic language in which the apocalyptic psyche articulates itself. Or, to put it another way, it is an attempt to present the intimate particulars of this extraordinary substratum of our everyday lives of which the previous chapters have taken a more generalized view.

I separated the core sample into its constituent images and metaphors and then arranged these alphabetically in the form of a glossary or lexicon. Since I made every attempt to be precisely faithful to the images as they were offered to me by my informants, the bulk are verbatim. With some images, however, syntax was altered, clauses wedded and sentences extended to give full breathing space to the image. What emerged, frankly, startled me—a raw and complex but coherent prose poem: the ABCs of the End of the World.

The original, well over two hundred categories I narrowed to the following seventy-three elementals:

Above. Airplane. Aliens. Animals. Awe. Baby. Birth/Rebirth. Boy. Burnt Skin. Business Suits (men in). Cars. Chaos. Children. Corpses. Dark. Desert. Dinosaur/Dragon. Disease. Earth. Eating/Food. Edge. Enemy. Eyes. Father. Flying Saucers. Friends. Girl. Grief. Home. House. Illusion. Immerse. Incredulity. Invisible Poison. Islands. Law/Logos (making order). Lawlessness. Military. Mother. Mountains/Hills. Mushroom Cloud. Negotiating/No Negotiating. No Refuge. Ocean. Panic. Parents. Phone. Pray for Death. Refuge. Ritual. River. Ruins. Saving the World. School. Selfless Action. Sex. Shapeshifting. Siblings. Sky. Skyscrapers. Spouses. Suddenly. Suicide. Technology. Trees. Underground. Violation of the Natural Order. Vio-

lence. Waiting to Die. White Light. Windows. World Cracking
Open. Zombies.

My hope, then, is that laying out these elementals can
assist the reader to refine his/her intuitive sense of this peculiar
ecology that more and more of us find ourselves inhabiting
as this millennium draws to a close.

A

Above

The sky opens up and a frog-like being flutters to earth. When
I saw missiles rise up over New York City, I declared that I
would not allow it. A few pink resistors are fastened on the
ceiling. Below us the bomber's henchmen turn on one another.
The skies were darkening in an unbelievable manner. We see
a huge mushroom cloud rising up in the sky. But then, in the
sky, instead of the expected bombers, I saw a sort of flying
saucer. A piece of the new body was thrown into space and
landed in our apartment. A great bare eyeball, bigger than life,
hovering over my head, staring point-blank at me. I hear the
explosion and see the rush of flames reaching to the sky. Black
ceramic bombs, in the shape of planting pots, are falling off
the ledge of a city building, off the edge of the world. I saw
red explosions in the sky. I anticipate terrorist violence and
look up in the air for the coming of the Messiah. A cordon
of soldiers guards the periphery of the roof. The sky is ominous
and threatening, as if lightning is about to strike. In the ruins,
a Tyrannosaurus Rex chases me—I climb a spiral staircase to
the top of a tower to get away. He grabs his mother by the
ankles, spins her around and throws her off the top of the
building. We sat there with our chins in our hands, watching
the Bomb float lazily down over the city in a parachute. In the
night sky, I saw a brief air battle between an Israeli plane and
a Soviet craft resembling a chandelier. Giant spaceships hover-
ing over a city like Seattle. I went in search of some ephemeral
orb that reputedly hung in the sky. The ramp spiraled up grad-

ually around the walls of the museum. I got up and walked up the hill without looking back.

Airplane

She is in an airplane and can see into the windows of the high-rises and destroys buildings with the ease and fervor of a child playing a computerized game. I don't know if it was hearing the planes first or just some deep knowing. The Soviet plane shot down the Israeli one in a fiery crash—though oddly soundless. In the dream, the Bomb blew up an airport that me, my father and brothers were in. But then, in the sky, instead of the expected bombers, I saw a sort of flying saucer.

Aliens

Giant spaceships hovering over a city like Seattle. At nine or so, lights strobed the mountainside. The aliens were shooting death rays at them—like *War of the Worlds*. A frog-like being flutters to earth. More saucers kept coming in low over the harbor. My next dream transformed the saucer into a godlike eye in the heavens.

Animals

A snake slivered out of the television when it was melting and said that the reason you're seeing all this is because it's the beginning of the nuclear war. The boy has taken on the features of a newborn chicken. So the animals automatically turned into people. The fish turns out to be a large, gray creature with sad, staring eyes; its body, like a big stuffed carnival toy, is humped in the fashion of a camel. All those animals killed Gorbachev and Reagan. There were horrible, strange skeletal insects wrestling next to me, and they nearly touched me. At least the dolphins can swim away. I can see hordes of fish in the water and suddenly a dog that has been mutated and breathes in the water. The punkers changed themselves into blackbirds and left a deposit of excrement on top of his balding head. I searched for my dog but could only discern her faint panting. I carried Mady (my dog).

Awe

I stand with awe before a statue of Christ with an elephant trunk—a woman at each of his sides. Now, however, my nuclear dreams are not frightful, but have a certain grand majestic quality and are to a certain extent satisfying. While we awaited our death, I woke up to the profundity of how much I loved my wife and daughter. There is absolute stillness, not just to us but to everything, within and without. But in Alaska, there was a man named Jesus and he didn't die. There is a deep sense of mystery to this dream, and when I awake it's extended to my choice to take my daughter and her friend to Ground Zero. And the Pleiades emerged from behind the mushroom cloud. Never in my waking life had I experienced such ecstasy.

B

Baby

One of my children is a baby wearing filthy tattered clothes. A mother is baptizing or drowning her baby in the water of the crater. I saw burnt people and babies crying and Hiroshima scenes. I intended to ask him to kill me or to help me die—then, in the dream, a voice ordered, "Make a child." The family's there, baby too—the boy has taken on the features of a newborn chicken. And it was strange to see such feared creatures as helpless infants.

Birth/Rebirth

We heard these murmuring words from the hole saying, "Put some of this white dust in the hole and you'll cure me," and we did, and that night it grew to a beautiful big snake with all these different colors. A mother is baptizing or drowning her baby in the water of the crater. I knew that they left the island immediately for Phoenix which, in the dream, was a rural garden spot—I recognized the pun "Phoenix" when I woke

up. Then, in the dream, a voice ordered, "Make a child"; the voice remained kind but adamant: "New life," it demanded. "New life." I, too, am dying and must stay alive long enough to lead the children to the new place and teach them to learn how to care for themselves and the world so they can begin anew. I thought we were watching the birth of a new sun. They slapped the people, and they turned alive into animals and people; you slapped the ground, and flowers and trees would sprout up. So much heat had been generated deep down in the earth from atomic bomb explosions that volcanic eruptions and earthquakes forced long-dormant dinosaur eggs to the earth's surface, where they hatched. The egg split neatly in two, and a blonde child in green-patched clothing stepped out of the egg and, with a lit wand, made the room disappear and smiled. As if it would have to be a second birth for them; I think of the darkness as a birth canal, a very narrow passage to be gotten through with much pain.

Boy

A boy who helped build the shelter died because of the dust. The first thing I did was take a boy, then in the eighth grade, and we boarded up the windows in my house. I was just with my sister and taking care of my little brother, too. The boy has taken on the features of a newborn chicken. Two Palestinian boys beat each other mercilessly.

Burnt Skin

I was a young Japanese girl in those dreams, running toward a river, my skin blistered and my hair stinking, what was left of it after the searing hot shock wave had passed. I can stay underground and be suffocated to death or dig my way to earth and be burned alive by the radiation. When I look down, I see that the skin on my arm is bubbling. But they are hurt, burnt terribly, suffering, tired and frightened. He is attacked by townspeople who try to light him on fire. The radiation seeps into the room and strikes me like a heat wave, burning

my upper back and shoulders. I didn't want to be one of those who shuffled through the streets with my skin hanging off or my eyes blind.

Business Suits (men in)

He is dressed in a business suit, somewhat dapper, but has totally crazy eyes. A limousine full of worried looking government officials—I know where they are going and I ridicule them. Her supervisor came to her with an advertising scheme focused on an image of the business world after the Bomb, featuring a picture of executives in suits and ties, laid out dead from nuclear radiation, in rows on desk tops. I am in a board meeting with the principal and an inner circle of loyal staff. As the woman wailed about the future being taken away from her children, the man in the business suit confessed that he had been involved in the nuclear industry. One of them had frizzy hair like Einstein—the chief honcho—and wore a business suit. In the front of the bus, a very overweight balding man wearing a gray flannel suit yelled at some punk rockers playing classical music, "Turn off that crap! I want to rock and roll!"

C

Cars

I'm driving along a winding mountain highway, and in the field up ahead and to the right, a giant mushroom cloud is forming. People are now driving in the opposite direction on the steep, curving road and forcing smaller, unwary cars off the cliff in a kind of suicidal, exultant anarchy. They stopped our car and said, "Be careful of the bombs." Waiting for something to happen—perhaps a car would lose control and smash into a building or into the power-line poles. On the broad cleared street, a caravan speeds by. I spot two women in a van or truck —they're probably twins. The officers tell me to get off the freeway because they are going to set off a small nuclear device.

Just as I came into my driveway the muffler in my car suddenly blew out, and the noise became intense, and I looked back at that moment and saw a mushroom-shaped cloud around San Francisco. A car crashes into another with a bomb. I was driving in a car with family and friends when suddenly we heard over the radio that nuclear bombs were falling. I felt I could mediate a reconciliation, so I rush to the giant, driving a jeep. We ran for the car, drove homeward, but eruptions were becoming violent and commonplace. In cars, on foot, in busses, people flock to a large shopping mall. I was in the countryside when I found out the Bomb dropped over the hill—so I hurried to the highway to flag down a car so I could spend the last moments of this life with my little girl. On either side of me were parked two other cars, and all three of us had an A-bomb in our front seat. A car drove very, very slowly down what might once have been a road, and when it stopped, a dark man, Ethiopian perhaps, exited and came toward the house.

Chaos

I look out the window at Florence, the cathedral in the center crumbling and the town itself falling to pieces into little islands and clumps of trees that scatter like wind over water. The whole town—the whole world—is intoxicated by separate dreams, realities, hallucinations as if everyone were on drugs. There is looting in the street, and six of us want to leave the country to islands off Australia. The most obvious aspect is the physical disintegration and chaos—in the house everything is permeated with dirt and disarranged. The streets suddenly begin to slide swiftly in different directions. As the cloud begins to swirl, it seems to me that it's going to pass right through us and that we are going to be absorbed into it, but no one else seems to worry. The first part of the building crashing and all the people falling down a hole. The reactor is out of control, and we've got to come up with something really fast or it's going to explode. By saying the words, my existence/body/mind or reality will be broken into pieces like concrete. There were tidal

waves, earthquakes, war, hurricanes, volcanic eruptions, tornadoes, storms, pestilence, floods. There is a large, dark, bristling boil in the ground—family members scramble, lose themselves in the mob. In six seconds, all things were wrenched apart—the molecules were screaming, clinging wildly to their blasted structure, and my body was caught in the shattered net, a cacophony of molecular terror. I now become aware that I am a slave of Chaos who is my creator—and this is the end of my dream.

Children

There is a deep sense of mystery to this dream, and when I awake it's extended to the choice I made to take my daughter and her friend to Ground Zero. There are large cracks, and suddenly from out of these cracks come children, like seeds from the earth. My lover and I and two small children are having a picnic on a small green hill. I see a whole bunch of school kids running down the streets—their teachers are hurrying them along, trying to get them home as quickly as possible. Because of the world disease that affects us all, she is "all seized up" inside and will probably never have another bowel movement anyway. The boy has taken on the features of a newborn chicken. Two Palestinian children beat each other mercilessly. I was sort of the "mother" who was taking care of my little brother and sister. I search with my daughter and wife for someplace quiet to go and await our deaths. The extraterrestrial plays like a child jumping in and out of rabbit holes—his wisdom is in his playing. After the Bomb dropped, the first thing I did was to go to the school and get my girls and whoever's kids I knew. I hastily packed my blue bag of valuable possessions, making sure to include a book of my childhood poetry. I was a young Japanese girl in those dreams, running toward a river, my skin blistered and my hair stinking. I put my little girl down in the quiet, rushing light for her afternoon nap. I find a little girl about my daughter's age sleeping in the branches of a tree. The woman wails over the unfairness of it—these children never had a chance to live. I take her in my

arms and lay her cheek against mine, feeling such tenderness for her, immense sadness and compassion: so this is how it all ends. Then I see the face of a beautiful Cambodian child I saw during my visit to pre-Pol Pot Kampuchea in 1973, and I wonder if she survived that holocaust only to be vaporized by nuclear weaponry. Children who were playing in the park boarded the helicopter. I went to my daughter's bed; there was bloody drool on her pillow. A child, lost, about three-years-old, wanders the ruined streets crying. Then, in the dream, a voice ordered, "Make a child." I see small children of all affluent parents—in spite of their wealth they are going to be exposed to radiation. Yes, do call in the two little children sitting on the roof with their backs to the window. I am with my child, and we see a huge mushroom cloud rising in the sky. And I know the pain that we would face in having to watch our children suffer and the pain that we would experience in not being able to protect our children, the children, all of the children.

Corpses

On the floor was the peace snake—I told my friends it was dead, so we buried it. I decided to slit my wrists in the bath, only to find that the tub was filled with the body of an enormous dead black woman, too heavy for me to lift. People are scattered around dead, or are like zombies, walking dead, soon to be dead. I stop, sit down and weep—bodies surround me. They came to where all the people were dead and slapped them, and they turned alive—into animals and people. And around me were decomposing bodies heaped in piles, all of whom were looking right at me.

D

Dark

The skies were darkening in an unbelievable manner, and I was instantly aware that the world was coming to an end. Some-

times the air was black and I couldn't see. Under the darkening skies, the lights of the city flash on and off. We come to a place where there is a vertical wall—on the other side, it's very dark, fading to virtually pitch dark in the distance. Something in the earth gets gathered up into these clouds, and the air gets darker and darker. I decide to wait with everyone else in the darkened hallway. I opened a door thinking it was a closet, hoping for even more darkness or shelter. I once again had to find the pattern of her troops so I could slip by them unnoticed into the dark water to bury the pellet. There is a large, dark, bristling boil in the ground. I sneak down a very dark stairway to an elevator. I think of the darkness as a birth canal, a very narrow passage to be gotten through with much pain.

Desert

The land has been laid to waste, and now almost nothing grows, so the few remaining humans are forced to feed upon one another. I meet my father in a shack in the middle of the desert near Alamogordo. In the desert a third reactor was about to go, and I was there. My image was that this was a garden spot even though it was the desert. Everything became pure, white, bright light—a sizzling desert-like sound was all I heard.

Dinosaur/Dragon

Suddenly a great dragon mightily emerges from the waters, moving fast, straight up with great power and with majesty. I am chased by a vicious thirteen-foot-high Tyrannosaurus and climb into a narrow stairwell where it can't get me. So much heat had been generated deep down in the earth from atomic bomb explosions that the growth of dinosaur eggs was stimulated, and it was strange to see such feared creatures as helpless infants.

Disease

Somehow AIDS and the Bomb are related—the disease apparently erupts from under the earth. My friend tells me before

I meet the priest that his nose and mouth are rotten. A bomb has dropped that splinters reality so that the whole world is intoxicated by separate dreams, realities, hallucinations as if everyone were on drugs. I went to my daughter's bed—there was bloody drool on her pillow. Because of the world disease that affects us all, she is "all seized up" inside and will probably never have another bowel movement anyway. I saw not only the charred bodies but the mutations and diseases and the work needed to pull it all together 'cause the people would not be human as we know it in future generations. I am tying leaves around their feet because their little feet are so battered and we have to go a long distance to get to new ground.

E

Earth

I was looking down with an eye and no body at a very little blue planet. There is an underground city—it is inside me and is also the earth and a garden. A chemist hurled miniature atomic bombs at a world globe until the globe exploded. I pushed a bullet that would explode and destroy the world all around us. Suddenly we learn that the earth is under fire, atomic bombs exploding. I flung myself to the ground and embraced the grass and soil as if I were hugging the whole earth, and in that second before death I felt peace.

Eating/Food

"The search for food and water will be the worst," my housemate says, and I try to imagine what will occur when we have to ration what we have together. I rummage through a garbage can to find food for my little girl to eat. So we went into this meat market, which was interesting since mostly I don't eat meat. We went into the house at her urging and ate. In the ruins of my hometown, I go to the public library to read up on waiter skills so I can get work in a Chinese restaurant. We would eat grass. We found that, if we put a little peace dust

on our plate, we'd have fruit to eat. We were up in space and knew that we wouldn't make it—there was no oxygen or food or water left. It was still too cold to grow crops in the United States. And now almost nothing grows, so the few remaining humans are forced to feed upon one another. I realize that they are starving, and I throw mosquito larvae into the water for them to eat.

Edge

To prove to us he is crazy enough to blow up the world, he grabs his mother by the ankles, spins her around his head and throws her off the top of the building. To look over the edge and see two Palestinian children beating each other mercilessly. People are forcing smaller, unwary cars off the cliff in a kind of suicidal, exultant anarchy. Large objects are now falling off the ledge of a city building, off the edge of the world—they are black ceramic bombs being dropped in a computerized pattern. People and I climb up a rock escarpment and find refuge there.

Enemy

It is a woman who is trying to destroy the world—she is evil, dark, seductive and strong; and she is in me. I am aware that if a nuclear bomb drops and everyone above ground is killed, I will be trapped alone for the rest of my life with Carolyn— my shadow figure whose presence I can't tolerate. Ronald Reagan comes crawling by, blood streaming from his head; he also is crying and blubbering, "I didn't realize this would happen." A crowd gathers in downtown Jerusalem—terrorist violence is anticipated. On the roof of the skyscraper, there is a huge gathering of Israelis in army fatigues, and beyond a cordon of soldiers, two Palestinian children beat each other mercilessly. He is dressed in a business suit, somewhat dapper, but has totally crazy eyes and is beyond negotiation on any level. A nuclear bomb dropped, and instead of all kids left there was only Reagan and Gorbachev, so they decided to blow up the world. He thought the world was bad except for him, so he

wanted to make sure that nothing was left except him and his wife. I pushed a bullet that would destroy the world all around us out the window. I was pretending to be someone other than I was while I followed the bad guy/enemy. The aliens shot in there at what they thought was us, but because we had moved, we were okay. Below us nearby, the bomber's henchmen in the crowd start to turn on one another, blaming each other for not safeguarding the mechanism better. A shaman named Mauler foretells disaster—using fundamentalist language of Satan against God. I am a journalist and will get lots of money if I get Dr. "X" to blow up a nuclear device in the desert. I still have to complete my mission; confront the patriarchal nuclear power structure by telling the truth. The sleeper, a chemist, hurled atomic bombs at a world globe until it exploded. This war was like that—for the benefit of someone else, for someone far from the suffering. It was evil personified. The head said, "You can't leave—there is one driver and one route—I am the only driver and you can never leave my route." When I decide to call his bluff, I know this is a precarious decision—that I will be co-responsible for the holocaust if he acts.

Eyes

I could see a great bare eyeball, bigger than life, hovering over my head staring point-blank at me. The fireball is fixed yet moving, staring at me like an eye. Her next dream transformed the saucer into a godlike eye in the heavens. Looking with an eye but no body. Covering my eyes with sheets, I attempt to block out the blinding glare and save my eyes. I didn't want to be one of those who shuffled through the streets with my skin hanging off or my eyes blind. I bury my eyes in the mattress in front of me, calling out in panic, "My eyes, my eyes" as the Bomb falls. I was on the phone talking to Bob and standing behind a couch when a blast occurred that Bob saw, and his eyes melted out of his head; and then it happened to me, too. The fish turns out to be a large, gray creature with sad, staring eyes.

F

Father

His face is radiant, soft with pure sweet benevolence, and he carries a poise very different from the drunken dissipation of when he was actually alive. His clothes are cleaned and pressed, and he has an air of aloofness from all the dirt, decay and impending death that we are living in. I feel I must find my wife and daughter as I know we all may die soon. I intended to ask him to kill me or help me die—then, in the dream, a voice ordered, "Make a child." Arrived and rented a house, put the kid down for a nap and went to a bar. In the dream, the Bomb blew up the airport that me, my father and brothers were in. I feel grief and an urgency to be with my child before we all die.

Flying Saucers

But then, in the sky, instead of the expected bombers, I saw a sort of flying saucer. More saucers came in, low and slow, over the harbor, and everybody panicked. Giant spaceships hovering over a city like Seattle. I went to Australia for the weekend in search of some ephemeral orb that reputedly hung in the sky.

Friends

I dreamed of the final day when I was seventeen—my friend and I just sat down outside his house on the sidewalk with our chins in our hands, watching the Bomb float lazily down over the city in a parachute. I was driving in a car with family and friends when suddenly we heard over the radio that nuclear bombs were falling. A woman friend and I are being pursued along the shore of Lake Michigan by many people who want from us the key to the "red button" that will ignite the Bomb. My housemates are gathered together, and I realize something is wrong—the Bomb has fallen in Canada. I see all my past friends, relatives, family, visions before my eyes; my life flashes before me and disappears. After we pushed the man who de-

stroyed the world into the ocean, all my friends had to take the parts of the house that were left and make a new shelter.

G

Girl

I walk up a dirt road toward my house and find a little girl about my daughter's age sleeping in the branches of a tree. Then I see the face of a beautiful Cambodian child I saw during my visit to pre-Pol Pot Kampuchea in 1973, and I wonder if she survived that holocaust only to be vaporized by nuclear weaponry. Then later, we stop and he has become a girl. When I awake, the mystery is extended to the choice I made to take my daughter and her friend to Ground Zero. I saw an eye sitting on the palm of a girl's hand. There was bloody drool on her pillow, and I picked her up and went out on a sunny hill to wait for news of the slow disintegration. I was sort of the "mother" who was taking care of my brother and sister. We are in the kitchen and standing on a pile of debris—her bottom is bare and smeared with diarrhea. I search with my daughter and wife for someplace quiet to go and await our deaths. I was a young Japanese girl in those dreams, running toward a river, my skin blistered and my hair stinking. Later we boarded up the windows in my house—I remember the girls being in their bedroom with lots of blankets, and they thought it was fun. I hurried to the highway to flag down a car so I could spend the last moments of this life with my little girl.

Grief

I felt such tenderness for her, immense sadness and compassion: so this is how it all ends. The feeling was one of indescribable despair, witnessing the end to mankind. I didn't believe it until I saw red explosions in the sky—then I became desperate and broken-hearted. Rising from the chair like two great mountains, Christ and Buddha sitting, talking, lamenting man and what he'd done with all their teachings. The feeling I had was

one of deep anguish for the destruction, amazement that I was alive to observe it and a knowing that I too would die from the fallout. Suddenly I am horrified to see the guns going off, and I stop, sit down and weep.

H

Home

When I was seven, I dreamt I was running out of my house in complete panic across the neighborhood while big craters opened up everywhere. We lived in a suburb of Washington, D.C., and in the dream I was looking out the window that faced toward Washington, and I saw the Bomb, billowing orange clouds of smoke, heat and dust. I start running home—which was my parents' home. My housemates are gathered together, and I realize something is wrong—the Bomb has fallen in Canada. All at once, during another explosive event, a piece of the new body was thrown into space and landed in our apartment. We ran for the car, drove homeward, but eruptions were becoming violent and commonplace. I walk up a dirt road toward my house and find a little girl about my daughter's age sleeping in the branches of a tree. I was driving in my car near my home, heading north toward San Jose. I run through the halls of my dorm as quickly as possible and into my room where I hastily pack my blue bag of valuable possessions, making sure to include a book of my childhood poetry.

House

The snake died from radiation, and we buried it next to our house. We were in a big white mansion when we heard a rumble outside and went out to see what was going on. Suddenly a feeling of panic and the desire to run for safety grip me, and the next thing I know I'm inside of a house submerged in the water of the ocean, and the water is rushing in to fill the house. I look at the mushroom cloud through the window of a house with an old friend. It was in an old farmhouse where a group

of us were having dinner at a large rectangular table. We went into the house at her urging and ate, four of us sitting down at a table because apparently the others had eaten. Anguished, I was looking out the window of a white frame farmhouse onto devastation. I was standing in the backyard with a close friend where I lived then—Watertown, Connecticut—in an old farmhouse surrounded by fields. On the couch in the family room of the old Peoria house—several of us there, also waiting it seems. I dreamed of the final day when I was seventeen—my friend and I sat down outside his house and waited for it on the sidewalk. Arrived and rented a house, put the kid down for a nap and went to a bar.

I

Illusion

We look at the mushroom cloud, and as we focus we see it is only an optical illusion—the arrangement of trees growing upward on an offshore island. The funny thing about these dreams is that it wouldn't happen—it'd just be a cloud, or the dream would just change directions and life would go on. Using my disguise I got to some big computer where I intended to get some data I could use to help, but I found it was just a sham and the machine was just for show. Still, the thought that had occurred to me at the moment I realized I wasn't vaporized persisted—that it had only looked like the Bomb, that it had been a test or a warning.

Immerse

A mother is baptizing or drowning her baby in the water of the crater. The whole house is submerged in the water except the upper part and the roof. When I look again, I see a monstrous wave threatening to engulf us. There was one evil man still trying to bomb us so he would be the only one left in the world—we got rid of him by throwing him to the bottom of the ocean. I must put the pellet in a tiny opening underwater—

this act will stop the bombs and neutralize her rage. There is an air of intense celebration, exhilaration as we all meet on the beach to greet the tidal wave that will engulf us.

Incredulity

I think, *My god, they haven't done it, have they?* Ronald Reagan comes crawling by, blood streaming from his head; he also is crying and blubbering, "I didn't realize this would happen; I didn't know it would be like this." On an electric sign, I read that a nuclear bomb has dropped on the town over the hill, and I'm incredulous—my god, it has finally happened. Seeing the mushroom cloud, I would feel, *My god, it's really happening.* We heard over the radio that nuclear bombs were falling, but I didn't believe it until I saw red explosions in the sky. All of a sudden, I looked up from my plate and saw the huge mushroom cloud and thought, *No, that can't be.*

Invisible Poison

I stay in the shadow to protect myself, knowing that I will have to do this work while I am also suffering radiation sickness. I shout, "But the air, the water, the earth will be ruined! Come out of your shell!" We wait for some kind of a sign, an earthquake or a tremor, but then I realize we'll feel, see nothing as the radiation blows our way. A picture of executives in suits and ties, laid out dead from nuclear radiation, in rows on desk tops. I am aware of the intense radioactivity that must be in the area and can't resolve whether she is baptizing her infant or killing it. It's weird: I can't see or feel it, but I'm in a death field of radiation. We ran out as fast as we could, being afraid that it might be radioactive. I thought, *I wonder if this food is irradiated* and then, *Well, what can I do?* I'll survive the initial blast, but afterwards there is the radiation. I imagine the contents will be safe; I will simply wipe off the radioactive dust. No escape, but still I knew that radiation levels were reportedly lower in the Mediterranean. When my friend does come up from underground, I'm afraid to touch him or even see him.

I worked not knowing when I myself will succumb—aware that I wouldn't even know when I was taken by other realms because the hallucinations are utterly real. The animals would clean up the world—where the birds flew the air would clear. A kid who helped us build the shelter died because of the dust. Layers and layers of clothes will be my protection against the radiation. Then I am in a room full of mattresses where I seek to be cushioned from the radiation. Rain drops are sprinkling through the screen window, and I crank it shut wondering if it's already acid rain. Our mood is that of people with a fatal disease who are waiting to die.

Islands

We want to leave the country—we look at postcards of little islands off Australia. Everyone wants to stay in this tropical paradise—they can live forever—ultimate depression. I walk around and around and wonder at the land that has suddenly appeared—green vegetation, white sands, blue skies, white clouds. We look at the mushroom cloud, and as we focus we see it is only an optical illusion—the arrangement of trees growing upward on an offshore island. We were in a farmhouse on an island—perhaps among the San Juan Islands near Seattle. I look out the window at Florence, the cathedral in the center crumbling and the town itself falling to pieces into little islands and clumps of trees that scatter like wind over water.

L

Law/Logos (making order)

I play the "Christ," the servant to others, trying to help them weave together provisional meanings even as things unravel. They think that by passing a few laws, they can stop this destruction, but it's too late. I do what I can till the end comes—I pick up a couple of dirty pink towels and carry them into the laundry room, throwing them to the foot of the washing

machine to wait for a future wash, even when I know I may never do a wash again. I'm hired immediately as a waiter in a fancy restaurant and intend to go to the public library and read up on what waiters do to impress my wife with my acquisition of bourgeois social skills. Instead of the roar of the jet, the sounds coming from the exhaust are similar to the harmonious chants of the Gyuto Tantric monks of Tibet.

Lawlessness

There were two people who were dressed like punk rockers, sitting next to each other near the back of the bus, and they had their radios tuned to a station that was playing classical music very loud. There is looting in the street, and several of us are in front of the broken windows of a store. There is a nuclear bomb threat against the American Christian church. This takes place in some sort of post-apocalypse setting when the old world has already ended and the new one is just beginning—a la "Mad Max," etc.

M

Military

I'm the General, a gentleman/saint who presides over the apocalypse—calm and benevolent; everyone wants to negotiate with me. On the roof of the skyscraper, there is a huge party with many Israelis in army uniforms—the main speaker also in uniform. The B-52 reaches its target, drops its atomic bomb and veers off sharply to the right. In the night sky, I saw a brief air battle between an Israeli plane (which looked like a backwards B-58) and a Soviet craft resembling a chandelier. The women are probably twins, and they are in brown or khaki suits and have a distinct military look. Once again I try to discover what the patterns of her troops are, where the guards are stationed, at what time they change positions, so that I can slip past them unnoticed into the dark water to bury the pellet.

Mother

To prove that he is crazy enough to blow up the world, he grabs his mother by the ankles, spins her around his head and throws her off the top of the building. The girls' mother asked me if this was Armageddon, and I said it was but that Armageddon was in the psyche. I want to go up and tell my mother about the remarkable scene outside—even though it looks like the most gloomy scene imaginable, I feel quite good. My mother calls and leaves a message on my phone machine after a nuclear explosion. I am with my child, and we see a huge mushroom cloud rising in the sky. A mother is baptizing or drowning her baby in the water of the crater. Two women, a mother and a daughter, were about to go out, and I stopped them saying, "Don't go. There's been an explosion. I think it is the Bomb." My mother is in the bedroom trying on clothes, one thing after another—I never realized she was such a clotheshorse. I was sort of the "mother" who was taking care of my brother and sister. I know the end of the world is about to happen, and this is where I will watch it—with this woman and her children in this rundown apartment in Istanbul.

Mountains/Hills

Imagine seeing a vast gray mountain of appliances from a great distance; as I got closer, I could see there were stereos, refrigerators, televisions and PC's wedged into the mass. My instinctual reaction was to pack my backpack and head for the mountains, in spite of the fact that I knew it would be a futile act. As night came on, the light dimmed, and at nine or so, lights strobed the mountainside. I picked her up, and we went out on a sunny hill, and there I waited for news of the slow disintegration. I'm driving along a winding mountain highway, and in the field up ahead and to the right, a giant mushroom cloud is forming. The mountains form a bowl, and I think that one might be safe there. Up on the hillside, I look down at several horned demons writhing around a blood-red pool, wailing.

Mushroom Cloud

The mushroom cloud exploded over and over in my mind. When I saw the mushroom cloud, I didn't run toward it like I have always told myself I would. In the dream, I was looking out the window that faced toward Washington, D.C., and I saw the Bomb, billowing orange clouds of smoke, heat and dust. I see a huge cloud very close to us which extends from the ground to the sky, and there are aspects that look like a mushroom cloud, but I know it isn't one because it is rather dark in color and also more variegated in its shape as it rises. In the field up ahead and to the right, a giant mushroom cloud is forming. I am with my child, and we see a huge mushroom cloud rising in the sky. It is awesomely beautiful, exactly as the photographs I've seen—first a perfectly hemispherical bubble and then bursting upward into the mushroom formation. I look at the cloud through a window of a house feeling a kind of melancholy acceptance that this is all happening. The stem kept rising up and up, pushing the big puff up past the window like a tree growing from the ground. And in that moment, it exploded and I saw the mushroom cloud. It looked quite pretty, but then the light got brighter and became a brilliant, rising mushroom cloud. I didn't believe it until I saw red explosions in the sky. And the Pleiades emerged from behind the mushroom cloud. I was looking across the Rio Grande Valley toward Los Alamos, where nuclear weapons are designed, when I saw a large mushroom cloud engulfing that city. We could see the mushroom cloud when we were walking and digging. Once the radioactive dust formed into an American flag, and we were all admiring it when a tornado came and swept it up and made a mushroom cloud, and it hovered over the world like a blanket of death. I looked up at the sky, saw the mushroom cloud blooming, and awoke from the sound of my voice crying out, "Oh, no, please God, no. . . . " I am looking right at the mushroom cloud, and at that moment there is a sense of horrific freedom—awareness of the obscenity and violence, but also an ineffable nowness that this thing so long feared

has at last come to pass. The fireball is generally reddish with a blue nucleus and seems to turn while burning with varying degrees of intensity. I see the mushroom cloud between the skyscrapers, and Steve gently pushes me and him into its light.

N

Negotiating/No Negotiating

It was clear that our idea of entreating with them was useless; there was no negotiating with them at all. Someone tells me that negotiations are failing and that nuclear war is imminent— I feel that I could mediate a reconciliation. I am the General, a gentleman/saint who presides over the apocalypse—calm and benevolent; everyone wants to negotiate with me. I am an envoy to negotiate with Saddam Hussein—he's in three-point restraints when I begin tying his last leg and is completely intransigent. I pretend that I'm an Arab, and they convince me to plead with King Hussein to stop cracking down on Palestinians. I and a few others gather around a boardroom table and try to negotiate with the man who wants to blow up the world, but he is beyond negotiation on any level.

No Refuge

I opened the door thinking it was a closet, hoping for even more darkness or shelter—but the door simply opened to a framed space in the wall that held the door. Warplanes fly over a field of people, spraying computerized bullets—there is no way that anyone can survive this kind of warfare. We share the bomb squads' fate—we all go together, live or die; there is no in-between anymore. They think that by passing a few laws, they can stop this destruction, but it's too late. I hold my child close and I try to run away—I know it is useless, so I pray for instant death. She tried to hide but could find no shelter— and saw in terror that the avenue was empty. We went outside to see what was going on—it was the Bomb, and when we saw it we all died. We were there facing our mortality, the inevi-

tability of dying. The experience of dying was not suffering; trying to escape was a very intense kind of suffering. Do I want to survive? I'll survive the initial blast, but afterwards there is the radiation. I wondered how long it would take for the second death to come. My instinctual reaction was to head for the mountains, in spite of the fact that I knew it would be a futile act. I'm pissed at a woman who believes that, after four hours following attack, we survivors will be safe. My daughter, wife and I go someplace quiet to await our deaths. It was like being under a blanket of death. I can stay underground and be suffocated to death or dig my way to earth and be burned alive by the radiation. I was a young Japanese girl in those dreams, running toward a river, my skin blistered and hair stinking, what was left of it after the searing hot shock wave had passed. We all dive beneath covers or, in my case, the afghan, even knowing it's futile. A weakened few trekked across the valley, but the nuclear storm rolled over them, too. Flamemakers think they'll be safe, but they too will be afraid—they'll run like hungry dogs, and their ears will be full. The feeling I had was deep anguish for the destruction, amazement that I was alive to observe it and a knowing that I too would die from the fallout. Then I see the face of a beautiful Cambodian child, and I wonder if she survived Pol Pot's holocaust only to be vaporized by nuclear weaponry. I could see a great bare eyeball, bigger than life, hovering over my head, staring point-blank at me. I was powerless to move. The real horror hit home as we came to where a bridge went over the road and met hundreds of people walking in the opposite direction—this was no place to go, no refuge; it affects us all.

O

Ocean

Suddenly everything became light, and the next thing I know is that I'm clinging to a shard of wood trying to keep afloat in a vast ocean. I am suspended over a great ocean, and there

is no land in sight. I am about to remark on how calm the sea is when suddenly it gets rough. We look at the mushroom cloud, and as we focus we see it is only an optical illusion— the arrangement of trees growing upward on an offshore island. I saw several lights illuminating the underside of the clouds across the sea at the horizon as far away, let's say, as Catalina. I am not killed, but the fallout/nuclear radiation has caused mutations to form in the sea—suddenly I see a dog swimming underwater—he is able to breathe in the water. The cathedral in the center of Florence crumbles, and the town itself falls to pieces into little islands and clumps of trees that scatter like wind over water. More saucers kept coming in low over the harbor. Everyone I know is gathered at the beach, and there is an air of intense celebration and exhilaration as we all await the tidal wave that will engulf us.

P

Panic

I went back into my house and called for my parents, and when there was no response, I grew frantic. Early in the night was the ugly part of this with my parents against me, darkness, possession starting to take place; the girls' mother asked me if this was Armageddon, and I said it was but that Armageddon was in the psyche. By some miracle I was still alive—I panicked and awoke. We ran out as fast as we could, being afraid that it might be radioactive. Big craters were opening up across the neighborhood, and I ran out of my house in complete panic. I ran away in panic, but I knew even as I tried that I couldn't get away. Family members scramble, lose themselves in the mob. I can stay underground and be suffocated to death or dig my way to earth and be burned alive by the radiation—I wake in total panic. I bury my eyes in the mattresses in front of me, calling out in panic, "My eyes, my eyes" as the Bomb falls. When I awake, for a few moments I thought I was dead until I slowly wriggled my fingers and felt my heart pounding.

There was also a miniature arched wooden bridge, but it spanned nothing, and when I noticed the water was "missing," I had a panic reaction. As I frantically motioned for the bus driver to slow down, the wild-eyed driver enjoyed my frustration and made the bus go even faster. I panicked and, remembering that there was an abandoned quicksilver mine shaft about two miles up the road, pushed on the gas to get up there before the shock wave of radiation got to me. The people were all breaking into little groups and fleeing—the aliens were shooting death rays at them. Suddenly a feeling of panic and the desire to run for safety grip me, and the next thing I know I'm inside of a house submerged in the ocean, and the water is rushing in to fill the house. She tried to hide but could find no shelter and saw in terror that the avenue was empty. I awakened short of breath and my heart pounding. Somehow I feel I am fighting for my life in this dream—if I lose, I will not wake up.

Parents

The feeling then was the loss of parents and loved ones in a short instant. I associated what had become (in my mind) my parents' death and my inability to find my dog, with the air battle. I started running home—which was my parents' home. Early in the night was the ugly part of this with my parents against me, darkness, possession starting to take place.

Phone

My mother calls and leaves a message. I was on the phone talking to Bob and standing behind a couch when a blast occurred that Bob saw, and his eyes melted out of his head; and then it happened to me, too. I feel a desperate need to find my daughter and my wife as I know we will all die soon, but when I try to call them on a public phone, I find I don't have the right change.

Pray for Death

I hold my child close and I try to run away—I know it is useless, so I pray for instant death. Do I want to survive? I'll survive

the initial blast, but afterwards there is the radiation. There was no fear really, only a hope that it would be over soon; thinking how close the cloud was I thought it should take seconds, but I didn't feel the blast or the heat and didn't die, though I prayed for it.

R

Refuge

I stay in the shadow to protect myself. I have to climb a long rotten ladder to get to the top of the tower where a Turkish woman, dark and cordial, serves me coffee. She said such and such apartment should continue to be rented during this transition period—meaning the apocalypse. I reflect back on the beast that shot up from the water and the fear and awe it evoked in me, but I feel safety and security because I'm in this house, this last bastion of hope and protection. Then I decide to wait with everyone else in the darkened hallway. The Bomb dropped out of the sky, and I ran in panic to a friend's house which had a shelter. They left the island immediately for Phoenix which, in the dream, was a rural garden spot. I got up and walked up the hill without looking back and entered the first house. The mountains form a bowl, and I think that one might be safe there. I take refuge in a museum run by Christian Hindu hippies and am intensely moved by the mystery of who they are. I am chased by a vicious thirteen-foot-high Tyrannosaurus and climb into a narrow stairwell where it can't get me. I climb up a rock escarpment and find refuge there. People come to me—I work out of a ramshackle house on the outskirts of town. We go someplace quiet to await our own deaths. I protect the frog-like extraterrestrial when the townspeople try to pour gasoline on him and burn him. Radiation levels were reportedly lower in the Mediterranean. Everyone wants to stay in this tropical paradise—they can live forever—ultimate depression. We were ushered to a large, half-demolished structure, a camp for refugees; here the suffering people huddled cold and hungry.

We are running through the barren hills, taking shelter in the ruins. In cars, on foot, in busses, people flock to a large shopping mall. We had to walk about twenty miles from our house where we could dig a hole in the ground to get air. We had to make a shelter for ourselves now out of wood from the ruined houses. We boarded up the windows in my house—I remember the girls (my kids and about four or five others) being in their bedroom with a lot of blankets, and they thought it was fun. I have chosen to be alone, seeking protection in my own underground shelter rather than be alone for the rest of my life with Carolyn. A nuclear thing was coming; I was walking in a grand hotel, and the place was rattling because of a quake; but I was in good spirits. I panicked and, remembering that there was an abandoned quicksilver mine shaft about two miles up the road, pushed on the gas to get up there before the shock wave of radiation got to me. The mountain was honeycombed with caves in which these people lived; furthermore, it was evident that these creatures had amassed certain types of products around their own particular cave. I am profoundly aware that when I die, I will be there in the children, but first I must get them to a green place, a new land, let them rest and heal, and learn to play again.

Ritual

I felt a little crazy, a little shaky about it, but I put coyote shit on my altar instead of flowers and then I had a dream. Some officials seem to be lighting an eternal flame in downtown Jerusalem, but on closer look, I see it as a fountain of water. A mother is baptizing or drowning her baby in the water of the crater. A group of people start doing a ritual dance along the string; it's a mechanical, zombie, dead energy movement. But when I am there, I decide to bow to everyone in the circle. Instead of the roar of the jet, the sounds coming from the exhaust are similar to the harmonious chants of the Gyuto Tantric monks of Tibet. The shaman's wife—shy, highstrung and beautiful—encircles the group with a handful of blue cornmeal.

River

The canals were my veins, the rivers of the world, my interior landscape of world/garden/body; I dove into the water, buried the pellet, neutralized her rage and woke up. It's the Brooklyn River—which I had forgotten existed. Finally the bus stopped in a park near a river. There was also a miniature arched wooden bridge, but it spanned nothing—there was no water running underneath it, and when I noticed the water was missing, I had a panic reaction.

Ruins

Anguished, I was looking out the window of a white frame farmhouse onto a flat ashen landscape. The world is being destroyed, everything is disintegrating, and we're all going to die. I walk past a ruined laundromat, piles of charred clothes scattered about. There is looting in the street; several of us are in front of the broken windows of a store. The area of Seattle was totally desecrated, leveled, with nothing but gray rubble and steamy clouds. The sky was red, as though the sun had crashed and burned; the earth, black desolation. We were ushered to a large, half-demolished structure, a camp for refugees.

S

Saving the World

I was tough-as-nails, good—with the right values, able to easily infiltrate into groups. A friend of mine is in the underground— and quite literally under the earth—where he is carrying out reconnaissance. A big catastrophe was going to happen, maybe the world was coming to an end—so using my disguise, I got to some big computer where I intended to get some data I could use to help. We come to the scene where the bomb squad is working on the Italian bomb. I have to pass as one of them,

but I must subvert them and their nuclear danger. I noticed the missiles rising up over New York City, and I declared that I would not stand for it—and they withdrew. They were in a council, trying to figure out what to do because it had gotten out of control. The children must be saved so they can start a new world. Someone tells me that negotiations are failing and that nuclear war is imminent; I feel like I could mediate a reconciliation. I pretend to give the key to the "red button"— the Bomb—to my comrade so I can escape with it under the nose of our pursuers. I and a few others gather around a board-room table and try to negotiate with the man who wants to blow up the world. A part of me thinks I can or should do this underground work alone, but another part believes that it is dangerous. I surreptitiously break into a nuclear bomb facility on the shores of Lake Atitlan in Guatemala, disconnect the alarm and defuse the Bomb—then return to my friends without telling them I did this. There was one evil man still trying to bomb us so he would be the only one left in the world—we got rid of him by throwing him to the bottom of the ocean. He says that if I tie all his limbs, he'll unleash chemical and nuclear weapons, and there will be a huge holocaust, so I pause, leave the room to meditate on this for a few minutes and then decide to call his bluff. I know if I put a pellet in a tiny opening underwater, I will neutralize her rage and the bombs will stop.

School

I am walking down the street when I see a whole bunch of school kids running down the streets; their teachers are hurrying them along, trying to get them home as quickly as possible. Myself and hundreds of others are present on the grammar school grounds; guns are emerging from an old oak overhead. A huge suburban elementary school houses a nuclear reactor. The first thing I did was to go to the school and get my girls and whoever's kids I knew whose Moms and Dads would not be home and lived a distance away.

Selfless Action

I play the "Christ," the servant to others, trying to help them weave together provisional meanings even as things unravel. I am profoundly aware that when I die, I will be there in the children, but first I must get them to a green place, a new land, let them rest and heal, and learn to play again. I looked up and said, "Don't worry—wherever I end up, I will take you with me" as if I were going to be able to take care of them in some way. I remember that I said I'd be around to help people put it together afterwards. The first thing I did was to go to the school and get my girls and whoever's kids I knew whose Moms and Dads would not be home. I was sort of the "mother" who was taking care of my little brother and sister. The disease apparently erupts from under the earth, and a friend of mine is in the underground—and quite literally under the earth—carrying out reconnaissance. I was now listening to the very same voice calmly insisting, "You see, you volunteered." Her refusal sparks a determination in me to do what I can until the end comes.

Sex

Now we knew the end was coming; I was ready to enjoy the fruits of two young prostitutes when suddenly they were turned into ancient hags. It occurs to me the other one probably won't want to engage in sex for the same moral principles I espouse, but to get away from the temptation altogether, I disassemble into the "pass through" mode and rise up to fly above the clouds. We start kissing, nibbling on each other's lips in a very sexual way; again I'm a much rougher person than I normally see myself. Funny how in the midst of terror of annihilation, mind will fix upon a small, apparently unrelated thing—like her. Who was she? Beautiful and sensuous, she walked calmly through the crowd, and people, observing her, calmed too.

Shapeshifting

The man changed himself into a big orange cat and jumped out the window in hot pursuit. Then later, we stop and he has become a girl. I turned into an old man; I was crotchety and my sister was bitchy, too. So the animals automatically turned into people. I go outside to the barn where I exchange my "found out" body for that of a middle-aged farmer, though first he was a young girl.

Siblings

I see all my past friends, relatives, family, visions before my eyes; my life flashes before me and disappears. Everybody was dead except my little brother and sister. My brother and the other guy drift off somewhere. I remember my brother Fred and an old woman, but there were others, too. I was in a big white mansion with my family when we heard a rumble outside and went out to see what was going on. The Bomb blew up an airport that me, my father and brothers were in. I am in a board meeting with the principal and an inner circle of loyal staff, including the principal's brother who runs the reactor. I was crotchety and my sister was bitchy, too. Two guys I know were somehow my brothers, and though they were in prison or in a small town, I wanted them to know that we were family in spite of our impending death.

Sky

The sky was red, as though the sun had crashed and burned. I hear the explosion and see the rush of smoke and flames reaching to the sky. But to get away from the temptation altogether, I disassemble into the "pass through" mode and rise up to fly above the clouds. The skies were darkening in an unbelievable manner. The land has suddenly appeared, green vegetation, white sands, blue skies, white clouds, etc. I see a huge cloud very close to us which extends from the ground to the sky. I am with my child, and we see a huge mushroom cloud rising in the sky. I was called to the window to watch

a phenomenon in the sky. I saw an eye sitting on the palm of a girl's hand. Suddenly it turned and leaped into the sky. I noticed the missiles rising up over New York City. I didn't believe it until I saw red explosions in the sky. A parachute is angling downward toward the mall; I add, "I don't like the looks of that." I anticipate terrorist violence while looking up in the sky for the Messiah. The sky is ominous with occasional heat lightning and dark clouds. The sky opens up and a frog-like extraterrestrial descends, flapping his feet so he lands lightly. We sat there with our chins in our hands, watching the Bomb float lazily down over the city in a parachute. More saucers kept coming in low over the harbor. A mushroom cloud hovered over the world—it was like being under a blanket of death. Where the birds flew, the air would clear. In the night sky, I saw a brief air battle between an Israeli plane and a Soviet craft resembling a chandelier. Giant spaceships hovering over a city like Seattle. I looked up at the sky, saw the mushroom cloud blooming and awoke from the sound of my own voice crying out, "Oh, no, please God, no. . . ." And the Pleiades emerged from behind the mushroom cloud. Suddenly I look up and see the Bomb dropping as if through a keyhole. I went in search of some ephemeral orb that reputedly hung in the sky. The trees, the hurrying bugs, the perfectly blue sky, our hearts.

Skyscrapers

I'm on top of one of the twin towers in New York City, and the world is going to blow up at midnight. She is in an airplane and can see into the windows of the highrises and destroys buildings with the ease and fervor of a child playing a computerized game. On the roof of the skyscraper, there is a huge party with many Israelis in army uniforms, the main speaker also in uniform. I see the mushroom cloud between the skyscrapers.

Spouses

He thought the world was bad except him so he wanted to make sure that nobody was left except him and his wife. "Frankly, I thought I'd go out to the market after I got here,"

he says innocently—as if markets exist anymore, as if all the food hasn't already been looted. His clothes are clean and pressed, and he has an air of aloofness from all the dirt, decay and impending death that we are living in. It would be silly to hold on to each other because then we would both drown. I must find my wife and daughter as I know we all may die soon. I felt an unbearable urgency to be with my wife and child.

Suddenly

Suddenly there is a blinding flash of light. All of a sudden the film of my life ran out, and everything turned white. Suddenly I look up and see the Bomb dropping as if through a keyhole. The streets suddenly begin to slide swiftly in different directions. Suddenly a great dragon mightily emerges from the waters, moving fast, straight up with great power and majesty. Suddenly the second body began to explode in spectacular colors that looked like an H-bomb explosion. Suddenly it turned and leaped into the sky and then came flying back toward me, so that, looking up, I could see a great bare eyeball, bigger than life, hovering over my head. All of a sudden, I looked up from my plate and saw this huge mushroom cloud. Suddenly we hear something outside, perhaps an aborted air raid siren. And suddenly, from out of these cracks come children, like seeds from the earth. Suddenly we heard over the radio that nuclear bombs were falling. Suddenly I am horrified to see the guns going off. Suddenly we learn that the Earth is under fire, atomic bombs exploding. Suddenly I remember that I said I'd be around to help people put it together afterwards.

Suicide

I drove toward where I thought Ground Zero would be as quickly as I could. The house is a sort of veterinarian facility, so I know there will be drugs when the time comes. The mystery is extended to the choice I made to take my daughter and her friend to Ground Zero. I did not want to continue living and

thought of suicide. But how? I pushed a bullet which would explode and destroy the world all around us out the window and waited for the mushroom cloud to come and bring quick death. Then we all started banging our bombs with hammers! When I saw the mushroom cloud, I didn't run toward it like I have always told myself. People are now driving in the opposite direction on the steep, curving road and forcing smaller, unwary cars off the cliff in a kind of suicidal, exultant anarchy. Desperate to kill myself, I decided to slit my wrists in the bath, only to find that the tub was filled with the body of an enormous dead black woman.

T

Technology

The false front box is dug out of the wall to expose the front of the actual bomb—it pulsates like a heart, and I know that is the part that is ticking. It was that strange bus driver's head, and inside his neck there were many red and green wires. A big catastrophe was going to happen, maybe the world was coming to an end—so using my disguise, I got to some big computer where I intended to get some data I could use to help. A leading Japanese scientist reportedly had a wartime dream in which he saw a deep cavern containing a great atom smasher from which emerged luminous rays striking around the earth to destroy Washington. "The Reactor is out of control, and we've got to come up with something pretty fast or it's going to explode." They are falling in a computerized pattern so that the concrete below is being cracked open per square foot or square yard. We had made a machine that just pushed the bad guy out of the way and into the ocean. A huge suburban elementary school houses a nuclear reactor. He is assembling a structure in the form of a man out of parts of shiny steel. Furthermore, it was evident that these creatures had amassed certain types of products around their own particular cave—

one had a concentration of radios, another of stoves, some new, some in disrepair.

Trees

I walk up a dirt road toward my house and find a little girl about my daughter's age sleeping in the branches of a tree. We look at the mushroom cloud, and as we focus we see it is only an optical illusion—the arrangement of trees growing upward on an offshore island. The cathedral in the center is crumbling, and the town itself falling to pieces into little islands and clumps of trees that scatter like wind over water. Guns are emerging from an old oak overhead. Somehow I'm on the edge, on the window ledge outside, out on a limb in a tree. My lover and I and two small children are having a picnic on a small green hill with a single tree on top when suddenly I look up and see the Bomb dropping as if through a keyhole. As I looked at the maple tree, it was like when watching a movie and the film runs out—all of a sudden the film of my life ran out, and everything turned white. After the peace dust went away, there was a big forest and a few people. You slapped the ground, and flowers and trees would sprout up. I saw a metal plaque that said, "It would take a saw 'x' number of years to cut enough wood to rebuild Hiroshima."

U

Underground

A part of me thinks I can or should do this underground work alone, but another part believes that it is dangerous. Carolyn cowers in the underground room with me while everyone else wanders around outside. We dug a hole in the ground so we could get air. We heard these murmuring words from the hole saying, "Put some of this white dust in the hole and you'll cure me." I can stay underground and be suffocated to death or dig my way to earth and be burned alive by the radiation. The first

part of the building crashed, and all the people fell down a hole. The streets suddenly begin to slide swiftly in different directions. All across the neighborhood big craters started opening up. There is an underground city; it is inside me and is also the earth and a garden. There are large cracks in the earth, and suddenly, from out of these cracks come children, like seeds from the earth. Other places in the world were reporting these eruptions, too. Somehow the Bomb and AIDS are related— the disease apparently erupts from under the earth. I tell him of the dream, and everything cracks open. He climbs in and out of rabbit holes; his wisdom is in his playing. I found myself reflecting on what it was going to be like, sharing that cave with others who happen to know about it.

V

Violation of the Natural Order

I see a dog swimming underwater (he is able to breathe underwater), and I throw mosquito larvae (which are in the air instead of the water) to feed it. I saw not only the charred bodies, but the mutations and diseases and the work needed to pull it all together 'cause the people would not be human as we know it in future generations. If they time-traveled enough, it could cause a backlash such that it became almost a bomb. The boy has taken on the features of a newborn chicken. There were horrible, strange skeletal insect things wrestling next to me, and they nearly touched me. Behind my back he tells others there are no seams to my fingers and somehow no nerves, and I'm missing a finger. So much heat had been generated deep down in the earth from atomic bomb explosions that the growth of dinosaur eggs was stimulated. The demon pointed out a ten-foot-tall dandelion. I think, *Kill it, knock it out of its pain,* but the hooked mouth is not the mouth of a fish or any other creature I have known; somehow as a human being I feel responsible for what is surely a wretched mutation.

Violence

The extraterrestrial is attacked by townspeople who try to douse him with gasoline and light him on fire. I knocked him off my shoulder and jumped on top of him, shattering his plastic face. People are forcing smaller, unwary cars off the cliff in a kind of suicidal, exultant anarchy. On the streets are many games and fighting matches. I anticipate terrorist violence while looking up in the air for the Messiah. To prove he is crazy enough to blow up the world, he grabs his mother by the ankles, spins her around his head and throws her off the top of the building. There is looting in the street. I look over the edge and see two Palestinian children beating each other mercilessly. It's pretty awful—dog eat dog, but I enjoy it.

W

Waiting to Die

Our mood is that of people with a fatal disease who are waiting to die. There was no fear really, only a hope that it would be over soon. We were there facing our mortality, the inevitability of dying; our friends had escaped. Then I decide to wait with everyone else in the darkened hallway. I don't know when I myself will succumb. I want to find someplace quiet for us to await our deaths. We were going to die, which was hard to accept. I wanted them to know we were family, in spite of our impending deaths. I know we will be dead in a few days and feel a deep sense of melancholy and acceptance.

White Light

Everything became pure, white, bright light: I was gone but I could still observe, see the light and hear the sound. I slowly turned my head and looked at the maple tree, and it was like watching a movie and the film runs out—all of a sudden the film of my life ran out, and everything turned white. Then it went, and everything dissolved at that moment, and I experi-

enced dissolving. The wind blew a scrap of paper past two silent kids, and then there was a white flash. Suddenly there is a blinding flash of light: the Bomb drops. Everything goes up in light; the Bomb has fallen, and the next thing I know, I'm in the ocean clinging to a shard of wood.

Windows

I tell the priest a dream about nuclear holocaust, and as I do, I look out the window at Florence and see the cathedral in the center crumbling. All of a sudden, I looked up from my plate and saw this huge mushroom cloud through the picture window. When I look out the window, I see a huge cloud very close to us which extends from the ground to the sky. It has little if any furniture, but is filled with clear light which enters the windows halfway up the wall on three sides. I am with other people I don't know, and we are trying to keep back the water that is rushing in through the windows. I look at the mushroom cloud through a window with an ex-lover. I was called to the window to watch a phenomenon in the sky. If there was a light source, it would have had to have been a small bulb on the ceiling as there were no windows. Anguished, I was looking out the window of a white frame farmhouse onto devastation. Somehow I'm on the edge, on the window ledge outside, out on a limb in a tree. I pushed a bullet out the window that would explode and destroy the world all around us. We boarded up the windows in my house. I face away from the outside window so my eyes won't be blinded by radiation.

World Cracking Open

The streets suddenly begin to slide swiftly in different directions. Suddenly from out of these cracks come children, like seeds from the earth. The first floor of the building collapsed, and all the people fell down the hole. Big craters were opening up across the neighborhood. The grounds erupting, swelling with volcanic rumbles. I look out the window at Florence and see the cathedral crumbling and the town itself falling to pieces into little islands. Volcanic eruptions and earthquakes forced

long-dormant dinosaur eggs to the earth's surface, where they hatched. Somehow the Bomb and AIDS are related—the disease apparently erupts from under the earth.

Z

Zombies

People are scattered around dead, or are like zombies, walking dead, soon to be dead. I ran down the line trying to get people to wake up but I couldn't; they kept walking. A group of people start doing a ritual dance along the string; it's a mechanical, zombie, dead energy movement. I didn't want to be one of those who shuffled through the streets with my skin hanging off or my eyes blind.

Bibliography

Bernal, Martin. (1987) *Black Athena: The Afroasiatic Roots of Classical Civilization*, 3 vols. Volume 1. New Brunswick, NJ: Rutgers University Press.

Brandt, Charlotte. (1966) *The Third Reich of Dreams*. Chicago: Quadrangle Books.

Chatwin, Bruce. (1987) *The Songlines*. New York: Viking Press.

Cohen, Arthur A. (1988) *The Tremendum: A Theological Interpretation of the Holocaust*. New York: Crossroad.

Del Tredici, Robert. (1987) *At Work in the Fields of the Bomb*. New York: HarperCollins.

Fontenrose, Joseph. (1959) *Python: A Study of Delphic Myth and Its Origins*. Berkeley: University of California Press.

Giono, Jean. (1980) *Joy of Man's Desiring*. Berkeley: North Point Press.

Hillman, James. (1979) *The Dream and the Underworld*. New York: Harper & Row.

_____. (1986) "Notes on White Supremacy." *Spring 1986: An Annual of Archetypal Psychology and Jungian Thought*: 29–58.

Life Magazine, 13 August 1945.

Lifton, Robert J. (1967) *Death in Life: Survivors of Hiroshima*. New York: Random House.

Lifton, Robert J., and Falk, Richard. (1982) *Indefensible Weapons: The Political and Psychological Case against Nuclearism*. New York: Basic Books.

Metzger, Deena. (1981) *The Axis Mundi Poems*. Los Angeles: Jazz Press.

Otto, Walter F. (1965) *Dionysus: Myth and Cult*. Bloomington: Indiana University Press.

Perry, John Weir. (1974) *The Far Side of Madness*. Englewood Cliffs, NJ: Prentice-Hall, Inc. (reprinted, Dallas: Spring Publications, 1989).

Rhodes, Richard. (1986) *The Making of the Atomic Bomb*. New York: Simon and Schuster.

Snyder, Gary. (1969) *Earth House Hold*. New York: New Directions.

Szasz, Ferenc Morton. (1984) *The Day the Sun Rose Twice*. Albuquerque: University of New Mexico Press.

Taussig, Michael. (1987) *Shamanism, Colonialism, and the Wildman: A Study in Terror and Healing*. Chicago: University of Chicago Press.

Walker, Barbara. (1983) *The Woman's Encyclopedia of Myths and Secrets*. New York: Harper & Row.

Weart, Spencer R. (1988) *Nuclear Fear: A History of Images*. Cambridge: Harvard University Press.

Weisskopf, Victor. (1991) *The Joy of Insight: Passions of a Physicist*. New York: Basic Books.

Wells, H. G. (1926) *The Works of H. G. Wells*. Volume 21. London: T. Fisher Unwin, Ltd.

Whitmont, Edward C. (1988) *Return of the Goddess*. New York: Crossroad.

Wilson, Jane S., and Serber, Charlotte, eds. (1988) *Standing By And Making Do: Women of Wartime Los Alamos*. Los Alamos: Los Alamos Historical Society.

Yeats, William Butler. (1959) *The Poems of W. B. Yeats*. New York: Macmillan.

Zweig, Connie, and Abrams, Jeremiah, eds. (1991) *Meeting the Shadow: The Hidden Power of the Dark Side of Human Nature*. Los Angeles: Jeremy Tarcher.

Film

The Day After Trinity. (1981) Pyramid Film Distributors.

ABOUT THE AUTHOR

Michael Ortiz Hill is a writer, registered nurse, and practitioner of traditional African medicine in the United States and among Bantu people in Zimbabwe. Born in 1957 to a Mexican Catholic mother and an Anglo-Buddhist father, his life always involved moving between different cultural communities. Hill is married to the novelist and feminist thinker Deena Metzger. They live in the Santa Monica mountains of California with their wolf Isis. His books include *Dreaming the End of the World*, *Gathering Names* (co-authored with Augustine Kandemwa), and *Overcoming Terrorism*.